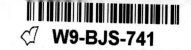
PHOTOGRAPHY
ART AND TECHNIQUE
Second Edition

View from the window at Gras, near Châlon sur Saône, 1826, by Joseph Nicéphore Niepce. The first photograph ever taken (it was called at the time a heliograph). Duration of exposure was eight hours. Reproduced courtesy of the Gernsheim Collection, Humanities Research Center, The University of Texas at Austin.

PHOTOGRAPHY
ART AND TECHNIQUE
Second Edition

Alfred A. Blaker

Focal Press
Boston London

Line drawings on pages 118, 120, 186, 212, 233, 234, 236, 237, 256–264, 280, 281, 316, and 320 were prepared by Boston Graphics, Inc.

Focal Press is an imprint of Butterworth Publishers.

Library of Congress Cataloging-in-Publication Data

Blaker, Alfred A., 1928–
 Photography: art and technique.

 Bibliography: p.
 1. Photography. I. Title.
TR145.B54 1988 770 87-24641
ISBN 0-240-51742-3

British Library Cataloguing in Publication Data

Blaker, Alfred A.
 Photography : art and technique — 2nd ed.
 1. Photography
 I. Title
 770'.28 TR146

ISBN 0-240-51742-3

Butterworth Publishers
80 Montvale Avenue
Stoneham, MA 02180

10 9 8 7 6 5 4 3 2 1

Cover photographs: Alfred A. Blaker

Printed in the United States of America

Contents

Preface

Because each photographer and photography teacher has a particular background of education and experience in the medium, each will have individual views on the art and craft of photography and on how it should be taught. This book is a summation of my thinking on such matters. My own view is that beginners in photography need a well-organized, thorough program of technical instruction with sufficient historical perspective. But they need more: They need an introduction to photographic aesthetics, presented both in text and in a broad sweep of photographic examples.

Photography: Art and Technique is intended to be a compact, comprehensive introduction for college students and for those studying photography on their own. Because the expressive possibilities of photography cannot be fully exploited without technical mastery of the medium, the technical chapters in this book provide a more thorough, detailed grounding than is supplied by most other texts. Throughout the book, however, technique is presented not as an end in itself but as something that, once mastered, becomes a foundation for creativity.

The photographs in the book include the work of over 100 photographers, most of them acknowledged masters, others relative unknowns, and one a first-course beginner. The breadth of approach and subject matter is one that provides the reader with the greatest possible variety of examples and inspirations. To emphasize the diversity of the medium, the photographs are distributed throughout the text as uniformly as context will allow. The photographers are credited in the captions; photographs not attributed by name are my own.

Although the sequence of chapters in *Photography: Art and Technique* is one that I think will be generally useful, I realize that not everyone has the same preferences. So that the chapters can be read in any one of several sequences, each chapter has been made substantially self-sufficient. For example, Chapter 7, "Lighting," presents a detailed general discussion of natural light and of artificial lighting, continuous and flash. But in addition, Chapter 13, "Close-up Photography and Photomacrography," describes lighting methods suitable to those techniques, and Chapter 14, "Photographing Action and People," describes lighting setups for casual and formal portraiture.

Certain areas of photography that are of importance or of great interest to beginners are neglected or given only perfunctory treatment by most texts. In this book an effort has been made to avoid such omissions or slights. Thus, in addition to the universally treated basics—a brief history of photography, cameras and lenses, exposure, lighting, developing, and printing—I have included a number of topics that merit special mention.

Whereas few books treat more than the bare essentials of filter use, Chapter 8 of this book treats filters at length, as versatile tools of great use to serious photographers, beginners included.

Chapter 9, "Camerawork," includes timely, detailed coverage of view camera technique. Formerly eclipsed by smaller camera formats and relegated to commercial studio work, the view camera is again coming into its own among serious photographers of all stripes. Student interest has likewise increased, to the point where sketchy coverage is no longer adequate.

Chapter 12, "Color Printing," is new with this revised edition, and is a result of public interest. It was written by George Post, and is a revision of a four-part series that he wrote for *Darkroom Photography* magazine.

Chapter 13, "Close-up Photography and Photomacrography," is extensive not simply because of my own interest and expertise in these areas but because student interest in them, as many instructors have indicated, is strong and apparently growing.

Chapter 14, "Photographing Action and People," addresses technical matters (and ethical ones as well) relevant to these areas of abiding fascination. Topics covered include photographing motion, lighting for portraiture, and approaching people in various contexts.

Chapter 15, "Camera/Print Alternatives," describes such techniques as soft-focus photography, "solarization" (the Sabatier effect), and photograms.

In far too many books the sole acknowledgment of photography's aesthetic aspects is the display of work by important photographers—usually with captions that dwell entirely on technical matters. The texts themselves neglect such topics as previsualization and composition, and they discuss only in a historical context the various approaches to the medium—the personal and social purposes that motivate photographers. The three chapters of Part Six, "Conceiving the Photograph," deal explicitly with the issues just mentioned.

In Chapter 16, "Seeing Photographically," the beginner is advised that photography, seriously pursued, both requires and promotes heightened visual perception, and that all photographers must become adept at previsualization.

Chapter 17 deals with composition. Some writers and instructors shy away from the topic of composition, because in the past it had come to be associated with the slavish following of mechanical rules. But it is true that every photograph has a composition—an arrangement of masses, lines, and tones, and areas of greater and lesser interest. I believe that beginners are disserved when they are required to deal with compositional problems unguided. Hence the inclusion of Chapter 17.

Chapter 18 addresses a subject that has become increasingly important to students in recent years: the possibilities open to them for careers in photography or in businesses related to it—everything from photojournalism to running a gallery.

Every book of this nature is a synthesis that draws on years of experience in the medium and of teaching it, on wide reading, and on hours of conversation with colleagues and students. Those who have influenced my work or my thinking over the years are far too numerous to mention, but a few have been so helpful that I must express my gratitude to them here.

What I learned from my teachers, and particularly John Gutmann, has always been valuable to me, and was of great help in this project. Victor Duran, with whom I worked for five years, pressed me to reach for better and better technical quality, and provided me with a steady series of fine examples. Rudolf Stohler, Ralph Emerson, and William Kaufmann introduced me to writing for publication. And publication got me into teaching, through the help of Ronn Storro-Patterson at first;

and then Sharon Arce at University of California Extension; Margaret Dhaemers of the Design Department, University of California, Berkeley; and Paul Raedeke of the Academy of Art College, San Francisco. Teaching, of course, led to this book.

Any author owes much to the staff of his publishing company. Although the group nature of publishing makes it difficult to identify or properly credit everyone involved, special notice must be given to at least a few. Gunder Hefta, who was "present at the creation," has been influential and infinitely helpful throughout. Linda Chaput and Kevin Gleason performed prodigies in editing, organizing illustrations, and general, all-around technical assistance. The fine work of the designers, Gary A. Head and Perry Smith, is evident throughout. No one could have had a better relationship with a publishing firm than I have had over the years with the staff of W. H. Freeman and Company, publishers of the initial edition of this book. Good relations have continued, with Karen Speerstra, Ken Jacobson, and others at Focal Press, the publisher of this revised edition.

The chapter on careers is a joint effort. Amy Rennert, author of *Career: Photography* (New York: G. P. Putnam's Sons, 1979), has provided inestimable assistance with this section, and many of the words that you read there are hers.

All authors come at last to their families. My wife, Sally, and my six children have put up with a lot since I took up writing, not least in this project. Their patience has been remarkable. But I must offer special thanks to my children—John, Frances, Barbara, Elizabeth, Harry, and William—who served unstintingly as "galley slaves" during editing. Other authors should be as lucky.

Alfred A. Blaker
El Cerrito, California
June 1987

PART ONE
BEGINNINGS

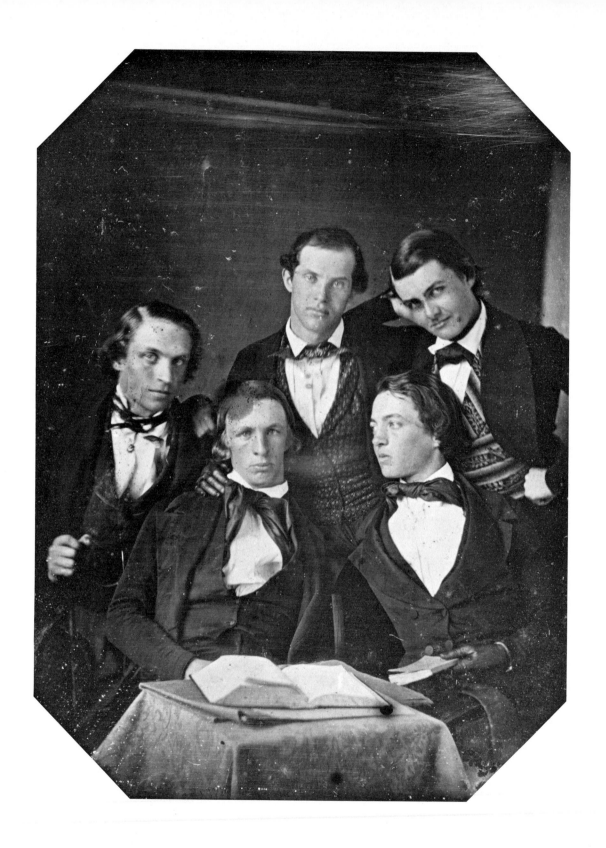

1

A Technical History

Daguerreotype, circa mid-1840s, photographer unknown. The figure seated at the right is Frederick Law Olmsted, who later designed Central Park and various parks in Boston. His companions are Yale College classmates. Courtesy of The Society for the Preservation of New England Antiquities.

Until the invention of photography early in the nineteenth century, there was no accurate way to objectively convey the appearance of any person, thing, or scene. Seamen recording the look of a landfall, explorers describing the lay of unfamiliar land, artists putting down for posterity a facsimile of a notable visage, and artisans passing on their designs were all at the same disadvantage.

Visual communication through drawing and painting was limited by an artist's skill, the prevailing artistic technology, and even the artistic fashions of the time. To get an idea of the variety of possible interpretations, one has only to examine portaits of the same person painted by several artists. Another impediment to accurate depiction was that the work could contain only a small fraction of the detail present in the original subject.

The impressions recorded in a drawing or painting were also affected by the time available to the artist. For example, dozens of sittings and many hours of intense labor might have been necessary to produce a fine portrait, but the time that a mariner had in which to render a landscape at a port of call would have allowed only a modicum of detail. The information conveyed depended on the artist's judgment of the relative importance of various features.

Cost has always been a limitation when skills and available time are insufficient to satisfy the demands. Only the wealthy could afford a portrait that was a "good likeness." Others had to make do, at best with the indifferent efforts of passing sign painters and at worst with nothing at all.

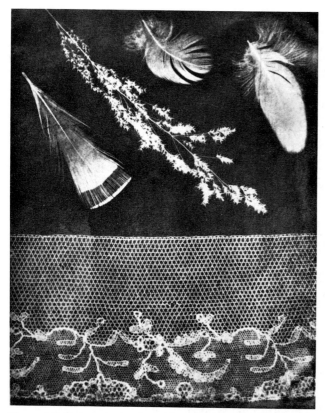

Figure 1-3 Photogenic drawing of feathers and lace, 1839, by William Fox Talbot. This picture is basically a photogram, made by laying objects on a piece of sensitized paper and then exposing it to light to produce a shadowgraph. Reproduced courtesy of the Gernsheim Collection, Harry Ransom Humanities Research Center, University of Texas at Austin.

to operate it, and had a plate size of something like 4 × 5 *feet*.

Collodion glass-plate equipment, though cumbersome, was not noticeably more so than that needed for making a daguerreotype of comparable size. In addition, glass was cheaper than metal, and an unsuccessful negative could be readily cleaned off and the plate reused. In England the process had the particular advantage of not being under the patent restrictions imposed by Daguerre.

The Dry Plate and After

Use of the collodion process rapidly eclipsed that of Daguerre's everywhere and dominated photography until practical dry plates were introduced in 1878. These were the invention of Richard Leach Maddox in 1871. The process was improved and accelerated by the work of John Burgess, Richard Kennett, and Charles Bennett.

Since then, the primary improvements in photographic films have been increasingly greater emulsion speeds, the substitution of flexible transparent backing for the original glass substrate, and the invention of methods for controlling the sensitivity of the emulsion to the various wavelengths of light. Eventually, this last improvement led to the invention of films for color photography, on which each of several layers of light-sensitive emulsions is made sensitive to a certain range of wavelengths. In processing, each of the layered images is made to accept a different dye. The result is an overall colored image.

The cameras and lenses used by early photographers were often quite crude. One early type of camera consisted of two boxes, one sliding within the other to adjust the focus. The earliest camera lenses were simple, single-element glass lenses, capable of producing sharp images only when a small lens aperture, or opening, was used. Although a relatively large lens aperture—perhaps f/5.6—was needed for composing and focusing the image on a ground glass viewing screen, a satisfactorily sharp image required use of an aperture no larger than f/16. (Apertures as small as f/128 were sometimes used.) The first method of adjusting apertures consisted of using a set of flat metal plates, called Waterhouse stops, each pierced with a hole of designated size, that could be slipped into a slot in the side of the lens mount. Soon, however, the fully adjustable iris diaphragm, of the sort still in use today, was introduced.

of pyroxylin in which the light-sensitive silver salts were suspended, offered a number of advantages over the daguerreotype. It did away with the danger of exposure to the poisonous mercury vapor used in developing the silver-coated plates. Exposure times were reduced to the 10- to 90-second range, very short for that time. Negative size was limited mainly by the size of equipment that the photographer wished to carry (it was not yet practical to make enlargements, and so the final print was the size of the negative). Plate sizes as large as 8 × 10 inches were common, plates up to 16 × 20 inches were not unheard of, and one photographer, John Kibble of Glasgow, used a horse-drawn camera with a 36 × 44 inch plate size. Further, there exists a photograph showing a camera mounted on a railroad flatcar. It required a crew

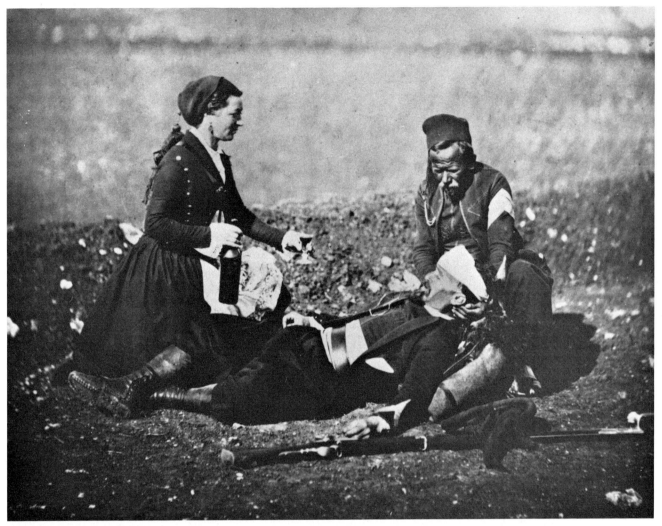

Figure 1-4 *Crimean War, cantiniére and wounded man,* 1855. A calotype by Roger Fenton.
Reproduced courtesy of the Gernsheim Collection, Harry Ransom Humanities Research Center,
University of Texas at Austin.

These unsophisticated early cameras and lenses were soon replaced with superior equipment, because there was an immediate surge of technical invention (which has continued to the present day). For example, in 1841 Friedrich Voigtländer introduced a conical brass camera with a fast portrait lens, designed by Josef M. Petzval, that could be used at its maximum aperture of f/3.5; it made daguerreotypes with circular images about 3½ inches in diameter, using exposures, in open shade on a sunny day, as short as 1½ to 2 minutes.

These and other designers continued their work, and soon cameras were introduced that generally resembled the view cameras of today. They were collapsible for transport, stood on adjustable tripods, had interchangeable plate holders, used a bellows for focusing, and used lenses of ever-increasing complexity. But, on the whole, they remained large and cumbersome because of the large plate sizes required in a day when photo-enlarging in printing was impractical.

Roger Fenton, recording the Crimean War in 1855,

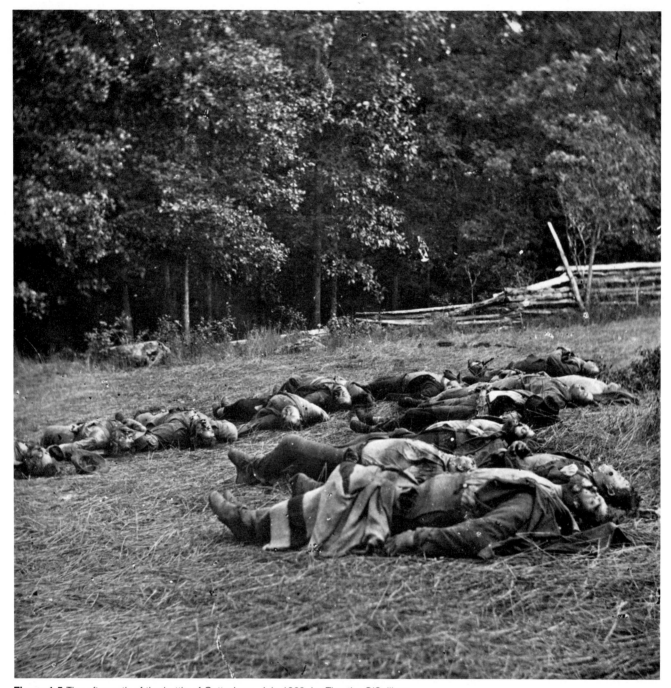

Figure 1-5 The aftermath of the battle of Gettysburg, July 1863, by Timothy O'Sullivan.
Reproduced courtesy of the Library of Congress.

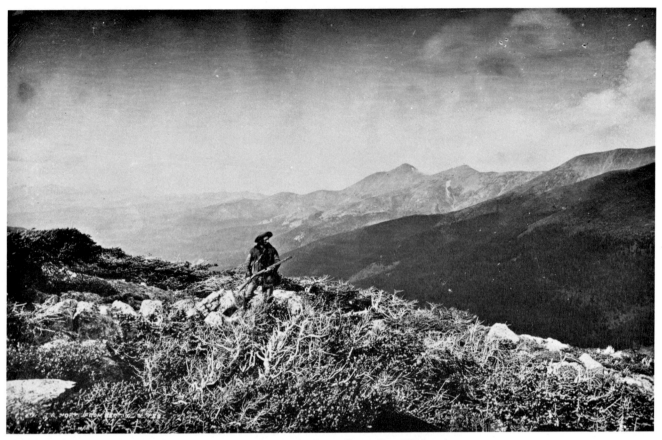

Figure 1-6 Harry Yount, hunter for the 1874 survey expedition (and later first ranger of Yellowstone National Park), photographed at Berthoud Pass, Colorado, by William H. Jackson. Reproduced courtesy of United States Geological Survey, Denver; no. 526.

and Mathew Brady and his various assistants, photographing the American Civil War from 1860 on, used horse-drawn photographic wagons to haul the apparatus needed for the collodion wet-plate process. Wagons or long trains of pack animals were used to transport the gear of such photographers as Timothy O'Sullivan (formerly a Brady assistant) and William H. Jackson on government-sponsored photographic explorations.

As dry-plate films that did not have to be processed immediately came into use in the last decades of the nineteenth century, the problems of bulk and weight diminished rapidly. Glass plates began to be replaced by flexible-base films, which were thinner and lighter. Because films could then be wound into rolls, cameras could

be designed that made numerous pictures without reloading. And the advent of electric lighting made photo-enlarging practical, so that relatively small film sizes could be used to make large prints. (Enlargers using the sun as a light source had been developed and used, but the sun's movement required constant readjustment of the mirrors, making the system both uncertain and inconvenient.)

Modern Cameras and Films

Roll film allowed the introduction of inexpensive snapshot cameras, and with them photography for everyone.

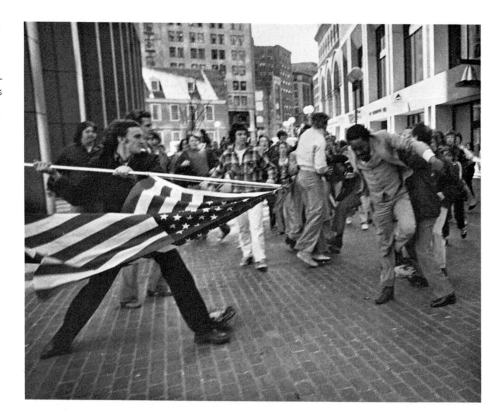

Figure 1-7 *The Soiling of Old Glory,* by Stanley Forman, 1977 Pulitzer Prize winner for spot news photography. Forman was working very close to the violent action at an anti-busing demonstration in Boston. His considerable skill as a photographer was substantially aided by the capabilities of his equipment and film. This picture could only have been made with a small, handy camera, a modern wide-angle lens, and a fast film. Suitable cameras and lenses came into use in the 1920s and '30s, but fast films did not appear until the 1950s. Reproduced courtesy of Stanley Forman and the Boston Herald American.

George Eastman manufactured such cameras in the late 1880s, using the name Kodak and the slogan "You push the button and we do the rest."

The modern precision-made small camera came into use in the first quarter of the twentieth century. Oskar Barnack, a German microscope designer, built the prototype of the Leica in 1914 to use 35 mm cine film, but, because of the economic dislocations produced by World War I, the camera was not mass produced until 1925. It was introduced then with a 50 mm f/3.5 lens capable of image resolution well in excess of the films of the day. The camera had a focal-plane shutter, a film advance coupled with shutter retensioning, and a film-frame counter. Models from 1930 on had interchangeable lenses and an accessory optical rangefinder.

In 1929, the twin-lens reflex roll-film camera called the Rolleiflex was introduced. It and similar cameras were used with great success, through a long train of modifications, by a couple of generations of photojournalists, documentary photographers, and amateur photographers, and remain in use today.

In the mid-1930s the first 35 mm single-lens reflex camera, the Exakta, was introduced. Single-lens reflex cameras were nothing new, having been available in plate and cut-film sizes for several decades (the venerable Graflex was one such); however, allying their design to small format, high-resolution films and interchangeable lenses of high quality revolutionized photography. After World War II, all three types of small-format roll-film cameras—rangefinder, twin-lens reflex, and single-lens reflex—became immensely popular among serious photographers, largely superseding cameras of other designs except for special requirements.

An exception to the rule was the line of cameras introduced in 1948 by Polaroid Land to use rapid-access Polaroid films, which gave a finished black-and-white print a minute after exposure.

By 1963 there was a color print film called Polacolor, and before long there were black-and-white slide films and a film that produced both a print and a good-quality salvageable negative. By means of special adapters, these films can be used with many makes and most types of

cameras, from 4 × 5 inch press cameras to the Nikon 35 mm single-lens reflex.

The technological triumph of the mid-1970s was the Polaroid SX-70 camera, a revolutionary folding single-lens reflex using a special color print film of unusual durability. Simpler cameras have been brought out since then which use this same film.

To backtrack a little, developments beginning in the late 1920s and in the 1930s greatly increased photographic versatility. Two of them had to do with flash lighting and the other with color reproduction.

Artificial Light for Photography

Flash photography by chemical means was done as early as the 1860s, using ignited magnesium wire and, later, magnesium-based flash powder; but the method was messy and not completely safe. The invention of chemical flash bulbs in 1929, using metal foil enclosed within a glass envelope, made it practical to do rapid, repeated flash photography almost anywhere. Such flash bulbs are widely used even today, in many forms. An early successful user of such lighting was Arthur Fellig (the famous Weegee), who worked in New York and Los Angeles in the 1930s and 1940s.

High-speed flash was a very early invention: Fox Talbot made photographs by the light of an electric spark in 1851, but the light produced was not bright enough to make the method universally practicable. It was not until Harold Edgerton's work in the 1930s resulted in the photographic electronic flash unit that it was widely possible to do very high speed flash photography. Its first fairly widespread use was in scientific and wartime photography.

Not until after World War II, however, were electronic flash units produced that were small enough to be portable. Today's beginners may not realize it, but the pocket-sized electronic flash unit is only a couple of decades old. Current units, with flash durations of from 1/1000 to 1/50,000 of a second or less, are so versatile and so inexpensive that they have largely superseded chemical flashbulbs in many uses.

Electronic flash exposure control has recently been automated. At first, control was exercised by placing a light sensor on the front of the flash unit. It picked up the unit's own light, as reflected from the subject, and when it sensed that enough light had been emitted to correctly expose the film, a switch terminated the flash output. All of this occurred in incredibly small fractions of a second.

Most recently, the sensor has been put inside the camera, where it senses light reflected from the film surface during the exposure. With a mated electronic flash unit, connected to the camera by special contacts, again the flash is terminated when the circuit decides that exposure is correct. This system is revolutionary in that it automatically takes into account any changes in the lens aperture or in image magnification.

Color Films

In 1935, two films, Kodachrome and Agfacolor, were introduced that made it possible to do high-quality full-color photography easily and conveniently, using small cameras. Kodachrome, especially, revolutionized magazine and book illustration. Although there were earlier methods of color reproduction, all were cumbersome, requiring three-color separation negatives and other methods not practical for photography with small cameras. No preceding color process was even remotely as good as Kodachrome in color accuracy, image resolution, or ease of use.

Since then many color films have been introduced, in both positive transparency (slide) form and in color negative/print form. In the past few years, color films have become as fast as the fastest conventional black-and-white films. Both the color quality and the image quality have been considerably improved in the faster versions.

In a very recent development, a film has appeared that uses color-negative structure and processing to produce a double-emulsioned black-and-white film of variable film speed. It uses a color dye image structure to provide two layers, each of panchromatic sensitivity, but of two different speeds. Used correctly, it can also significantly increase general image quality by eliminating the appearance of film grain. This film, Ilford XP-1 400, can be exposed as slow as EI 50 and as fast as well over EI 1000.

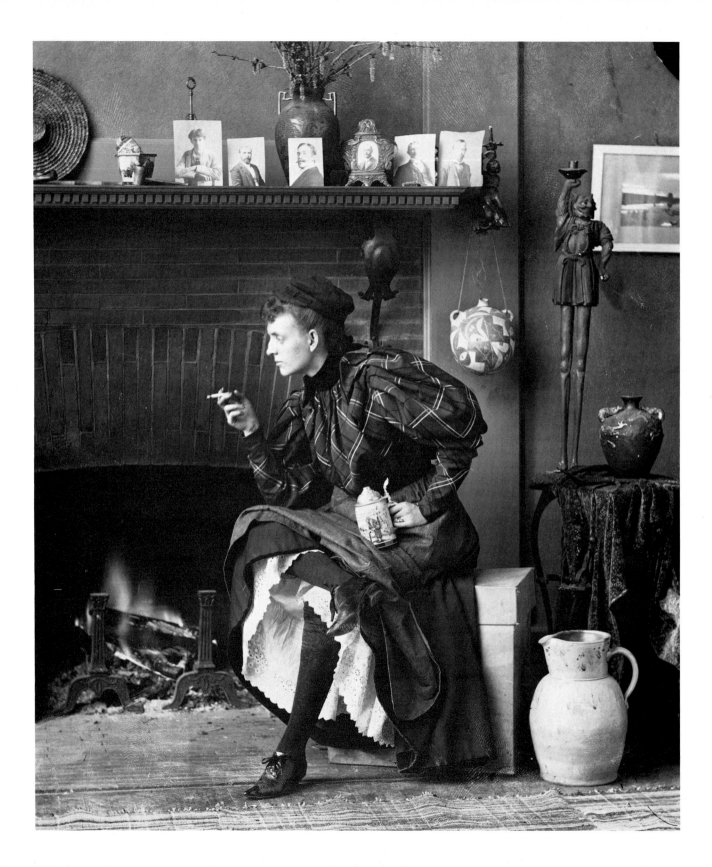

2
A Pictorial History

Three symbols of rebellion against Victorian formality, a self-portrait by Frances Benjamin Johnston, made about 1896. Proper Victorian women did not smoke, drink beer, or show their petticoats. Reproduced courtesy of the Library of Congress.

The history of photography is not solely a record of technical evolution; it is also a story of aesthetic change, as is illustrated by a vast body of surviving images, the work of many photographers. Of the many photographers who have become well known, some have done so in their own right, whereas others are more representative of schools of taste and theory. Because this historical sketch must be brief, it will emphasize those people and movements that have been especially influential in the United States. (Several detailed histories of various aspects of photography are listed in the Bibliography.)

Photography was immediately perceived as being quite unlike all previous forms of visual illustration. Its initial impact owed much to its superior ability to record the visible world with realism, accuracy, and fidelity; but it also presented a new aesthetic, based upon its wholly new technical underpinning. In this aesthetic the ability to draw was irrelevant; essential instead was the ability to see the fall of light on a subject or scene and to interpret it as an abstraction of colors and tones into shades of gray.

Photography is perhaps a unique pictorial medium in that it is neither possible nor sensible to divorce documentation from aesthetics or vice versa: even the most straightforward photodocuments have their built-in compositional structure, and the most self-consciously artistic creations remain somehow records. Nowhere is it possible to separate the intertwining strands of photographic history, and deal with a single, coherent, linear movement; consequently, much of what follows is a necessarily simplified record of multiple engagements, cross-connections, and mutual influences.

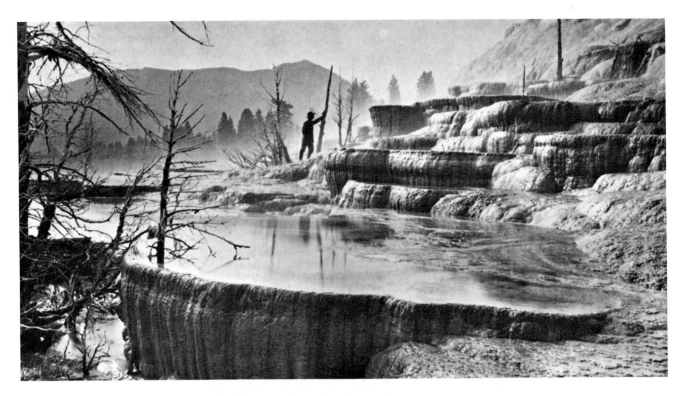

Figure 2-5 *Mammoth Hot Springs, lower basins, looking up, Yellowstone*, 1872, by William H. Jackson. A collodion wet-plate photograph. Reproduced courtesy of the Library of Congress.

F. Jay Haynes, a contemporary, were influential in the preservation of the area as a park (see Figure 2-5).

The English landscape tradition began in the earliest years of photography and was consciously artistic, after the manner of painters and etchers. The tradition prospered from the 1870s to the 1890s, led by Henry Peach Robinson (Figure 2-19), Peter H. Emerson, George Davison, and others. Their work founded a long-standing landscape form featuring tranquility and a concern with the land and its occupants (see Figure 2-6).

Some schools of landscape photography are not easily discussed without reference to schools of aesthetic theory about photography in general. Several such schools are named here but discussed later in the chapter. In the 1890s, a "secession" movement in photography developed in England as a reaction to the Naturalists. Influenced by such painters as James McNeill Whistler and George Inness, its landscape mode exploited the half-lights of dusk, dawn, and misty weather to produce moody evocations of nature with a soft, indistinct, and often melancholy aspect. Among the chief advocates of this school in the United States were the "Photo-Secessionists" Alfred Stieglitz and Edward Steichen.

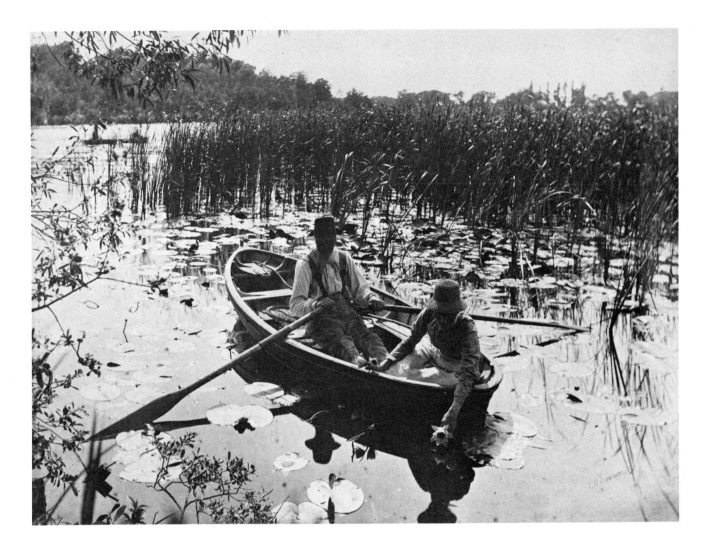

A countermovement to such ideas arose in the American West in the 1920s: members of the f/64 Group sought sharpness, apparently infinite depth of field, and total pictorial clarity. Although f/64 photography (so called for the small lens apertures that were used to produce great depth of field in the image) included a wide range of subjects, landscape photography was a strong element within it. Moreover, it was in landscape that the new thinking made perhaps its strongest and most lasting impression. From the early 1930s onward, it has become very much the leading aesthetic in contemporary landscape photography, following the strong lead of Edward Weston and Ansel Adams (see frontispieces, chapters 6 and 10).

Figure 2-6 *Gathering Water Lilies*, 1885, by Peter H. Emerson. This is an example of Emerson's "naturalistic" approach to photography, done in reaction to the work of Henry Peach Robinson and others. Reproduced courtesy of the International Museum of Photography at George Eastman House.

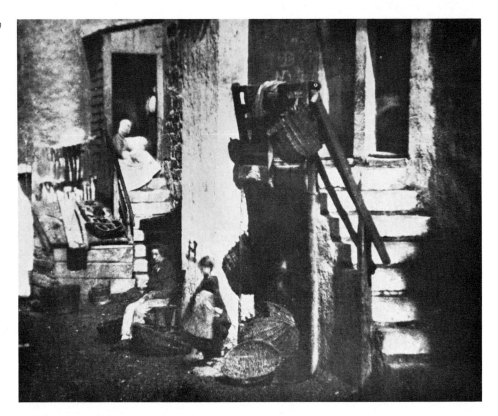

Figure 2-7 *Fisherman's cottage with outside stairs, Newhaven*, 1844, by David Octavius Hill and Robert Adamson. A calotype. Reproduced courtesy of the Gernsheim Collection, Harry Ransom Humanities Research Center, University of Texas at Austin.

Wynn Bullock began with tack-sharp landscapes in the f/64 tradition and eventually began to add nude figures to the landscape. Further, he added the dimension of time to his seascapes; by using time exposures to average out the wave motion, he created some almost otherworldly images. Other landscape photographers with some affinity to the ideas of f/64 are Paul Caponigro, who has made studies of rock faces (see Figure 16-3) and of manmade megalithic structures, and William Current, whose landscapes give special prominence to trees. For yet another, and most original, view of landscape, the aerial photographs of William Garnett are unique. His views of the land, nearly always with the strongly slanting light of early morning, have an almost live quality to them.

Documentary Photography

Recording the lives of ordinary people was an early interest in photography. In the late 1840s, Hill and Adamson did a fine series of studies of life in and around Newhaven, a port town near Edinburgh in Scotland (see Figure 2-7). Another Briton, Frank Sutcliffe, working around the 1880s, compiled a classic series of photographs at Whitby, in England. (See Figure 2-8.) In the United States, F. Jay Haynes photographed all aspects of frontier living, recording alike, on the northern plains, its new cattle industry and its Indians, at a time when many were as yet untouched by outside influences (see Figure 14-19).

Around the turn of the century it became evident that many American Indian cultures were dying. In addition to Haynes, there were several photographers who were interested in portraying these people and their cultures as they then existed. Appraised by the magnitude of his effort, first among these was Edward S. Curtis, who embarked on the monumental task of attempting to record with his camera all surviving Indian groups. Between 1892 and 1927, he did very nearly that (see Figure 2-9). Adam Clark Vroman ranged out from southern California to record the Indians and landscape of the great

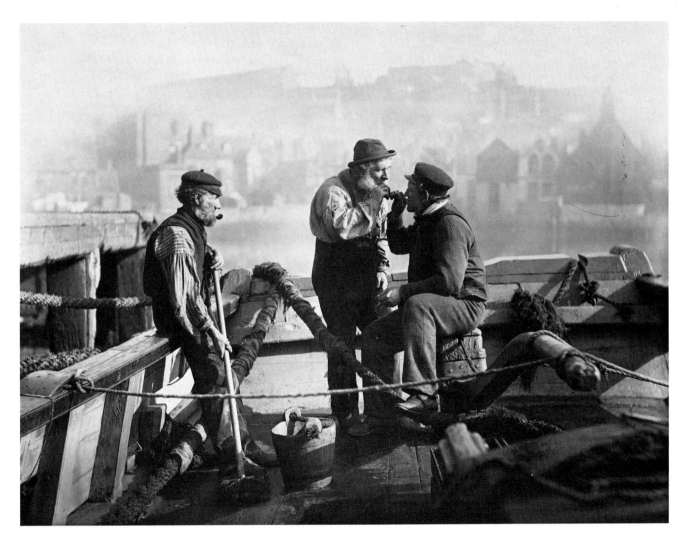

Figure 2-8 *Stoking up*, by Frank Sutcliffe, one of Emerson's natur-
alistic followers. This picture is one of a fine series showing life in
the English port town of Whitby in the 1880s. Reproduced cour-
tesy of Bill Eglon Shaw, The Sutcliffe Gallery, Whitby, England.

Southwest. Where Curtis worked in a moody, directorial
style, Vroman used a sharp, clear, objective method (see
Figure 6-6).

During the late nineteenth century, Frances Benjamin
Johnston, a photojournalist with sociological interests,
worked south out of Washington, D.C., to document the
lives and living conditions of Southern blacks. At about
the same time, Jacob A. Riis, a New York reporter, made
his well-known photographs of the New York poor. Fol-
lowing in this tradition was Lewis Hine, after 1905,
whose work was influential in curbing exploitive child
labor.

In Europe, in the years after 1890, there was a wave
of documentary photography that was less sociological in

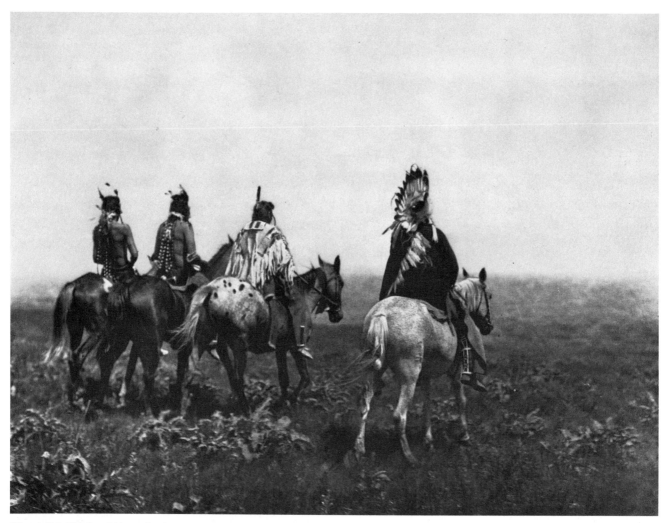

Figure 2-9 *Chief and his staff—Apsaroka*, circa 1905, by Edward
S. Curtis. Reproduced courtesy of The Bancroft Library, University
of California, Berkeley.

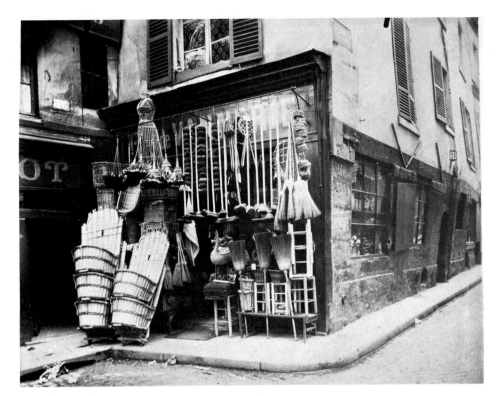

content than the work of Riis or Hine, but of great value in recording the culture of the time. Of special importance were two Frenchmen: Eugène Atget (see Figure 2-10), who recorded the physical face of Paris between 1898 and 1927; and Jacques-Henri Lartigue, who, beginning in childhood, accomplished a remarkable body of work that showed as no other source the nature of middle- and upper-class French society in the years between 1901 and 1914. Lartigue was the master of the inspired snapshot (see Figures 2-11 and 14-1). He lived on, photographing all the time; but his best-known (and possibly his best) work was done before World War I, perhaps because the society that produced him and was the subject of his work—the *Belle Epoque*—died under the drumfire of Verdun and the other great battles of that war.

Meanwhile, in Germany, August Sander, a Cologne portrait photographer, had begun a massive body of work that he intended as a "museum of mankind," choosing subjects who, to him, represented archetypes of humanity. He worked on this project from just after the turn of the century until after World War II, eventually compiling over 20,000 pictures (see Figure 4-12). Although not as representative of mankind as a whole as Sander had originally intended, his work is a superb record of the physical and social types of Germany of that period.

In France, Henri Cartier-Bresson began in the 1930s, and continues in the present, to compile a remarkable record, revealing the workings of human nature in many places. Of particular interest are his pictures of people in France, England, North Africa, Greece (see Figure 6-11), China, Russia, and India (see Figure 2-23). One of Cartier-Bresson's most characteristic features as a photographer is his ability to construct strong compositions within the 35 mm film frame, with little or no image cropping in printing, catching "the decisive moment" when the subjects before his camera are in constant motion.

In the United States, the economic disaster of the 1930s resulted in the great work of the Farm Security Administration (FSA) photographers. Under the inspired direction of Roy Stryker, photographers such as Walker Evans, Arthur Rothstein, and Dorothea Lange (see Figure 2-12) recorded for the world, and for posterity, an unparalleled record of the sufferings and anonymous gallantry of the nation's poor.

Figure 2-11 *Zissou and our tireboat, Chateau de Rouzat*, 1911, by Jacques-Henri Lartigue. (Zissou is the photographer's brother Maurice.) Photograph copyright © Association des Amis de J.H. Lartigue.

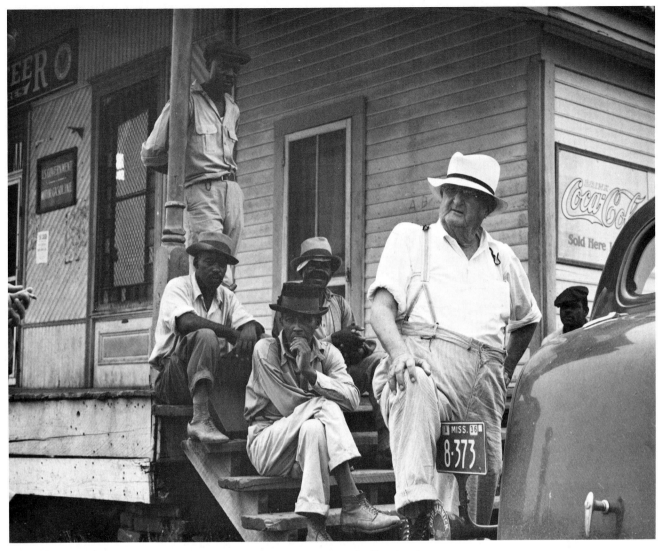

Figure 2-12 *Plantation owner and his field hands, Mississippi delta*, 1936, by Dorothea Lange.
Reproduced courtesy of the Library of Congress.

With the coming of World War II, an American photographer of great future importance came to public notice: W. Eugene Smith became justly famous for his sensitive coverage of the island landings in the Pacific theater of operations. After the war ended, he continued as a photographer for *Life* magazine; his documentary picture stories of the daily round of an American country doctor, of the work of Dr. Albert Schweitzer at Lambarene, in Africa (see Figure 2-13), and, after leaving *Life*,

his coverage of the effects of industrial mercury poisoning in Minamata, Japan (see Figure 4-16), are all classics. Smith died in 1978, following years of suffering from injuries incurred in World War II and in beatings at the hands of company toughs in Minamata.

Among the many fine documentary photographers of recent times are Danny Lyon, whose book *The Bikeriders* chronicled the activities of outlaw motorcyclists, and Bruce Davidson, whose *East 100th Street* is possibly the

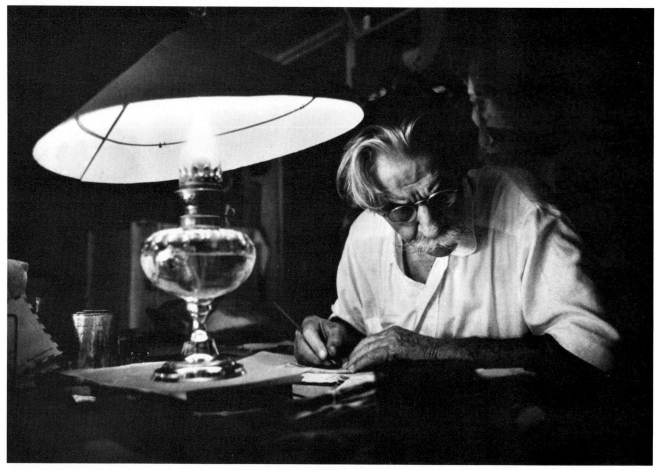

Figure 2-13 *Albert Schweitzer in Africa*, 1954, by W. Eugene Smith. This picture, made by the soft light from Dr. Schweitzer's own oil lamp, is a near-perfect example of extemporaneous portraiture. This, however, is not to say that it was done casually or in haste. Copyright © 1954 W. Eugene Smith. W. Eugene Smith prints from Center for Creative Photography, University of Arizona.

finest pictorial coverage of New York ghetto life yet done. And Bill Owens' recent documentary publications, particularly his *Suburbia* (see Figure 2-14), tell us the facts of contemporary living.

Photojournalism

Although photojournalism and documentary photography substantially overlap in both subject matter and presentation, photojournalism is more the pictorial recording of spot news, the chronicling of significant or interesting events as they happen. In its best instances, and especially where it overlaps the more general documentary photography, it combines artistic and sociological concerns. Its roots can be found deep in the nineteenth century, in the work of daguerreotypists such as George H. Barnard and calotypists such as Roger Fenton (see Figure 1-4). The Mathew Brady group followed Fenton's lead in war photography done during the Crimean War, with collodion wet-plate work on the battlefields of the American Civil War (see Figure 1-5). Building on the earlier work, they established a strong tradition of truth in reporting that survives today. Con-

Figure 2-14 *"Sunday afternoon we get it together, I cook the steaks and my wife makes the salad."* This photograph by Bill Owens, with its quoted caption, is an illustration from his book *Suburbia*. Owens' approach to photography amounts to a contemporary ethnology—a quite successful attempt to illustrate the basic terms of his own segment of society, to strip it of pretense and show it for what it is, for better and worse. Photograph copyright © Bill Owens.

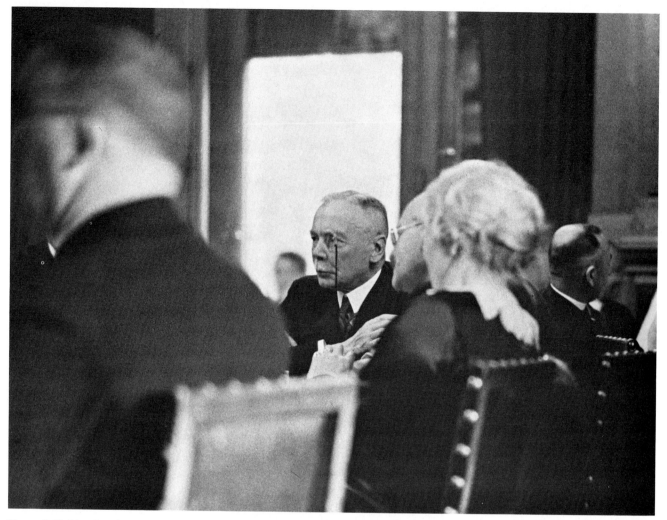

Figure 2-15 *"Von Seeckt, who more than anyone else had contributed to the rebirth of the German Army, seen during lunch in the restaurant of the Reichstag,"* 1930, by Erich Salomon, who was a noted pioneer in the use of compact, small-format cameras in photojournalism. Salomon covered nearly every important political event in Europe from the late 1920s to the early 1940s. Photo courtesy Dr. Erich Salomon/Magnum Photos.

tinuing on through the work of the Frenchmen Nadar (born Gaspard Félix Tournachon) and his son Paul Nadar, who pioneered the photo-interview form in 1886, photojournalism reached its full flowering in the work of Erich Salomon (see Figure 2-15), who worked the salons, peace conferences, and political meetings of Europe in the 1920s and 1930s for journalist gold. Salomon died in the concentration camp at Auschwitz in 1943.

In the early decades of the present century there had developed a colorful tradition of newspaper photography in which the photographer was considered to be a hard-driving, get-the-picture fellow of the rough diamond type. The archetype of this pattern was Arthur Fellig, who used the pseudonym Weegee. Working as an independent and using a police radio in his automobile to learn of newsworthy events, Weegee spent his nights in the 1930s and '40s roaming the streets of New York, and later Los Angeles, 4 × 5 Graphic in hand, looking for

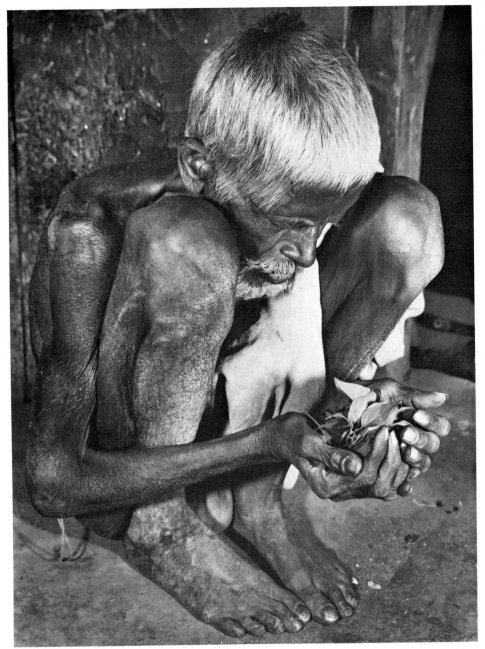

Figure 2-16 *Too weak to stand, India*, 1946, by Margaret Bourke-White. High-level photojournalism does more than present a record of a spot news event. It deals with enduring social and human problems. A good journalistic photograph requires a succinct, accurate, and informative caption to get the most from a picture. The caption here tells all that is needed in only five words. Margaret Bourke-White, Life Magazine, copyright © 1946 Time Inc.

fast-breaking pictorial news or picturesque human interest items. Some of his best work later appeared in his books *Naked City* and *Weegee's People* (see Figure 3-15).

Beginning in 1936, there developed in the United States what can only be called the "*Life* magazine school of photojournalism," represented by the work of such fine photographers as Margaret Bourke-White (see Figure 2-16), Andreas Feininger, Alfred Eisenstadt, W. Eugene Smith, David Douglas Duncan, and a host of others, whose influence on photojournalism endures.

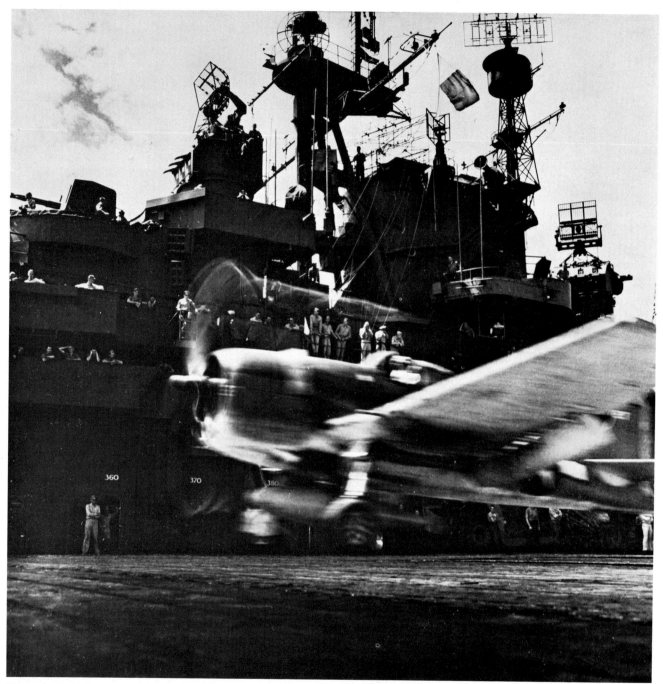

Figure 2-17 *U.S.S. Carrier Lexington: Hellcat goes thundering off the deck*, 1943, by Edward Steichen. In this fine war action photograph the aircraft was deliberately allowed to blur, to accentuate the feeling of speed and excitement. National Archives photo no. 80-G-418194.

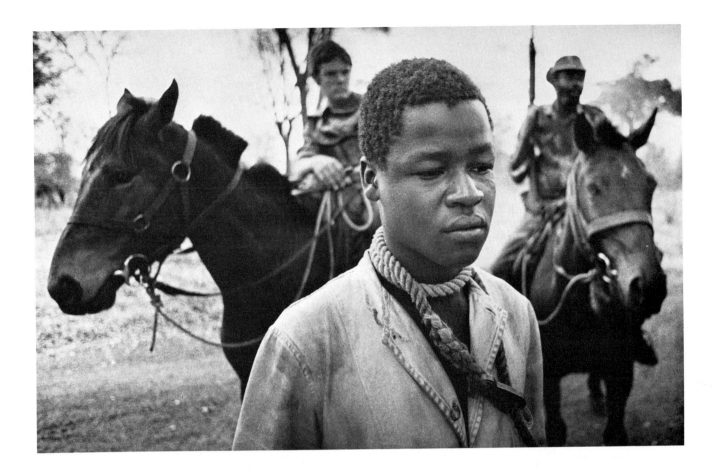

The wars of this plagued century have been the source of much suffering and more than a modicum of gallantry for the photojournalist to record. In World War I there were a large number of photographers, most now anonymous. They left a pictorial record of warfare fit to wither the soul. It was to have been the "war to end wars," and these photographers must have felt that they were contributing to that end. Among those who were not so anonymous was Edward Steichen, one of the famed Photo-Secessionists, who was taken into the United States army to organize photography of and for the American forces in Europe. He was instrumental in the development of aerial photography. Steichen came into his own as a war photographer, however, when he was commissioned to participate in and direct the work of U.S. Navy photographers during World War II, a task that he accomplished with great style (see Figure 2-17).

Individual photographers of note were not lacking in

Figure 2-18 *Suspected guerrilla*, by J. Ross Baughman. This photograph was made in Rhodesia's western war zone under difficult lighting conditions, at twilight (an exposure of 1/15th of a second was used), but is nevertheless technically excellent. The picture is ambiguous in content: we do not know—and probably cannot know—the full truth of the circumstances. Nevertheless, it is a powerful image, capable of affecting how people think about war—and especially about this type of war, where there are no perceptions of total good or bad. The ambiguity of the picture reflects the ambiguity of the circumstances. Photo courtesy J. Ross Baughman/Visions IVI.

this new conflict. World War II had been preceded by virulent outbreaks of conflict in the Orient, in Ethiopia, and in Spain; Robert Capa, a Hungarian who immigrated to the United States in the late 1930s, was one of the many notable war photographers of this earlier period. During the war itself not only W. Eugene Smith but several other photographers as well intrepidly recorded its events. David Douglas Duncan joined the Marines in their trek through the far reaches of the vast ocean spaces west of Midway Island and north of Australia. Margaret Bourke-White recorded the horrifying discoveries in the Nazi death camps, and went on to portray migration and strife in the time of the partition of India in 1948. In the early 1950s, while photographing the war in Korea, she contracted Parkinson's Disease and was forced to retire.

During the long years of the struggle in Viet Nam a host of photographers from many countries participated in recording the horrors of that conflict. One of the most notable was Larry Burrows, one of the many journalists who did not survive the war. Although at this writing there are no armed conflicts involving American troops, war is still being waged from time to time in many parts of the world; Southeast Asia is still embroiled in conflict, and South Africa is a focus of struggle (see Figure 2-18).

Most war photographers are—or rapidly become—horrified by the human waste of armed conflict, and their pictures show it. Most go to war repeatedly, often in spite of terrible personal fears, to make a record that will help to persuade noncombatants of the folly of the process.

Photojournalism suffered a decline when the great news magazines *Life* and *Look* went out of business some years ago. But, though temporarily down, they were not out. Both have been revived, with some changes in emphasis and format. It remains to be seen whether a new heyday of photojournalism will result.

Aesthetic Movements

Whether photography is an art or a craft has occasioned a longstanding debate. Painters have often held that it cannot be an art, since the image is formed optically rather than being based upon drawing. The point seems specious: Every artistic medium has its unique aspects, and photography's uniqueness lies, in part, in its optical image formation. More to the point, all visual arts have craft aspects and uses, and all have inherent qualities of

artistry. Whether a particular work should be regarded as art will often depend both upon the maker's intentions and the viewer's appraisal of the success of the effort.

The first self-consciously artistic movement in photography was that of allegory, where posed figures were used symbolically to assist in telling a story. The most ambitiously allegorical photographer was Oscar G. Rejlander, who was Swedish by birth but worked in England. He built upon the idea of multiple printing that had been developed by the landscape photographers for the purpose of printing in sky effects. In one of Rejlander's best-known efforts, his 1857 composition, "The Two Ways of Life," more than 20 people were posed in small groups and at various size scales. The resulting paper negatives were then printed in combination with a photograph of a model stage set to yield a single complex composition. Rejlander went on making complex allegorical photographs for many years.

A year later, in 1858, Henry Peach Robinson produced an allegorical multiple print composition called "Fading Away," portraying the final decline of a dying young woman: the reclining woman is attended by a servant, while her mother sits facing her and her father is seen silhouetted, gloomily looking out the half-shrouded window in the background. Though simpler in composition than Rejlander's typically complex multiple prints, the image was stronger and was an excellent example of Victorian aesthetics and sentimentality.

Robinson and his followers felt that any artifice, any "dodge, trick, and conjuration," was acceptable in photography "to avoid the mean, the base and the ugly." Much use was made of costumed models, often experienced amateur or professional actors, both in the studio and in natural surroundings. When well done, many of these photographs were very fine. They related well to and were often imitative of the aesthetic concepts of painters of the day, and particularly that sentimental school, the Pre-Raphaelites (see Figure 2-19). When done with less skill and sensitivity, however, they could descend into mawkishness.

Present-day photographers and writers sometimes denigrate the Victorian photographers for imitating the painters of their time; it should be realized, however, that there is much legitimate interplay among the arts at *any* period. Recent photography has, in some hands, come to resemble the painterly school of Abstract Expressionism; at other times it has become difficult to tell

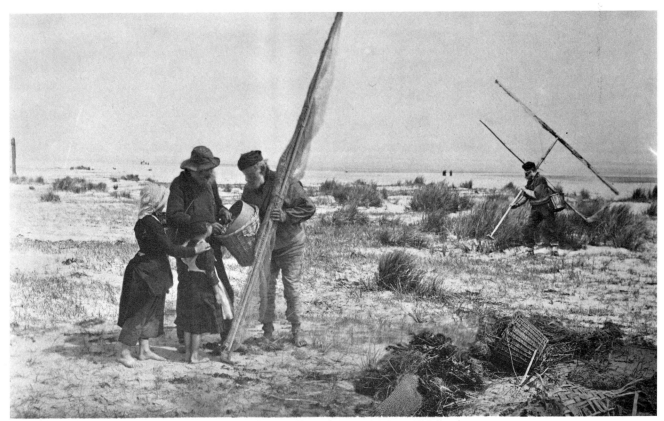

Figure 2-19 *The Shrimpers*, 1887, by Henry Peach Robinson. A contemporary of P. H. Emerson, Robinson worked in a self-consciously "artistic" manner, often using costumed models to set up what were often rather self-consciously artistic compositions. His best work, of which this is an example, sometimes managed to look both artistic *and* natural. Reproduced courtesy of the Royal Photographic Society of Great Britain.

the supremely realistic paintings of a Charles Sheeler (himself also an important photographer) or an Edward Hopper from the photographs of any of a number of well-known photographers.

By the 1880s Peter Henry Emerson was leading a new movement in opposition to the allegorical mode. He felt that the duty of the artistic photographer was to present natural scenes in ways that resemble as much as possible the view as seen by the eye. Emerson spoke and wrote forcefully on the subject, and in 1889 he published an aesthetic and technical guide called *Naturalistic Photography* that had a wide-ranging influence on both English and American photographers. His new aesthetic advocated simple equipment and a rejection of artifice. Emerson and his followers made use of the then-new process

of platinum printing, which they appreciated for its delicate gray tones and its very long printing scale (that is, its ability to do justice to both very dark and very bright areas in the same print—a capacity commonly thought to be missing from modern papers unless great pains are taken). Platinum printing became a much favored technique among Naturalist photographers. Emerson's prints tend to look gray and lacking in brilliance by today's standards (see Figure 2-6), but that was part of the aesthetic.

Emerson's ideas sparked strong controversy (particularly his advocacy of peripheral unsharpness in images as a simulation of the visual process of the human eye). But as time passed, those ideas changed and, in 1891, he came full circle with the publication of a pamphlet

Figure 2-20 *The Terminal*, 1915, by Alfred Stieglitz. Reproduced courtesy of the Gernsheim Collection, Harry Ransom Humanities Research Center, University of Texas at Austin.

called *The Death of Naturalistic Photography*, wherein he declared that the concept of photography as an art was erroneous, that he had been mistaken in his earlier views. This, combined with new developments on the painting scene, was too much for many British photographers, and the time was ripe for change.

Beginning in the 1890s, and progressing into the first decade of the new century, a new school of art, eventually to be called Tonalism, developed in England and the

United States around the painting of Whistler and Inness. This school favored indistinct imagery, muted tones, and a sometimes melancholy point of view. Some of the English photographers, among them Robinson and George Davison, had formed a "secession" movement from Naturalistic photography, and they moved to join photography to the then-rising stream of Impressionism in art.

This idea crossed the Atlantic and came to public

attention in New York as the Photo-Secessionist movement, with the opening, in 1902, of an exhibit by that name, produced by Alfred Stieglitz and featuring the work of many prominent photographers. The photographs of the Photo-Secessionists made use of many technical approaches—among them platinum printing, gumbichromate printing (in which a tarlike substance receives the image, the portions struck by light become insoluble and the rest washes off, and a charcoal-like image results), and color toning—to achieve pictorial effects artistically related to the Tonalist paintings. Among the more notable Photo-Secessionists were Stieglitz, Edward Steichen (who was also a noted Tonalist painter), Clarence White, and Gertrude Käsebier. The movement enjoyed a critical success, and soon became the dominant photographic style.

By the early twentieth century cameras and films had evolved to the point where the stopping of fast subject motion and the use of handheld cameras were genuinely practical. With these developments, photography became more dynamic. The inspired snapshots of Lartigue, referred to earlier, offer vivid examples of good action photography of the period (see Figure 14-1).

In the 1920s, following the Great War, there was a surge of change in art and literature, and the modernist experimental movements in those fields had counterparts in photographic experimentation. Man Ray, an American in Paris, engaged in a considerable amount of darkroom experimentation. Among other matters, he began to produce his well-known photograms (which he dubbed Rayograms). Although the basic idea was not new, being an updating of Fox Talbot's "pencil of nature" contact-printed shadowgrams of feathers, ferns, and other objects (see Figure 1-3), Ray's work had a flamboyance to match that of his personality. Photograms are much used at present to teach aspects of basic darkroom technique, as well as to make original new works (see Chapter 11 for technical details; see also Figure 11-22).

In 1919, the architect Walter Gropius had founded the great school of design at Weimar called the Bauhaus, where, in 1923, Laszlo Moholy-Nagy began teaching a wide range of experimental photographic techniques (among them the photogram), and incorporating into his instruction many ideas related to Dada, Surrealism, and other artistic concepts of the day. The Bauhaus was to have a tremendous influence on art and design generally, and not least in photography. The school was closed in

1933 by the Nazis; but, during and after World War II, its teaching plan was continued at the Chicago Institute of Design and at other schools in the United States, where many members of the Bauhaus faculty and some of their students came to teach.

As the century advanced, yet other influences arose. Among them was the f/64 Group, mentioned earlier in this chapter. This group, organized loosely around Edward Weston and Ansel Adams in the late 1920s and early '30s, included such well-known California figures as Imogen Cunningham and Peter Stackpole. The aesthetic was one of honesty, directness, and naturalism in self-expression, previsualization of the final image at the time of photography, the use of small lens apertures to yield negatives carrying almost infinite subject detail, and a generally nonmanipulative approach to printing. This distinctive reaction to the manipulative, dreamy, self-consciously artistic photographs of many photographers of the time was the origin of the current West Coast school of photography centered in northern California. This derivation of f/64 Group principles is now being spread in wider circles by teachers and writers such as Fred Picker, who works in New England.

In the years since World War II, a new photographic aesthetic has appeared, developed out of the characteristic appearance of small-camera, handheld photography, as typified by the documentary photojournalism of Henri Cartier-Bresson and W. Eugene Smith. The artistic content of such photography arises out of tension between the straightforward documentary nature of the subject matter (nearly always human beings, or definitely human environs) and the sophisticated compositional interests of the photographers. It is becoming ever more difficult to determine at first glance whether you are looking at straight documentary photography or at examples of the new aesthetic. A real determination may require examining a body of work by the same person. Although possibly confusing to those who like to have their ideas neatly slotted into a logical framework, the overall effect of this congruence of artistic and documentary concern is beneficial to both art and documentation.

Allied with these matters has been the introduction of applied psychology to the concerns of photography, particularly in the teachings of Minor White (see Figure 2-21) and his associate Ralph Hattersley. Ambiguities of appearance and uncertainties of intent are rife in contemporary photography. A look at the work of Robert Frank,

Figure 2-21 *Barnacles, 1964*, by Minor White. In this picture the lines and masses are strategically placed, illustrating one of the guides to composition discussed in Chapter 16. The main sweep of the composition is between a quarter and a third of the way in from the right, and comes across horizontally below the center. Copyright © 1969 by Aperture, Inc., as published in *Mirrors Messages Manifestations*.

Diane Arbus (see Figure 2-22), Gary Winogrand, and many others may well leave the viewer wondering and thinking. This complexity of intent and response can greatly add to the richness of experience involved in both making and looking at photographs.

Looking at the work of other photographers, both the early workers and one's own contemporaries, is part of the visual education of a beginner in the field. However, the work of other people should not simply be imitated; it should be studied as a way of understanding the possibilities of the medium. Such study will better enable a new photographer to build upon earlier ideas, rather than to spend precious time on needless repetition of others' experiments, or in pursuing concepts that have lost their validity. Ideally, we should stand upon the shoulders of our predecessors, rather than linger in their shadows.

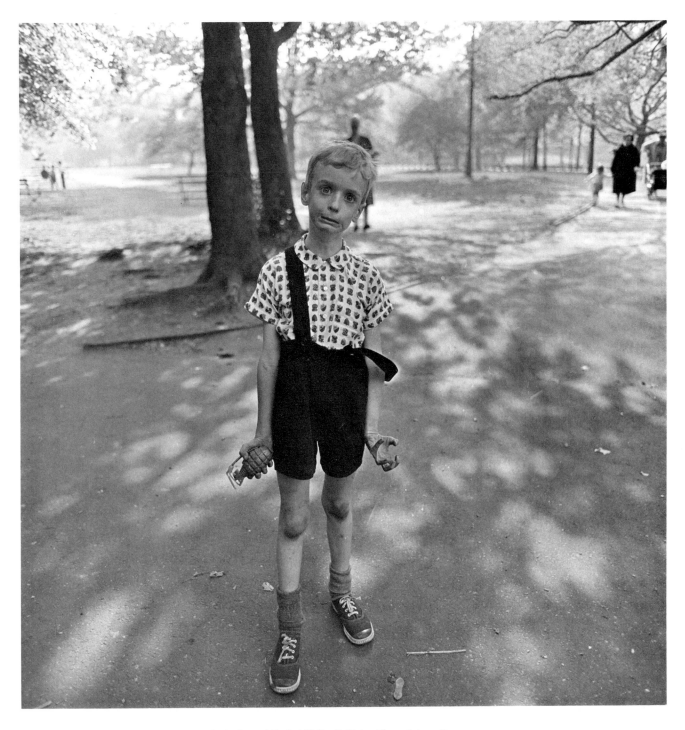

Figure 2-22 *Child with a toy hand grenade in Central Park, N.Y.C.*, 1963, by Diane Arbus. Copyright © Estate of Diane Arbus 1962.

PART TWO
TOOLS

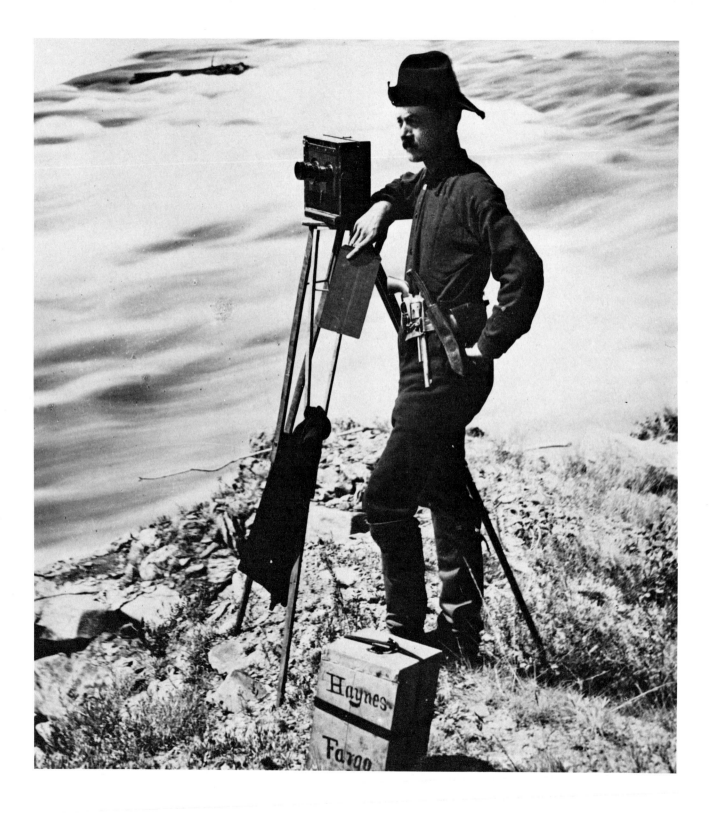

3
Cameras

F. Jay Haynes, aged 27, at the Great Falls of the Missouri River, 1881, a self-portrait. Years afterward, looking at this picture, Haynes said, "What a dashing young man this was! What self-confidence!" Reproduced courtesy of the Haynes Foundation, Bozeman, Montana.

The photographer's basic hardware item is the camera. Because no one type of camera is ideally suited to all types of work, the choice of what camera to use depends on the subject or subjects to be most often photographed.

Thus, photographers are well advised to guard against any bias or habit by which they tend to prefer the equipment most familiar to them. (Indeed, such habits should never be allowed to form.)

It is nearly always better—and often cheaper—to buy separate cameras for dissimilar jobs than it is to attempt to buy one "perfect" camera, which will then require an endless series of special adapters or additional gadgets to enable it to do jobs that the basic camera was simply not designed to handle. In some cases, such additions can adversely affect the picture-making capabilities of the camera. On the other hand, some cameras are highly versatile, and every photographer should probably have one such camera. Choosing it requires attention to its degree of adaptability and to its readiness to accept accessories that were not built by the same manufacturer.

A beginner who just wants the simplest worthwhile camera might well consider buying a twin-lens reflex. It is easy to handle and is inconspicuous to use in photographing people. A more ambitious beginner would do better to obtain a low- to medium-priced 35 mm single-lens reflex camera. Not only is it easy to use, but it offers a broader range of photographic possibilities through the addition of lenses and accessories.

Those who plan to engage in specific types of photography as a career may require cameras suited to the purpose. For example, an entomologist or a nature enthusiast wanting to photograph live insects in their natural habitats will most likely find that a small, highly maneuverable single-lens reflex camera is satisfactory. A landscape photographer needing to record large areas in great detail probably will get best results with a stationary camera of large film size. Any serious photographer who does a significant amount of work at both scales would be wise to consider owning one of each applicable type of camera.

Purchasing a camera or cameras necessarily involves financial considerations. Many people just starting in photography buy the cheapest equipment possible as long as it will do the intended job. This can be false economy, unless the photographer's interests and technical needs change drastically as he or she acquires experience in the medium. Given their durability and versatility, even the best cameras and lenses are inexpensive in the long run if handled with reasonable care and adequately maintained. Before buying a camera or making any costly purchase of photographic equipment it would be wise to consult knowledgeable persons—for example, advanced amateurs doing work of the sort to which you aspire, photography instructors, or even professional photographers, if consulted in a relaxed moment.

Camera Components

All still cameras have the same general components, but the design and arrangement of these components distinguish one type of camera from another and make them especially suited to specific uses. These components are:

1. *A lens,* usually consisting of several glass and air elements, to form the image and put it on the film.

2. *A means of focusing* this lens on subjects at various distances.

3. *A viewfinder* to allow image composition; this may be a separate device or simply a ground glass at the film plane that can be removed or displaced for insertion of the film holder.

4. *A shutter* to keep the image-forming light off the film until the desired moment, to control the time that the light is on the film and thereby assist correct exposure of the film, and to determine the degree to which motion is "stopped."

5. *An iris diaphragm,* to control both the amount of light reaching the film (in conjunction with the shutter) and the depth of field in the image.

6. *A lighttight container* to hold the film ready for exposure; this may be a separate item or it may be part of the camera itself.

Types of Cameras

What are the commonly used types of cameras, how are they differentiated, and what are their advantages and disadvantages?

1. *Rangefinder cameras.* Today most such cameras use 35 mm film. Certain press cameras, which come in larger sizes and are described in category 5, can also be included in this category.

2. *Single-lens reflex cameras.* Many use either 35 mm or 2¼ × 2¼ inch film, but some use film as large as 4 × 5 or even 5 × 7 inches.

3. *Twin-lens reflex cameras.* Most use 2¼ × 2¼ inch film, but some use 35 mm or 4 × 5 inch film.

4. *View cameras.* These cameras use films that range in size from 2¼ × 3¼ inches through 4 × 5, 5 × 7, 8 × 10 inches, and larger.

5. *Press cameras.* Basically rangefinder cameras that include some features of the view camera; traditionally, press cameras used 4 × 5 inch film, but now many of them take 2¼ × 2¾ or 2¼ × 3¼ inch roll film, and at least one uses 5 × 7 inch film.

The Rangefinder Camera

Formerly more readily available in a variety of sizes and forms, rangefinder cameras are now most commonly found in the 35 mm format. Basically, these are box-body cameras with an optical rangefinder mounted on top (or on the side). The rangefinder is connected to the focusing mechanism and usually incorporates the viewfinder window (see Figure 3-1).

Figure 3-1 A 35 mm rangefinder camera.

This type of camera is held so that the eye looks through the rear rangefinder port, the eye port. The viewfinder, usually the same port, frames the approximate area recorded by the lens upon the film. As the lens focusing mechanism is moved, a small section of the viewed image (produced by additional optics and often colored by a pale filter) moves relative to the larger surrounding image. Exact focus is obtained when the two overlapping images coincide at the decided plane of focus (see Figure 3-2).

Some rangefinder cameras have a horizontal, diagonal, or vertical split dividing the two images. The focus is correct when lines at the chosen plane of focus cross the line without any displacement. Appropriately, this is called a *split-image rangefinder*. Rangefinder cameras are best suited to photographing people and fast-moving events, which make focusing on a ground glass a serious distraction. They are small and light, fast in operation, relatively inconspicuous in use, and usually have very quiet shutters. Most, however, are poorly suited to either very close up or extreme telephoto use, except when quite expensive and cumbersome accessories are added. There is also the problem of *parallax*: the viewfinder

Figure 3-4 *London, coronation of George VI. Waiting for the procession*, 1936, by Henri Cartier-Bresson. Reproduced courtesy of Henri Cartier-Bresson/Magnum Photos.

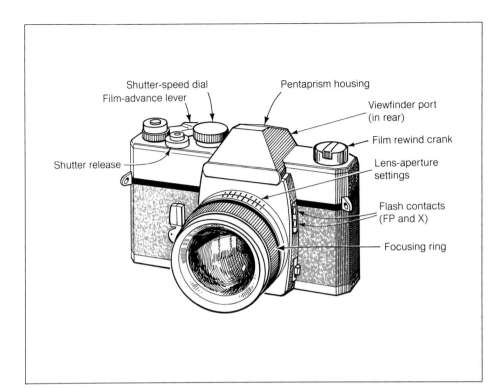

Figure 3-5 A 35 mm single-lens reflex camera.

Shutter-speed dial
Film-advance lever

Pentaprism housing

Viewfinder port
(in rear)

Film rewind crank

Shutter release

Lens-aperture
settings

Flash contacts
(FP and X)

Focusing ring

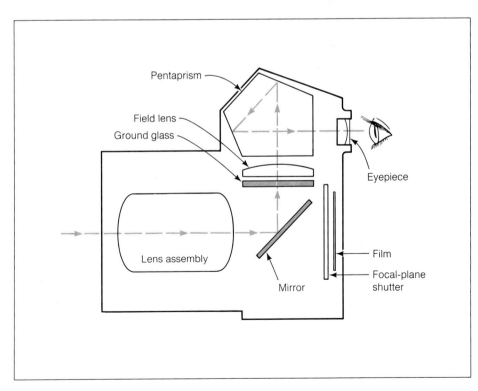

Figure 3-6 The light path in a typical single-lens reflex camera. When the shutter release is pressed, the mirror swings up parallel to the ground glass, the focal-plane shutter opens, and the light passes straight through to the film.

Pentaprism

Field lens

Ground glass

Eyepiece

Lens assembly

Film

Mirror

Focal-plane
shutter

from the lens is directed to a viewing screen by the mirror, and from there to the eye by way of the prism. The prism reverses the image reflected from the mirror into the correct left-right configuration, and allows eye-level viewing as well.

In modern single-lens reflex cameras, pressing the shutter release sets off a train of mechanical activity: the mirror swings up out of the light path and the focal plane shutter opens, which allows the image to be recorded on the film. In most modern designs, the iris diaphragm in the lens mount is "set" at the desired opening prior to focusing but actually remains wide open until the shutter release is pressed. Then, just before the shutter opens, the iris automatically closes down to the chosen setting for the duration of the exposure. In most cameras, the mirror comes back down and the iris reopens automatically as soon as the shutter closes, to restore viewing at once. Thus, direct viewing of the subject is interrupted only for a split second longer than the duration of exposure, allowing virtually constant monitoring of subject activities. Although single-lens reflex cameras have the most complicated mechanical design of any common camera type, nearly all of them are remarkably dependable.

They are also highly versatile. Since viewing and picture making are accomplished with the same lens, there is no parallax problem. Extreme close-up and very long telephoto photography are readily accomplished and there is wide interchangeability of lenses. Meanwhile, the basic camera approaches the rangefinder camera's small size, lightness, and speed of operation (indeed, most 35 mm versions have a small variation of the split-image rangefinder built into the viewing screen to speed up and assist focusing). Some manufacturers have recently introduced unusually small and compact 35 mm SLR models, and a general trend toward smaller size is now apparent. SLRs using films as small as the 110 size are now available, including models with interchangeable lenses.

As for disadvantages, the single-lens reflex design is slightly more conspicuous in use owing to the combined noise of the focal plane shutter and the moving mirror, and in a few very critical uses "mirror-flop" can introduce unwelcome vibrations. (These latter will be most detectable if slow shutter speeds are being combined with high magnification, as with extreme telephoto photography.) In a few SLRs the mirror can be manually locked up out of the path of light prior to exposure to avoid the problem. This is useful when the subject is motionless.

Single-lens reflex cameras using 35 mm or smaller films share with 35 mm rangefinder cameras the disadvantage of small film size. However, the better designs partially compensate for this by very exact framing characteristics, which allow absolutely full use of the available film area, an essential feature if color slides for any critical or important use are to be made.

The special subject areas in which the 35 mm single-lens reflex camera excels are photojournalism and nature photography of small, live, moving objects, such as insects. As an indication of the popularity and versatility of single-lens reflex cameras, approximately 90% of all photojournalists now use this type of instrument—as does probably a similar percentage of all serious photographers.

The Twin-Lens Reflex Camera

The twin-lens reflex (TLR) camera, formerly the mainstay of magazine photographers for many years, remains popular with both professional and amateur photographers. It is most commonly used in the 2¼ × 2¼ inch format, but can be had in formats as small as 35 mm or as large as 4 × 5 inches.

Twin-lens reflex cameras can vary in shape and proportions, but Figure 3-8 shows a typical design. This type of camera is basically two box-body cameras placed one atop the other, with one mechanism controlling the focusing of the two lenses. The lower lens, the "taking" lens, forms the image directly on the film, while the upper lens, the "viewing" lens, has its light path deflected upward to a horizontal ground glass viewing screen. This screen is usually protected by a collapsible hood to prevent stray light from obscuring the image. Within the hood is a folding magnifier, which aids in accurate focusing when it is swung into position over the ground glass. In operation, the photographer holds the camera at waist or chest level, looks into the top of the camera while framing and focusing the image, and makes the picture when ready.

Figure 3-9 shows a simplified internal diagram of a twin-lens reflex camera. The viewing lens has no shutter, and usually no iris diaphragm. The shutter mechanism

4
Lenses

The lens is the camera's primary image-forming device. Light rays reflected from most subjects travel randomly in different directions. Thus, light passing through the open shutter of a camera with its lens removed would strike the film without forming an image. A lens forms an image by gathering light rays and focusing them on film located the proper distance behind it. All lenses have certain physical or optical characteristics that are of practical concern to photographers. The most important characteristic is focal length.

Focal Length

Nearly all camera lenses are made up of more than one *element*, or piece of glass or air space between two pieces of glass. Different types of glass having various shapes and optical qualities are played off one another to produce lenses with various desirable characteristics. Nevertheless, for ease of definition, we will pretend momentarily that the lens consists of one element (which, in fact, is all many early lenses had). For a thin, single-element lens, then, of symmetrical configuration, the *focal length* is the distance between the center of the lens and the image projected by that lens when the lens is focused at infinity (or, practically speaking, on a very distant object).

Because the point from which the focal length is measured (the *rear nodal point*) can be placed at any of a variety of locations along the optical axis,

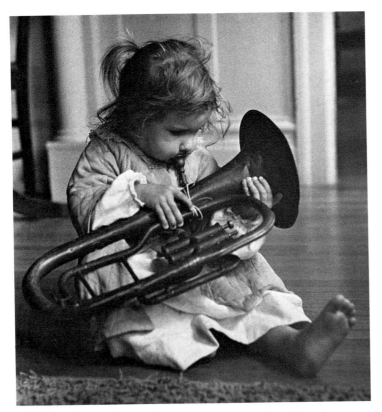 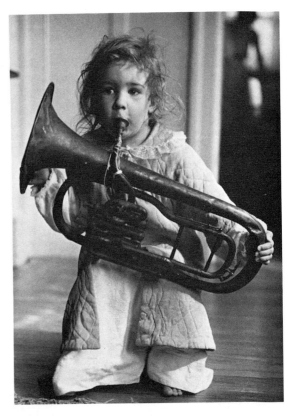

Figure 4-11 *Barbara and the horn.* In both of these pictures, the depth of field is quite shallow. The principal plane of focus passes through the child's eyes. Things nearer to or farther from the camera are more or less out of focus. Left. Here the child extends through the principal plane of focus; her extended foot, for instance, is quite unsharp. Right. Reducing image magnification has slightly increased depth of field. More important, the child is oriented parallel to the film plane, and so her image is quite sharp all over. But note that the background is still quite unsharp.

The Lens for the Job

Working with a camera that takes interchangeable lenses requires the photographer to decide, from time to time, which lens to use to photograph a given subject or to achieve a particular effect. The optical properties described in preceding sections, by which lenses of various focal lengths differ, are what the photographer must weigh in making a choice. (Some photographers insist on using a single focal length for all subjects—they do all wide-angle work, or all telephoto work. These people may be forfeiting a valuable control effect.)

Using Normal Lenses

As its name indicates, a normal lens is one that is normally expected to be in use on the camera, unless special circumstances arise. Normal lenses are used for the great majority of all photography.

Lenses of normal focal length are suitable for all ordinary types of photography, whether of objects, people, structures, or scenes, unless there arises some special need for a wider viewing angle, a larger image magnification, or the like. Many photographers feel no urgent need to own or use any other type of lens, and some

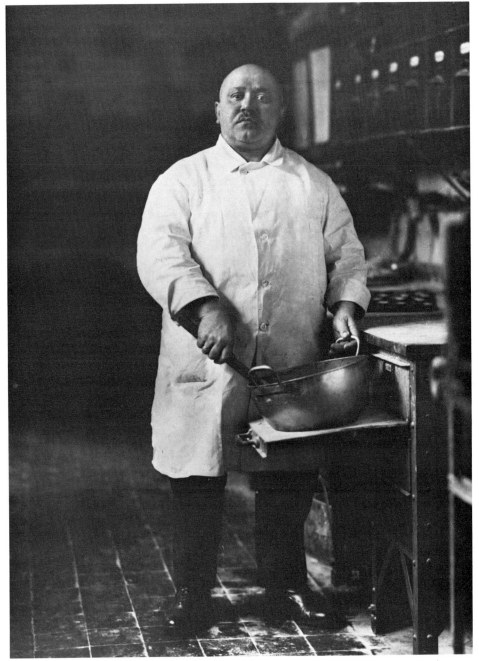

Figure 4-12 *Pastry cook, Cologne, 1928,* by August Sander, a portrait from Sander's important book *Deutschenspeigel* (published in English as *Men Without Masks*), in which he sought to make images of archetypes—individuals who represented the various types of person or of social stations in German society. Such existing-light photographs characteristically display very little depth of field, because a reasonably fast shutter speed is needed to stop subject motion. Photo copyright © The Sander Galley, Inc.

Figure 4-14 When one picture element is held at a constant image magnification, as the woman's profile is here, but the focal length of the lens is changed, the relative sizes of foreground and background objects change. For these pictures lenses of the following focal lengths were used: Top right. 150 mm. Center. 70 mm. Bottom. 35 mm. The camera was moved to keep the size of the woman's image constant; it was nearest her in the bottom photograph and farthest in the top. Had the image of, say, one of the potted plants been kept constant in size, the woman's image would have changed in size. (All three negatives were enlarged the same amount.)

Figure 4-15 Lens focal length is an important matter in portraiture. If the focal length is too short, filling the film frame with a head will require that the camera be so close to the subject that distortion results. Far left. A 55 mm lens was used; the image is distorted. Near left. A 105 mm lens was used; the image is undistorted. The pose and lighting were the same in both pictures, and both negatives were enlarged to the same degree.

proach distance), and that will therefore avoid undue apparent distortion of the sitter's features, a certain distance must be kept between the camera and the subject. This is especially true when the 35 mm camera is being used for a head-and-shoulders portrait. Filling the viewfinder frame with this part of the anatomy when using the standard 50 mm lens will bring you too close for good perspective, and so close that the sitter will feel a sense of encroachment. A much-preferred focal length for this use would be a 105 mm lens. It doubles the camera-to-subject distance, and makes everyone feel more comfortable.

The larger the film format, the longer the focal length of the normal lens, and so the greater the working distance. Thus, distortion and social distance are both less of a problem. With a 2¼ × 2¼ inch twin-lens reflex camera, the lens has a normal focal length of about 85 mm; usually no lens change is possible. Therefore, it would be best to stand back a little and compose the head and shoulders in about a 1 × 1½ inch area of the viewing screen, to avoid close-approach distortion. With a 4 × 5 inch (9 × 12 cm) format, a lens of about 180 mm works out well for portraits. Beyond that film size,

normal lenses are quite acceptable for head-and-shoulders portraits.

Using Wide-Angle Lenses

The other side of the coin from telephotography is wide-angle photography, in which lenses of shorter-than-normal focal length have the effect of increasing the angle of view rather than decreasing it, and of decreasing image magnification at the same camera-to-subject distance. There are several basic reasons for using lenses of short focal length. Not all of these are concerned primarily with the *idea* of increased angle of view, but all use it.

Wider Angle of View

A lens of normal focal length has an angle of view ranging from 45 to 55 degrees, give or take a little. But, from a given camera position, not all subjects will fit into this acceptance angle. Examples of subjects that are likely to require wider angles are landscape views and architectural studies. They are also useful in circumstances that

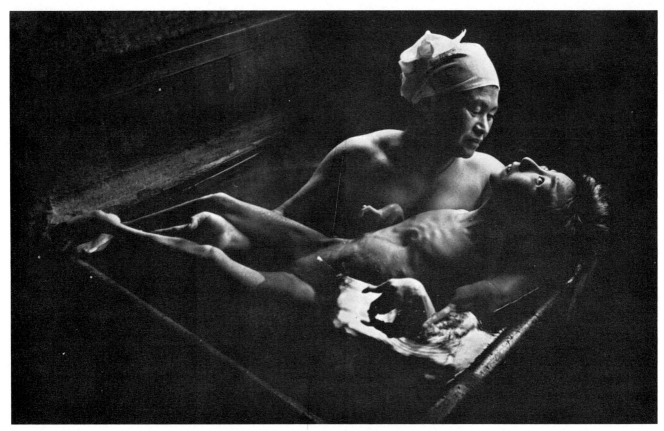

Figure 4-16 *Tomoko in bath,* 1972, by W. Eugene Smith. This photograph of a mercury-poisoning victim being bathed by her mother is one of a series of pictures illustrating the effects of industrial pollution in Minimata, Japan. The perspective in this scene is typical of that produced by wide-angle lenses, which must usually be used when working room is restricted. Photo copyright © 1972 W. Eugene Smith. Photo courtesy of the Center for Creative Photography, University of Arizona.

force you to position your camera unusually close to the subject. Wide-angle lenses are often used in landscape photography because when people look at such views they normally sweep their eyes across it to take it all in; the view as photographed with a normal lens tends to look cramped. In architectural photography the perspective effects induced by a close approach tend to make the picture look more dramatic, even if not actually needed.

Apparent Distance

Because wide-angle lenses have a greater angle of view than normal lenses, they produce less image magnification than such lenses when both are used at the same distance from the subject. Thus, wide-angle lenses are useful when you desire to make it appear that a given camera-to-subject distance is greater than it actually is.

Perspective Arrangement

Another such use occurs when you wish to exaggerate the relative sizes of subjects at different camera-to-subject distances (the opposite effect, that is, of the one produced by telephotography). This technique can be used to place visual emphasis on the nearer subject, when there is no need for direct size comparisons. It is quite an effective technique.

Figure 4-17 *Cooperage cellar, Simi Winery.* This is a conventional wide-angle interior photograph, made with a 35 mm lens. The image distortion often seen in wide-angle photographs is not evident here, because the camera was carefully leveled to avoid any unusual camera angle, and a low-distortion lens designed for architectural photography was used. Photo by A. Blaker.

Wide-Angle Techniques

Just as all serious photographers should take a medium capability telephoto lens along on each session, so should they take a moderate wide-angle lens. It is not extreme demands that cause us trouble in most circumstances, but rather those demands that just slightly exceed the capacities of our equipment. The most useful wide-angle lens seems to be one with about 70% of the normal focal length. In the 35 mm format, this would be a 35 mm focal length; for a 2¼ × 3¼ inch (or 6 × 7 cm) format, it would be about 65 mm; for 4 × 5 inch (or 9 × 12 cm), about 110 mm; for 5 × 7 inch (or 12 × 18 cm), about 150 mm; and for 8 × 10 inch (20 × 24 cm) format, a 210 mm lens is appropriate.

Indeed, in landscape photography, the lens most frequently used is the 70%-of-normal wide-angle. As noted earlier, lenses of normal focal length simply do not have enough breadth of view for many landscape photographs. Perspective-control lenses are available for 35 mm cameras and are becoming increasingly available for cameras in other small formats. Such lenses allow something of the perspective control of a view camera. Lenses of this type are discussed in detail in Chapter 9.

Zoom Lenses

In recent years the widspread introduction of the *zoom*, or variable-focal-length, lens has sometimes made it un-

necessary to have a whole series of lenses of various focal lengths. A zoom lens is designed in such a way that one or more of its glass elements can be moved with respect to one another, so that its focal length can be continuously changed throughout a fairly wide range. The usual ranges are from somewhat wide-angle to somewhat telephoto, from very short to moderate wide-angle, from moderate wide-angle to normal, or from a short to a longer telephoto. This can be a great convenience when the photographic situation is changing so rapidly that there is little or no time for changing lenses.

Zoom lenses can be divided for convenience into four general categories. The most versatile in some ways are those that combine wide-angle, normal, and telephoto focal lengths, such as a 35 → 105 mm lens. Next handiest are the short-to-longer telephoto zooms, typified by a 70 → 205 mm range. Less often seen, but sometimes very useful, are those that feature focal lengths that range from wide-angle to normal—say, a 24 → 50 mm lens. The fourth category, and one of the newer ideas in lens design, is the macro-zoom lens, typically a short-to-longer telephoto lens with a close-focusing capacity. Lenses of this design are discussed in the section on macro lenses.

Zoom lenses can generally be used much like other lenses, but they give you the unique capability of infinitely adjustable image size, within their individual zoom and focusing range. This is useful in any form of photography, but is especially so in color slide work, where you cannot adjust the image size or composition, after the fact, in the darkroom.

Additionally, zoom lenses offer a further unique capability: you can change the lens focal length, and hence the image magnification, over the period of a time exposure, thus radially smearing the image. This technique has many applications, as will be seen in Chapter 15.

Figure 4-18 Lens focal length is important in landscape photography. A normal focal length is often not suitable because its angle of view is narrower than that of the sweep of your eyes. Thus, use of a wide-angle lens is often desirable. On the other hand, sometimes it is desirable to use a long-focal-length lens to isolate detail. Opposite page. A scene photographed with a 35 mm lens on a 35 mm camera. The white outline indicates the view that a 55 mm lens, on the same camera in the same position, would have taken in—one much less open, more constricted. Top near left. The point of interest in this scene was the interplay of tones in the backlighted grass surrounding the old tree in the middle distance. As photographed with a 55 mm lens, the important image area takes up only the center of the picture. Bottom near left. Photographed with a 210 mm lens from the same viewpoint, the composition is much tighter and the textures in the grass show up much better. (A nearer viewpoint and shorter focal length could not be used to get the same view because of the slope of the land.)

Figure 4-19 Left. A human eye photographed at × 1 with a 55 mm macro lens, using close-up flash technique (described in Chapter 13). Enlarged above to × 4.4.

Zoom lenses often pose certain characteristic problems. They are frequently subject to substantial internal reflections that tend to introduce "flare" (a lowering of image contrast), and—if the lens is pointed toward, or nearly toward, a light source such as the sun—possibly single or multiple bright spots or pseudo-images on the film. Flare is significantly reduced and often eliminated by closing the lens diaphragm one or more f-stops from maximum. Actual bright spots from light sources must be watched for any time you are working into the light. It is sometimes possible to use them as creative image elements if you see them and integrate them into your composition. But if you fail to notice them while composing, they may well spoil your picture.

In times past, no zoom lens could offer as much image resolution (picture sharpness) as a fixed-focal-length lens of comparable focal length. In recent years, however, advances in lens design—and especially the widespread introduction of computer designing coupled with the use of special rare-earth glasses—have greatly improved the general quality of zoom lenses.

The best new designs are very good indeed, and they offer a degree of operational flexibility and versatility unmatched by more conventional equipment.

In small-camera photography, zoom lenses are the wave of the future and very nearly that of the present. Indeed, fixed-focal-length lenses may eventually come to be limited to special uses.

Specialized Lenses

The lenses so far discussed are not the only ones with which photographers should be familiar. Other types— here called specialized for lack of a better general term— have their uses. Such lenses range from the versatile, such as macro lenses, to those with narrow but important areas of usefulness, such as the fisheye wide-angle and the catadioptric, or mirror optic, telephoto lens.

Macro Lenses

A specialized type of lens that has risen to great favor in the last decade or so is the macro lens, commonly a lens

Figure 4-20 Use of macro lenses and fisheye adapters. Far left. Bull thistles photographed with a 55 mm macro lens, to enlarge the plant enough to display full detail. Note how little background appears in the picture. Near left. The same plant photographed with a fisheye adapter on a 210 mm lens. Although the main thistle head is approximately the same size as in the far left picture, there is a great deal of surrounding background showing, thus visually relating the plant to its environment.

of approximately normal focal length that has been made to unusually high standards of quality and provided with a built-in extended focusing range that allows maximum image magnifications of from × ½ to × 1, without resorting to auxiliary equipment. (This means, for example, that if you photograph your fingertip at × 1 magnification with a macro lens on your 35 mm camera, the *unenlarged* negative will have a life-size image of it.) The macro lens is designed especially for close-up photography, but is also entirely satisfactory for use as an ordinary normal-focal-length lens—you need not own both types. Macro lenses are especially useful for anyone interested in nature photography, especially in the 35 mm format, because less enlargement in the darkroom is needed to achieve a given image magnification.

More recently, macro lenses have been introduced in focal lengths both shorter and longer than normal, some to be used directly on the camera and others meant to be used on bellows attachments. (The techniques of close-up photography are described in detail in Chapter 13, and include both available-light and flash photography.)

Fisheye Lenses

The descriptively named fisheye lens has a bulbous glass front lens that accepts light from an angle of 180 degrees or more. The usual focal length for a fisheye lens for a 35 mm camera is a mere 8 mm, and is an extreme example of the retrofocus design. These lenses record the entire 180 degree hemisphere in front of the camera as a circular image on the film. Occasionally there is a need for such coverage. This is really just an extreme example of a need for a wider-than-normal acceptance angle, but it is so special a case that it deserves separate consideration. Examples of fisheye uses are whole-sky studies of cloud formations for meteorological research or other studies that require monitoring of cloud cover; or photographs made from the door of a room or the mouth of a shallow cave or rock shelter, that must include all aspects of the floor, walls, and ceiling. (This latter example might be lit by a bare flash bulb placed next to the camera, just behind the area covered by the lens, and as nearly as possible equidistant from all major surfaces.)

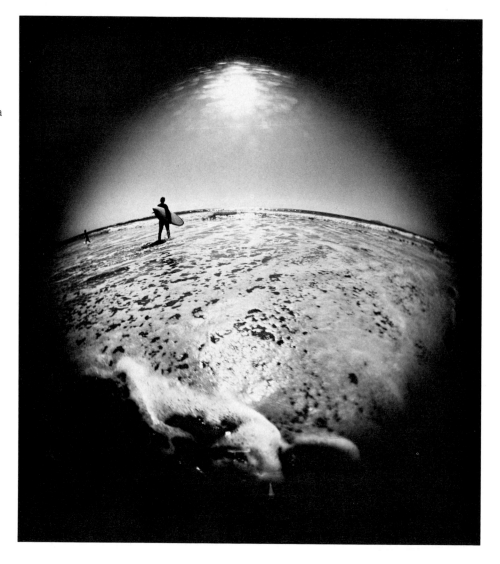

Figure 4-21 Beach scene photographed with a fisheye lens. Fisheye lenses characteristically distort the image: lines show barrel distortion and surfaces appear to swell. The angle of view is approximately 180°, and everything in front of the lens is shown on the film as a circular image, with the edges vignetted. Photograph courtesy of Robert Ishi.

Catadioptric Lenses

The lenses discussed so far are of normal construction: they are refracting instruments, with all their glass elements being lenses. For especially long telephoto use there is another type of construction that in essence is a reflecting telescope with a "folded" light path that incorporates one or more refracting elements (called *correcting lenses*) to yield a flat image in the film plane. These lenses are called mirror optics or, more correctly, *catadioptric* optics. A pure reflecting system is unusually free of most optical aberrations, but it cannot produce a flat image, its image naturally being a portion of a sphere (spherical aberration is described later in this chapter). Thus, correcting lenses of some type must be introduced. A representative design for catadioptric systems is shown in Figure 4-22.

These designs have a number of advantages, in addition to their potentially fine optical quality. They are unusually compact and light in weight, they focus rapidly over considerable distance ranges, they are usually of very long focal length, and they frequently have a fairly

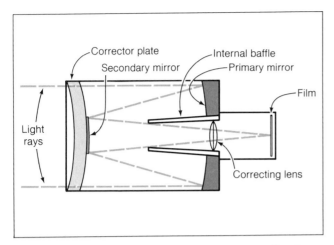

Figure 4-22 Path of light through a representative catadioptric lens: it passes through a transparent corrector plate and is reflected forward by the primary mirror to a secondary mirror on the rear of the corrector plate; this mirror reflects it again to the rear, where it passes through additional correcting lenses and the image is brought to a focus at the film plane.

wide aperture for such a focal length (although they are slow compared with normally constructed lenses of short to medium focal length). Their overall lengths are as short as 7–8 inches (17.8–20.5 mm). Their focal lengths usually range from about 500 mm to 2000 mm and their relative apertures range from about f/4 to about f/11 (a very few may have operating apertures as slow as f/16 or f/22).

The extreme image magnification and typically great working distances of these very-long-focal-length lenses introduce two major limiting factors in obtaining good images:

1. Any movement or vibration of the camera will blur the picture.
2. Convection currents and other air movements between the lens and the subject will badly degrade the image.

Movement and vibration must be very carefully controlled to eliminate most or all such effects. Atmospheric conditions may require that most such work be done in the early hours of the day, when air movement is at a minimum.

Catadioptric optical systems have certain disadvantages. These include:

1. Photographs made with them display a very shallow depth of field, because of the combination of high image magnification and a fixed, rather wide aperture.
2. Exposure control is a little abnormal, in that the aperture is fixed, and control is exercised by varying the shutter or film speed; or, in a few cases, by using neutral-density filters (described in Chapter 8). Only rarely can exposure control be exercised in increments of less than a full stop.

Nevertheless, remarkably good photographs of distant people, and of small, hard-to-approach wildlife, can be made with catadioptric lenses (see Figure 4-23).

Lens Aberrations

Any failure of a lens to meet theoretical standards of perfection is termed an *aberration*. Virtually no lens is entirely free of some residual aberrations, no matter what the effort to achieve perfection. In lens design and manufacture, as in most other aspects of photography, there is constant compromise, as one thing is traded off to improve another. For instance, lens speed is often obtained at the expense of flatness of field or freedom from distortion, which may also have to be sacrificed to obtain width of coverage in wide-angle lenses. Nearly any economy of manufacture requires some departure from perfection in the lens system. Further, any demand for unusual perfection in a single optical feature tends to require some compromise elsewhere in the design.

With the recent introduction of sophisticated computer technology in lens design, and the increasing use of new types of glass in manufacture, most modern lenses are amazingly good. Lenses that give genuinely poor performance are becoming increasingly rare. However, it is useful to know a little about lens aberrations in case you run across the unusual in practice.

Some types of aberrations have more effect—or have more obvious effects—on photographic images than others. Some are more likely to appear, given the manufacturing methods of the day and the design emphases that are most common. Those that are most often a practical problem are described in the following sections.

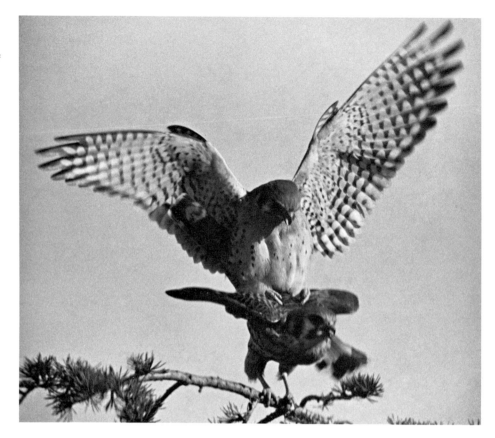

Figure 4-23 *Kestrels (sparrow hawks) mating.* This photograph was made with a 1250 mm Celestron 5 mirror lens from a distance of about 85 feet (about 25 m). Photo by A. Blaker.

Astigmatism

When you are photographing a subject that has lines radiating from a common center, such as a spoked wheel, you may infrequently notice that some lines focus more sharply than others, and that refocusing at different levels through a scene may make lines at a different angle appear sharper. This effect is called *astigmatism*. It is a result of unequal radial curvature in the lens manufacture. Image quality can be improved by closing down the lens aperture.

Chromatic Aberration

When you are focusing an image it sometimes happens that rainbowlike colors appear, fringing the edges of the subject. This defect is called *chromatic*, or color, aberration, and is an effect visually similar to the spreading of

Figure 4-24 Astigmatism. If an image containing radiating lines of uniform thickness is made with an astigmatic lens, some of the lines will appear to be thicker than others.

white light into its spectral components by a prism. It can take two forms: lateral and longitudinal.

Lateral chromatic aberration occurs when different colors of light (that is, light of differing wavelengths) form images of different sizes. Longitudinal aberration occurs when different colors of light come to a focus at different distances from the lens. Chromatic aberration is a basic lens fault that cannot be corrected by closing the lens aperture. In black-and-white photography, however, where the effect is to blur the image, you can increase the image sharpness by using color filters to absorb one or more of the color fringes, focusing with the filter in place (only when the filter is in place can you tell when a true focus is achieved, because otherwise all you see, at best, is an unsharp image).

Coma

If you focus on a field of point light sources, such as the starry sky, you may discover the effect called *coma*: although the central points image sharply, those out toward the frame edge show as short lines or teardrops, radiating away from the center; the farther away from the center, the greater the effect.

The effect may also be visible with any other subject that is richly detailed with a small pattern, whether regular or irregular. An enlarger lens with coma may produce this effect in the enlarged film grain, for instance. Coma may sometimes appear, also, when an otherwise satisfactory lens of normal focal length is used for close-up photography or photomacrography.

The effects of coma can generally be reduced by closing the lens aperture. In close-up work, reversing the lens, back to front, on the extension tubes or bellows will usually much improve the image, and the coma effect may disappear completely.

Curvature of Field

A lens that projects an image as a portion of a sphere demonstrates the aberration called *curvature of field*. The center can be sharply focused but not the edges, or vice versa.

Although curvature of field is not correctable, its effects can be minimized when photographing a flat subject (where it will be most noticeable) by focusing the image at a point a little out from the center, thus taking best advantage of the depth of focus at the film plane.

Flat subjects are best photographed with a "flat-field" lens, which has been corrected in manufacture to be free of this aberration. Most macro lenses, and some wide-angle lenses designed for architectural photography, are especially well corrected for this fault.

Diffraction

When the light forming an image passes through a lens aperture, the wave front is distorted in much the same way as an ocean wave is distorted as it passes through an opening in a breakwater. The result is reduced image resolution (picture sharpness). The smaller the aperture (or the higher the f-number) the more the distortion. This distortion effect is called *image diffraction*.

Diffraction, being produced by the presence of the lens aperture (usually an iris diaphragm) rather than by

Figure 4-25 Coma is an aberration sometimes seen in close-up photography, and occasionally in enlarging lenses of poorer quality. Left. Black paper perforated with pinholes was put in an enlarger and projected onto a piece of film with a lens that displayed, among other things, massive amounts of coma. Each point of light is dispersed outward from the center of the image in comet-like shapes. Right. The same subject projected with a good-quality enlarger lens. No such dispersion is visible.

refractive qualities of the lens, is not itself a lens aberration. However, since all camera lenses have an aperture, and since diffraction impairs image quality, photographers must take it into account.

Closing the lens aperture to reduce the effects of residual lens aberrations introduces image diffraction. Diffraction itself can only be reduced by widening the aperture (that is, using a lower f-number). Therefore, camera lenses have an *optimum aperture:* a point beyond which further closing down will introduce diffraction more than it will correct aberrations. This optimum aperture differs from lens to lens, but usually occurs between f/4 and f/8.

Fortunately, because its onset is relatively gradual, diffraction is not a serious problem in most photography. It is more of a problem in technical photography, where the optimum lens aperture must be determined for very critical sharpness. The most drastic effects occur at very small apertures; a sharp drop in lens performance occurs after about f/90 to f/128. Since few, if any, lenses are calibrated to such small apertures, the worst effects are limited to high-magnification photography. (Diffraction is discussed further in Chapter 13, on close-up photography.)

Distortion

When photographing regular, gridlike forms, as in architectural photography or in copying artwork that contains square or rectangular elements, you may notice that lines that are straight or parallel in the subject are reproduced as curves in characteristic ways. A door or window, or a drawn rectangle, may appear to have its sides curved inward ("pincushion" distortion) or outward ("barrel" distortion). This aberration, by the way, has no effect on image sharpness.

Any such distortion is inherent in the lens design and is not correctable. Fast wide-angle lenses are especially likely to display noticeable barrel distortion. If you are buying a lens with the intention of using it at least in part for careful photography of rectilinear forms, beware. Look instead for low-distortion lenses, such as are designed for architectural work or for copying, and are advertised as such.

Flare

Internal reflection of light, called *flare*, within a complex lens produces stray light rays that tend to "fog" the whole

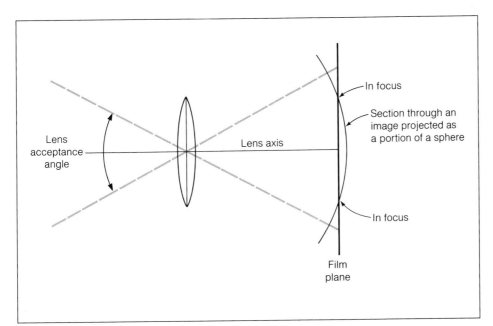

Figure 4-26 Curvature of field. An image projected onto the film plane by a lens with this aberration is a portion of a sphere, rather than a flat field. Such an image can be focused sharply at the center or at the edges, but not simultaneously at both.

In the figure: Lens acceptance angle; Lens axis; In focus; Section through an image projected as a portion of a sphere; In focus; Film plane.

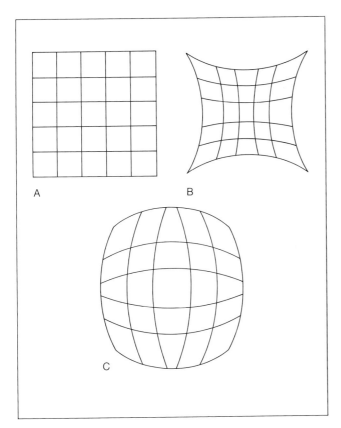

Figure 4-27 Image distortion. A. A grid as it would normally appear. B. Pincushion distortion. C. Barrel distortion.

A

B

C

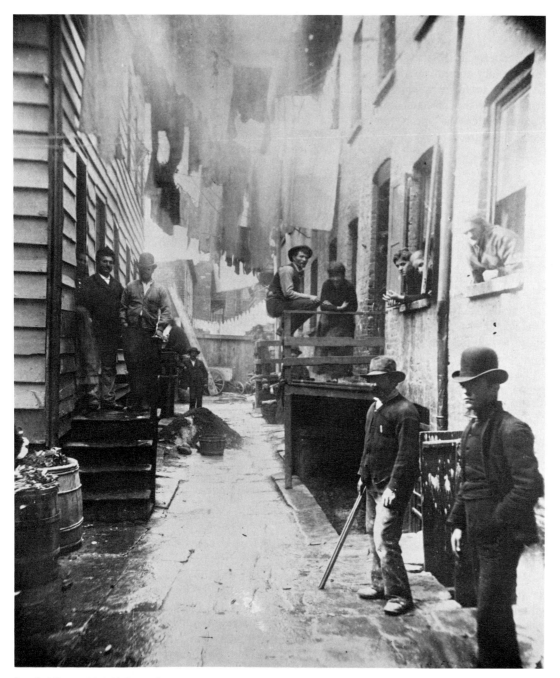

Bandits' Roost, 39½ Mulberry Street, c. 1888, by Jacob Riis. A newspaper reporter who crusaded against the social conditions that bred crime, vice, and disease, Riis took up the camera out of conviction that photographs would move where words had failed. He had no interest in camera artistry, so few of his images have the graphic force of Lewis Hine's or the paradoxical beauty of Donald McCullin's. They do, however, convey the information that Riis intended them to; and the best of them carry surprising authority as pictures. Photo courtesy of the Museum of the City of New York.

5
Films and Papers

The difference between modern cameras and their antecedent the camera obscura is their use of film to record a virtually permanent image. Modern films are infinitely easier to use than their nineteenth-century counterparts. This chapter deals primarily with black-and-white materials, those most commonly used by beginning students. Only the fundamentals of color films and papers are described.

Films

As with cameras, there are a variety of types of film, each type being especially suited to a particular use or set of circumstances. Let us first consider the basic characteristics of photographic films in general, and then proceed to the particulars.

Films can be defined as light-sensitive materials that have been coated onto a transparent supporting medium, and that are cut and packaged in rolls or sheets in standard sizes for use in cameras. They come in either black-and-white or color-recording types, and their use can be tailored to a wide variety of tasks, many of which are often only dimly understood by the beginner.

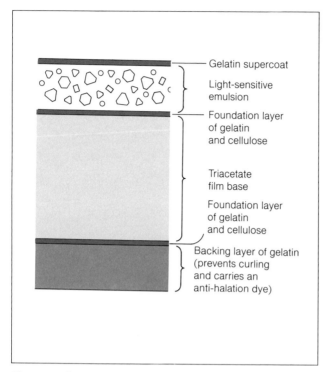

Gelatin supercoat

Light-sensitive emulsion

Foundation layer of gelatin and cellulose

Triacetate film base

Foundation layer of gelatin and cellulose

Backing layer of gelatin (prevents curling and carries an anti-halation dye)

Figure 5-1 Cross-section of typical black-and-white film.

The Structure of Film

Black-and-white films render the naturally colored image that is projected upon them by the lens as a monochromatic (that is, one-color) image: one composed of an infinitely shaded series of grays whose lightness or darkness corresponds inversely to the brightness of the light forming the image in those areas. Such films consist of a sandwich of several layers bonded together, as Figure 5-1 shows. First there is the *film base,* or medium of support—usually a flexible plastic, but occasionally glass or a rigid plastic. The *emulsion* deposited upon this consists of light-sensitive silver halides suspended within a transparent, water-absorbent gelatin. Included in the sandwich are layers of dyes; one of these dyes (the *anti-halation coating*) absorbs the stray light scattered within the emulsion and film base, and other, light-filtering dyes determine the basic color sensitivity of the film.

Exposure to an image—that is, to light focused on the film by the camera lens—causes physical changes in the emulsion that establish a *latent* image, visible only after

the film has been chemically developed.* To give a brief, simplified sketch of what is described in detail in Chapters 10 and 11, during development the emulsion absorbs the developing agents, and the portions of the light-sensitive compounds in the emulsion that were affected by exposure to light are chemically reduced to grains of metallic silver. These clump together roughly in proportion to the amount of light that struck their area of the film; in the aggregate, they make up the developed visible image. After development, the image is made permanent by chemical *fixing,* which also removes unexposed light-sensitive materials from the emulsion. At one stage or another, all this chemistry also removes the anti-halation layer and the color-sensitizing dyes. The result, after washing and drying, is a *negative*: a reversed-tone, translucent image on the film.

So-called color films are actually multiple-layered black-and-white films in which there are three or more layers of emulsion, each sensitized and filtered so as to record only certain wavelengths of light. In the course of processing, the silver grains forming the various layered images are dissolved out and are replaced by appropriately colored dyes. The result can be a color negative, with all colors the chromatic reverse of those that will appear on the color print; that is, blue color will appear yellow on the negative, green will appear magenta, red will appear cyan, and so on. Alternatively, reversal processing can provide a direct-positive transparency—what we call a color slide—with colors rendered quite naturally.

Variable Film Characteristics

Films come in many types, to suit many needs. All share the same basic components, but carry a number of variable characteristics, among them speed, grain, contrast, and color sensitivity.

Speed

One of the three basic variables in photographic exposure (the others being the aperture setting of the lens, and the

*There are wholly new types of films and processes, some still highly experimental and some nearly practical, that do not form a silver image and that are developed by heat rather than by chemical soaking, but those used in ordinary photography work in the manner described.

timing of the shutter) is the speed of a film, or its degree of response to a given amount of light. Exposure, as such, is considered in detail in Chapter 6.

In the past the two most widely used film speed systems were called ASA (in the United States) and DIN (Germany)—the letters are acronyms for sponsoring organizations. Recently a new international system has combined these two as ISO ratings (for the International Standards Organization). Table 5-1 compares ASA, DIN, and ISO film speed ratings.

For our purposes here, it will be enough to say that films vary in speed from slow (under about ISO 50/18°), through medium (from about ISO 64/19° to about ISO 200/24°), to fast (anything above about ISO 25/25°). As you can see, slow, fast, and medium are somewhat arbitrarily stated, but the terms serve to indicate approximate speed levels.

Grain

Grain is a descriptive term for the visible random clumping of the minute silver grains that make up the image in a negative. The individual grains themselves are much too small to see in any normal photographic usage, so the term is a slight misnomer resulting from a sort of verbal shorthand.

Generally speaking, grain is tied to film speed in one of photography's characteristic compromise situations. Briefly put, faster films have coarser grain structure and slower films have finer grain, other conditions being equal. When the natural appearance of the photographed subject is of prime importance, fine grain is to be desired. When processes and actions are more important than their detailed appearance, and where available light is an inhibiting factor, grain can be tolerated to whatever degree necessary. The point to remember is that although grain is an inherent part of photographic image structure, it is no part of the subject itself. Therefore, most photographers try to avoid or at least minimize visible grain in pictures. There are some notable exceptions, however, such as the photograph by Ralph Gibson at the beginning of this chapter, in which grain is accentuated to enhance the photograph's mysterious ambiguity. It is important to remember that a film's inherent grain structure cannot be made smaller, but it can be made larger by improper handling of the film in use and in development. Thus, within limits, visible grain size in any given type of film

Table 5-1 Equivalent film speed ratings.

ASA	DIN	ISO
3	6°	3/6°
4	7°	4/7°
5	8°	5/8°
6	9°	6/9°
8	10°	8/10°
10	11°	10/11°
12	12°	12/12°
16	13°	16/13°
20	14°	20/14°
25	15°	25/15°
32	16°	32/16°
40	17°	40/17°
50	18°	50/18°
64	19°	64/19°
80	20°	80/20°
100	21°	100/21°
125	22°	125/22°
160	23°	160/23°
200	24°	200/24°
250	25°	250/25°
320	26°	320/26°
400	27°	400/27°
500	28°	500/28°
650	29°	650/29°
800	30°	800/30°
1000	31°	1000/31°
1200	32°	1200/32°
1600	33°	1600/33°
2000	34°	2000/34°
2400	35°	2400/35°
3200	36°	3200/36°

is somewhat controllable through careful exposure and development. Nevertheless, any grain structure, no matter how fine, will be most visible in out-of-focus areas of gray undifferentiated tones, as can be seen in Figure 5-2.

Contrast

The term *contrast* describes the range of light and dark tones in the subject that a film is capable of encompassing. Films able to show a wide range of detail-filled tones are said to have low contrast (or a "long scale of gradation"). Those that can, in any one exposure, show only a portion of the tones represented in an average scene

ability to do photography under widely varying exposure conditions on the same roll of film is a very worthwhile characteristic. You might, for example, do a high-speed action photograph at an indoor basketball game requiring an exposure index of EI 800 on the first half of a roll, and then finish off by making very high quality portraits of individual players at EI 200 on the rest of the roll. There would be no need to give compensatory processing. Just expose different frames—alternating frames, if you wish—of the same roll at whatever exposure index you think best for the particular picture. Within the limits stated, all will be readily printable.

At the rated film speed of ISO 400/27°, the image quality will be comparable to conventional black-and-white films of that speed, perhaps a little better.

When overexposed (used at EI 320 or less), there is a marked improvement in image quality. By the time you get down to EI 200, film grain virtually disappears. The resulting negatives will print at least as well as slow films of the ISO 32/16° type. Highlights and light middle tones, which tend to show grain the most in most films, will take on a grainless, creamy character, and fine detail will be very well shown. Moreover, the blocking-up of highlights—the marked lowering of contrast—that is normal in overexposed conventional black-and-white films is greatly reduced. By burning-in while printing, you can retain detail that might otherwise be lost.

When underexposed (used at faster indexes such as EI 800, 1200, or 1600), film grain tends to remain similar to regular ISO 400/27° films that are exposed normally. Grain is markedly better at EI 1200 than with conventional film of that speed. Meanwhile, shadow detail holds up remarkably well. For further comment on the printability of XP-1 film, consult my article, "The Craft of Chromogenics" (see the Bibliography).

How is all this done? The film has two overlaid light-sensitive emulsions that differ primarily in their speed. The top layer is a fast, highly sensitive emulsion; the bottom layer is a slow, low-sensitivity emulsion. Both are fully panchromatic in sensitivity.

If these two layers were conventional silver-based emulsions after development, overexposure of the top layer would result in a nearly opaque heavily blocked-up image in the negative. The lower layer would serve no useful purpose. But the color-negative processing used with these films results in the washing out of the original silver image and its replacement with a translucent dye image. Although the image does block up with overexposure, you can print through it with very little loss of contrast. Meanwhile, the actual blocking-up results in the overlapping of the edges of adjacent dye clouds (each of which has replaced a silver grain), with the result that grain edges disappear and grain structure is not apparent.

Note that you *must* use standard color-negative processing (Kodak C-41 process or the compatible Ilford kind). If you use regular black-and-white processing, you will get a conventional silver image of rather poor quality that loses the special advantages of the film, and it is therefore pointless to do so. You can, by the way, process this film together, in the same set of baths, with any color-negative films that are compatible with the C-41 process. You can, for that matter, have Ilford XP-1 400 processed routinely, for negatives only, at any commercial color-negative lab, including the 1-hour labs. Having them make prints, however, just results in monochromatic prints that are expensive without being particularly attractive. You should make the prints yourself, using ordinary black-and-white printing papers.

Are there disadvantages to this "chromogenic" black-and-white film? Only one—the cost. You pay color-negative film purchase and processing costs. To me, though, it is worth it.

Infrared Films

There is a color infrared film—more properly known as a "false color" film. It operates by dropping out the shorter-wavelength (blue-violet) sensitivity band entirely. The sensitivity of each layer of the film is then moved up one toward the longer wavelengths, and the layer that normally records the visual reds is sensitized to record only infrared. The result is sensitivity in two layers to visible light and in one to infrared. This combination records information outside the capabilities of black-and-white infrared film. In fact, copying color infrared film into black-and-white does not produce the equivalent of original black-and-white infrared either, but gives yet other possibilities. Color infrared film is normally used with a Wratten 12 yellow filter.

In general photography, the more exotic films designed for really special-purpose uses—of which there are a sizable number—will not often be needed. The correct color filters can convert any pan film to almost any color-

Figure 5-5 Native American cliff art, Dry Fork Canyon, near Vernal, Utah: photographed on Type 107 Polaroid film. The design was pecked into the face of a sandstone cliff and painted with earth pigments. (Because the original paint was worn off by wind-borne dust, an archeologist, to make the design more visible for photography, retraced it with chalk—a practice no longer condoned.) Photo by A. Blaker.

sensitivity range that is needed—although this technique entails emulsion speed losses (for instance, a Wratten 44A filter will convert panchromatic to orthochromatic film, but its use requires approximately 10 times the normal exposure). Exposure compensations, called filter factors, required by the use of filters are described in Chapter 8.

Polaroid Films

No discussion of films is complete without mention of the remarkable Polaroid Land films. The black-and-white films range in speed from ASA 50 to 3000. Most types produce a finished print only, but the P/N (for positive/negative) type produces both a print and a high-quality negative. Another type, available in both medium and high contrasts, produces only a positive transparency, which can be mounted in a snap-together plastic frame for quick, easy projection. A finished slide can be projected about two minutes after exposure. Other spe-

cialized Polaroid Land emulsions include two forms of color print films. A color transparency film is also available, in 35 mm size.

Although only the P/N version offers the quality and versatility of normal black-and-white sheet films of comparable size, each of the Polaroid Land films has its own special area of preferred use. But for outdoor photography P/N film has the disadvantage that, to save the negative, you must use great care in taking it out and placing it in a container of a liquid film cleaner and fixer for storage. (See the directions provided with the film.) In photographic education, it is invaluable to be able to show a finished print after a total processing time (darkroom-free) of less than a minute. It is particularly useful in demonstrating effects that are transient, that depend on careful or special lighting, or that require the use of filters. As a public-relations device, when working in the field with or near people who are somewhat less than enthusiastic about your aims or presence, these films can be enormously helpful.

Figure 5-6 A New England culch pile: photographed on Type 107 Polaroid film. A culch pile consists of material not worth storing carefully, but kept because it "might come in handy." Figures 5-5 and 5-6 were enlarged 35% in reproduction. Photo by A. Blaker.

Polacolor film was a disappointment at first, but recently a new version has been brought out that has some improvement in sharpness, and considerable improvement in color rendition. The photographer Marie Cosindas has made prolonged and masterful use of Polaroid color materials, as Color Plate 21 shows. SX-70 color film offers increased sharpness, improved color brightness, and is almost completely free of the usual Polaroid plethora of waste materials to dispose of. It is durable in ordinary time spans (ten years, or so) to the point of indestructability, whereas other Polaroid Land films all have delicate surfaces. Although it also requires the purchase of a special camera, since its development processes are incompatible with those used in all other Polaroid Land films, the better SX-70 cameras are revolutionary folding single-lens reflexes that offer considerable versatility and convenience in use.

Both types of Polacolor present a practical problem in that the ambient temperature is a controlling factor for obtaining a correct exposure and developing it properly. (To a lesser degree this is also true of all other Polaroid Land films.)

Polaroid Land films must be used either with Polaroid cameras, or with adapters mounted on cameras made by others. Most such adapters fit only the larger cameras, such as 4 × 5 press or view camera, but some now fit various 2¼ inch cameras, such as the Hasselblad and the Mamiya RB-67. Few 35 mm manufacturers have attempted this, an exception being Nikon, who used to make an ingenious tandem-camera adapter (in tandems, one camera rides the back of another) called the Speed-Magny (see Figure 5-7). At present, Polaroid adapters of many types are made, mainly by two firms: Polaroid Corporation; and NPC Photo Division (Newton Upper

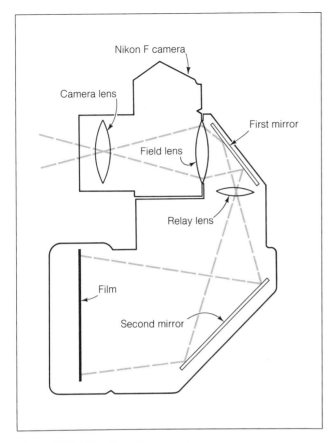

Figure 5-7 A Nikon Speed-Magny adapter.

mats, combine very high contrast with extremely high resolution and virtually microscopic grain. For situations where a relatively slow film speed can be tolerated, it is possible to use them with small cameras to obtain negatives of such high quality that even quite large enlargements will closely resemble contact prints from large negatives.

Special developers are used to lower the film contrast so that it can record a full range of tones with normal subjects and ordinary existing lighting. Optimum quality will result only from impeccable technique in camera handling, exposure, processing, and printing. Only the very best optics on both camera and enlarger will make full use of the quality inherent in the film. Examples of such films, from various countries, are Fuji Microfile, Agfa Gavaert Docupan, and H & W Control VTE Pan, though one or two are long on reds and shy of greens. A number of developers will act to lower film contrast, but probably the best combination is H & W Control VTE Pan, a fully panchromatic film, used with H & W Control developer (these come from American Photo Products, St. Johnsbury, VT).

Kodak has entered the field of high-resolution photography with Technical Pan film, a development from their earlier document-copy films, available in either 35 mm or 120 size. There are two versions of their companion Technidol developer, one a liquid and the other a powder mix. Though generally panchromatic, Technical Pan has extended red sensitivity and lessened greens. It has met with considerable market success. (Some workers use both it and H & W VTE Pan, each for its own special sensitivity range.) See Kodak's literature for the latest details of use.

Falls, MA). NPC makes an adapter for 35 mm cameras. Like the old Speed-Magny, it makes enlarged images— about 2 × 3 inches—and it, too, is a tandem camera. However, its design is somewhat different from the Magny; its image ends up underneath the 35 mm camera as well, but at 90 degrees to the original film plane instead of the Magny's 180 degrees. For more information, check with NPC.

High-Contrast Films

Other black-and-white films designed for specialized use, but of particular interest to nature photographers and mural printers, are the types intended for document copying. Such films, made for 35 mm and 120 size for-

Ultraviolet (UV) Films

No films are specifically sensitive only to ultraviolet radiation, but all normal black-and-white and color films can record the longer-wavelength ultraviolet (called the near-UV) if visible light is filtered out and if suitable light sources are used. The glass of the lens is likely to be the limiting factor, as glass absorbs all but the longest ultraviolet wavelengths. Special lenses for recording the ultraviolet are expensive. Color films record ultraviolet as a shade of blue.

Papers

Most photographs other than color slides are produced and displayed as prints on photographic printing paper. As with film, printing papers are available in both black-and-white and color.

Paper Contrast

A basic characteristic of black-and-white photographic papers is contrast. Because negatives can differ in contrast, it is necessary to have papers that also vary in contrast to produce acceptable prints. There are two common ways of achieving contrast variation in printing paper.

Paper Grades

In one method, papers are produced in grades of contrast, numbered from 0 (zero) to 5. Number 0 paper is very low in contrast, and is intended for the printing of very high contrast negatives. Normal negatives are printed on number 2 paper, very low contrast negatives on number 5, which is itself very high in contrast.

Variable Contrast Paper

The second method of changing contrast is to use variable contrast papers, which have double emulsions, one of high and one of low contrast. The photographic image is projected through filters of various colors, and the two emulsions are sensitized in such a way that a change in the color of light causes a contrast change in the print. An almost infinite range of contrast variation can result, including different contrasts on different parts of the same print. With variable contrast papers it is not the paper but the filters that are numbered, to indicate the contrast range that results from their use. Different manufacturers use different numbering systems for the filter, but the systems are similar—low numbers give low contrast, and high numbers high contrast. Although the variable contrast papers have a somewhat narrower contrast range than graded papers, it is enough for most uses. Variable contrast papers are especially useful in low-use darkrooms where it would be uneconomical to stock separate packages of all the different grades.

Paper Characteristics

Paper Thickness or Weight

Black-and-white printing papers are available in four weights, or thicknesses: documentweight, singleweight, mediumweight, and doubleweight. The paper most commonly used is singleweight, a fairly thin, flexible paper suitable for most general uses, particularly if the finished print is mounted on a board. If left unmounted, singleweight prints tend to curl, sometimes quite tightly if the air is dry; the emulsion side will be inward. And if singleweight prints are mounted on a rough-surfaced board, the texture of the mountboard may show through.

Doubleweight paper is more expensive, but may be worth the cost for display prints. It is much less subject to curling when unmounted, is sturdy enough to withstand considerable handling, and is thick enough so that the texture of a mountboard will not show through it.

Both documentweight and mediumweight papers are specialized. Documentweight papers are approximately the same thickness and texture as typing paper, and they are used mostly for making report illustrations. Mediumweight papers are primarily used in making resin-coated photo papers. (These are discussed in detail in a following section.)

Paper Surfaces

Black-and-white printing papers also come in a variety of surface textures; among them are glossy, semi-matte or smooth matte, matte, pebble, canvas, and silk.

Glossy-surfaced papers provide the highest image resolution and the broadest scale of grays. Because of their mirrorlike finish, light is reflected off them with little surface scattering; so blacks look blacker and whites look whiter than with textured surfaces. A matte surface has a slight random texture; smooth matte and semi-matte surfaces have finer textures. Pebble is a coarse-textured surface made up of myriad tiny domes, giving an effect like a packed surface of tiny smooth pebbles. Canvas and silk papers, which are not actually made or surfaced with cloth, are textured in a weave pattern. Canvas is coarse and rough, and is intended to resemble the look of artist's canvas. Silk has a somewhat shiny, luxurious look, and is much used for wedding pictures. The surface textures of these nongloss papers tend to break up fine image

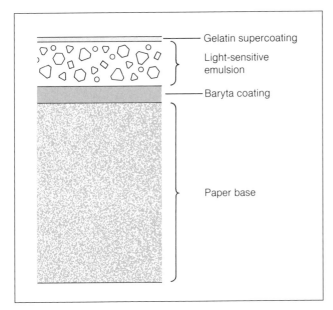

Gelatin supercoating

Light-sensitive emulsion

Baryta coating

Paper base

Figure 5-8 Cross-section of conventional black-and-white printing paper.

detail; the rougher the paper, the stronger the effect. Additionally, textured surfaces tend to scatter the light by which the prints are viewed, and so print contrast is lower than with glossy papers. However, many photographers prefer them. Large prints for wall display, especially mural-sized prints, are normally made on matte-surfaced papers, to avoid the surface reflections that appear on highly glossed prints. Photographers aiming for impressionistic effects sometimes make use of textured papers, to achieve the desired effect.

Types of Black-and-White Papers

Conventional Printing Papers

Black-and-white printing papers come in two basic speeds, a very slow (or relatively insensitive) type referred to as *contact* paper, and a much faster paper that is used for projection printing with enlargers.

Conventional printing papers consist of a layered coating bonded to a paper of very high quality (see Figure 5-8). The top layer is an overcoat of gelatin, which protects the main emulsion. Under this is the light-sensitive emulsion, a suspension of silver halides in gelatin. Below

that is a layer of baryta, a white claylike compound of barium, that is impressed with the basic paper texture.

If printing papers were sensitive to all colors of light, printing would have to be done in total darkness, so conventional papers are made sensitive to only some wavelengths of light. Darkroom lighting is provided by a "safelight," an enclosed light source with a filter over its open side. The instruction sheet packed with each package of paper details the correct filter and directions for its use. (There are "universal" safelight filters that are safe for all but panchromatic papers, described later in the chapter.)

Resin-Coated (RC) Papers

The most recent innovation in printing papers is resin-coated (RC) paper. This plastic-coated material does not absorb chemicals, so washing times are very short and print permanence is very good. RC papers are also available in glossy and nonglossy surfaces, and in both graded contrast and variable contrast forms.

RC black-and-white printing papers have been the subject of some adverse criticism in the photographic press. Such papers have been said to be capable of less tonal sublety and depth than conventional papers. But recent technical articles, backed up by scientific testing, indicate that, as compared to conventional printing papers, there is no difference in the ability to achieve heavy black tones on RC papers (except possibly a slight improvement); further, there is no overlying "haze" due to the plastic coating, as had been reported. (The light-sensitive emulsion lies on top of the plastic coating, as is shown in Figure 5-9, and so could hardly have a "plastic-y" surface—had the coating plastic been on top, no developer could have reached the emulsion for processing.) For more comments on RC papers, see my article, "The Case for RC" (see the Bibliography).

RC papers offer substantial savings of water and time in print washing, ease and rapidity of drying and glossing, and unusual resistance to curling after drying.

Panchromatic Papers

Color prints cannot normally be made from black-and-white negatives (setting aside complex methods of color printing by means of several black-and-white negatives, called separation negatives, each of which records a sep-

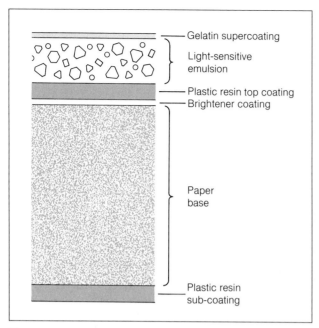

Gelatin supercoating

Light-sensitive emulsion

Plastic resin top coating
Brightener coating

Paper base

Plastic resin sub-coating

Figure 5-9 Cross-section of resin-coated black-and-white printing paper.

arate color). Color negatives can quite readily be printed as black-and-white, but if they are printed on normal photo papers, there will be considerable changes in the gray-tone rendition of color brightnesses, due to the inability of normal papers to record all colors of visible light. Still, the results may be satisfactory for some uses. If all of the color tones are to be recorded in grays that are comparable in tone to those that result from printing a panchromatic negative, a panchromatic printing paper must be used. Such papers require use of a special darkroom safelight, as those that are usually used with normal printing papers will "fog" (that is, partially expose) panchromatic papers, just as they would a panchromatic film.

Color Printing Papers

Conditions in color printing are quite different, so these papers neither have nor need much contrast variation, but have almost infinite color variation when they are used with the appropriate color correction (CC or CP) filters. There are a variety of types and makes of color printing papers. So far, none is as simple to use as black-and-white paper, but the difference is more a matter of tedium than of real difficulty. If the directions for color filtering, and for processing the paper, are read carefully, and are as carefully followed, anyone familiar with ordinary photographic practices can produce satisfactory color prints in any but the most primitive darkrooms. Basic elements of color printing will be covered in a later chapter, since color work has its own particular set of problems. On the whole, it is better to learn black-and-white printing first, and go on to color printing afterward.

An interesting exception to this is Polacolor, in which processing is a fully automatic single step, carried out in the camera itself. The largest amateur size is slightly under 4 × 5 inches, and the subsequent production of any additional prints is essentially a sophisicated full-scale copying process. However, within its limitations it has its uses. For instance, it is possible to invert a Polaroid Land sheet film holder under an enlarger, and project color transparencies directly onto it, thereby achieving singlestep reversal printing in a form suitable for study, without involving yourself in any complex procedures. In this usage it is necessary to convert the tungsten-light color temperature to daylight levels. An approximate conversion, from 3200°K to 5500°K, can be done with an 80A conversion filter. If the lamp burns at a lower temperature—and it could be as low as 2800°K with some enlarger bulbs—fine tuning can be done with CC filters (described in Chapter 8). Or the less well known #820 or #840 blue filters (available by special order) can be used.

In an interesting new development, Polaroid has now introduced Polacolor in the 8 × 10-inch format, suitable for use, with special film holders, in conventional view cameras. Processing is done using a special desk-top sized machine. The color quality and sharpness are excellent, and the results—available for use in a couple of minutes—are good enough for immediate wall display or for publication. An experimental 16 × 20 inch version is now being provided to a few well-known photographers.

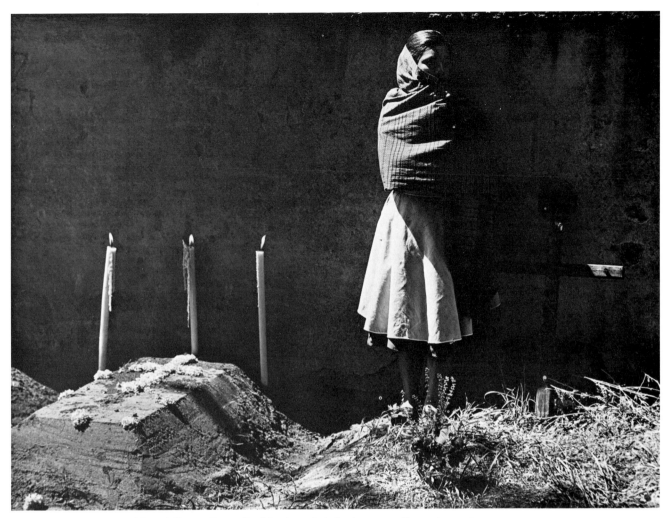

Figure 5-10 *Visitacion,* by Manuel Alvarez Bravo. For this strong but simple composition, enhanced by the strong lighting contrast, great care in printing is required to avoid losing highlight or shadow detail. Norton Simon Museum, Gift of Mr. Shirley Burden, in memory of Flobelle Fairbanks Burden.

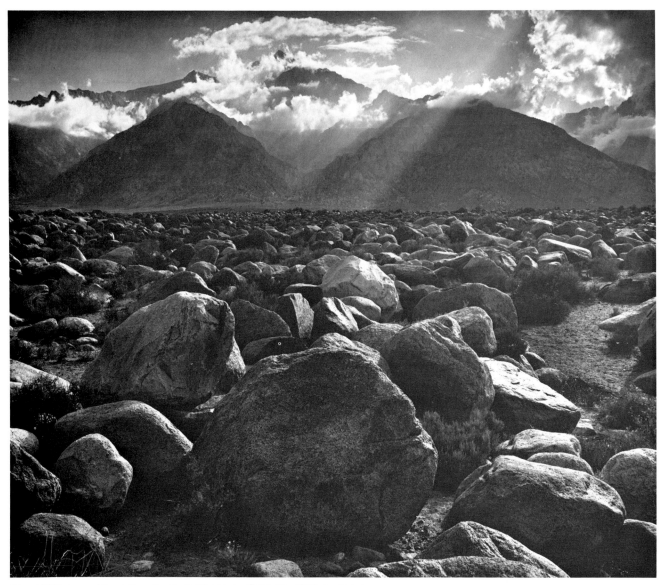

Mount Williamson, Sierra Nevada, From Manzanar, California. 1944, by Ansel
Adams. Adams is the originator of the well-known Zone System of photographic
exposure (described in this chapter). Courtesy of the Trustees of the Ansel Adams
Publishing Rights Trust. All rights reserved.

the best and most complete method of exposure and development control so far devised.

To the beginner it may look complicated, but actually, and in principle, it is very simple. As S. G. Ehrlich, a highly regarded scientific and legal photographer, aptly described it, "It is simple, but not easy." For every photographer, learning the Zone System can be well worth the effort. And it is nowhere nearly as time consuming to apply in practice as has sometimes been implied. Although the principles of the Zone System are now summarized, those who wish to use it are urged to work from the original sources, given in the Bibliography.

The basic premise of the Zone System is that, from knowledge of the capabilities of the photographic medium, and of his or her own chosen view of it, the photographer *previsualizes* the final print from the appearance of the original scene, before taking the photograph. Previsualization (which is discussed at length in Chapter 16) requires a full understanding of the relations between and among all portions of the process, from the first look at the subject matter right through to the completion of the final print. This is really no more than asking you to understand what you are doing—and indeed, all other photographic exposure methods involve the same series of understandings. But because they are likely to be less clearly worked out, they are likely to be less reliably successful.

The Scale of Zones

For ease of understanding and convenience of operation, in the Zone System the actually infinite series of tones in a black-and-white photograph are divided into 10 zones. The first, representing dead black in the print (no exposure of the negative), is called Zone 0 (zero). The others are designated in Roman numerals, from Zone I (the threshold of negative exposure) through Zone IX (dead white in the print). The zones represent one-stop exposure differences, and each zone represents the standard appearance in the gray scale of a common type of subject matter, as shown in Table 6-3. See also Figure 6-24.

If exposure and development are worked out correctly, the 10 zones in the negative will just fill the reproduction capacity of the normal grade of printing paper.

(In the latest version of his books, *The Negative* and

Table 6-3 Zone System print values

Zone 0	Dead black (film base + fog) in the print
Zone I	Exposure threshold of the negative, pure black in the print
Zone II	Textured black
Zone III	Black clothing, to show creases
Zone IV	Shadows in sunlit landscapes, portraits; dark foliage
Zone V	Middle gray (the tone of a standard 18% gray card)
Zone VI	Average Caucasian skin tone; shadows on sunlit snow
Zone VII	Snow in grazing light; very light skin
Zone VIII	Lightest differentiated tones
Zone IX	Pure white (of the printing paper base)

The Print, Ansel Adams expanded the scale of zones to 11; however, the 10-zone scale is very well established, and so far very few seem willing to go along with this expansion. Therefore, I will retain the 10-zone scale here.)

Coordinating Exposure and Development

The fullest use of the Zone System requires the use of sheet film, so that each exposure can be developed separately. Why? Because varying the development time allows the scale of grays in the negative to be expanded or contracted. Thus, a scene whose basic contrast range is, for example, six stops, can be expanded through corrective development to fill the tonal range of the print to seven or more zones. Conversely, a scene in which the metered brightness range exceeds the normal can be contracted by development to fit into the printing zones as desired. When the image is previsualized, and after it has been carefully metered, an exposure is chosen that is coordinated with the intended development, for a negative is always a function of *both* exposure and development.

In the Zone System, exposure and development are linked for two purposes. One is to expose a given subject luminance (light-intensity) value so that it appears as a previsualized tonal value in the print. The second is to develop the negative so that all other subject luminance values will be compressed or expanded to just fill the full tonal scale of the print, as previsualized. (It is understood that the photographer may choose to allow high- or low-zone tones, or both, to print as white or black.)

It is assumed in this theory that:

Zone

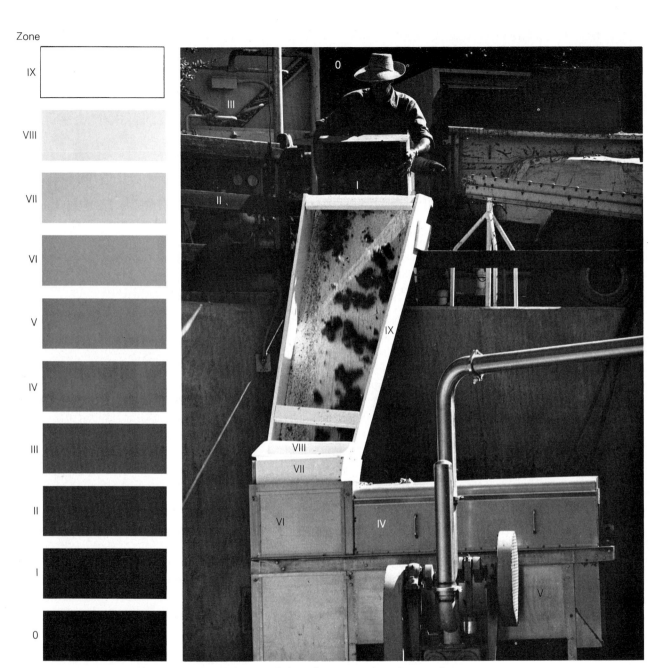

Figure 6-24 In the Zone System the virtually infinite gradations of gray tones in a photograph are keyed to 10 exposure zones, labeled zone 0 (total black showing no detail) through zone IX (dead white). In this photograph, of premium grapes being put into a crusher at a small winery, the major print values are related to the 10 zone gray scale. Photo by A. Blaker.

Figure 6-25 *Abandoned gun emplacement, San Francisco,* 1963, by James Hendel, a study in lines and masses. This photograph was made using the Zone System of exposure. Exceptionally careful control of exposure was necessary in this very contrasty lighting. Photo courtesty of James Hendel.

1. In the finished negative the intended Zone I will represent, as nearly as possible, the exposure threshold of the film.

2. Zone I in the negative will appear as Zone I in the print.

3. Your chosen subject luminance value will then appear at the previsualized printing zone.

4. All other subject luminance values will then fall as they will in the print, subject only to generalized contrast control through development, as in step 2.

With roll film, it is of course not possible to develop each exposure separately. Using single sheet films, it might be possible to aim at printing all negatives on the same grade of paper. But with roll film the options may be more limited, and so more use of different grades of printing paper may be required to substitute in part or whole for the lost control over variability of negative contrast. Other things being equal, then, it may be an advantage in 35 mm work to load and use special short rolls to simplify matters. In short, with roll films exposed by the Zone System, one of two methods must be followed:

1. You must restrict the photographic contents of any given roll of film to a single development requirement,

 a. by changing to scenes of varying subject contrast only when changing to a new roll of film, or

 b. by using interchangeable camera film backs (or separate cameras), if available, with the film in each designated for a specific development, and the back to be used selected for each exposure according to the subject's range of luminance values.

2. Or you can develop so that the 10 zones of the single most contrasty scene will be compressed, as a group, to no more than the full range of a given grade of printing paper—and then use the higher contrast graded papers to allow for the existence of lower negative contrasts in the remaining pictures. (This second choice is little more than is normally done when the Zone System is not used at all.)

Developing films to expand or contract the overall tonal scale in the negative requires first that a "normal" development time be determined for each type of film to be used. The recommended method of doing so is to photograph an evenly lit 18% gray card, reading your meter so as to place it at Zone V. Develop the film according to the manufacturer's instructions, with the developer of your choice. Print this resulting negative on normal-contrast paper so that the Zone 0 area (an adjacent blank frame on roll film, or an unexposed area on a sheet film) is exposed, in the contact frame or under the enlarger, just long enough so that it just barely prints to a maximum black for the given paper. Make a graded series of print exposures, test-strip style as described in Chapter 11, to be sure of getting an accurate exposure time. At this exposure time, print the image of the 18% gray card. After processing and drying, this resulting gray tone should match that of the original card. If it does not (and it probably won't), the film development time must be altered. If the print appears too dark, increase the time; if too light, decrease it. Repeat as necessary until you obtain a match between print and gray card. Things will be speeded up and accuracy increased if a number of sheets or rolls of film are exposed in one session, all identically, and the films held for processing at various development times, according to need. After establishing the "normal" development time, hereafter referred to as "N," you are prepared to undertake plus and minus development, to achieve contrast control by expanding or contracting the tonal scale.

To *increase* negative contrast by one zone (for instance, so that a five-stop contrast range will print as six zones of print values), develop $N + 1$. This is equal to the normal developing time *multiplied* by 1.4, or 40% more than normal. To increase print contrast by two zones, develop the negative to $N + 2$, by multiplying the $N + 1$ time by 1.4.

To *decrease* negative contrast by one zone (for instance, so that a six-stop contrast range will print as five zones of print values), develop $N - 1$. This is equal to the normal developing time *divided* by 1.4. It is not recommended to process below $N - 1$ unless special techniques are used, but two-bath development will allow minus processing as far as $N - 4$. (See Dowdell and Zakia, *Zone Systemizer*—in the Bibliography—a booklet and dial calculator combination, for one of the clearest accounts of plus and minus development.)

The Zone System can be used satisfactorily with any negative material, including color negative film and Po-

Figure 6-26 *Chicago,* 1960, by Aaron Siskind. Although, like much of Siskind's work, this photograph is simply a study of markings on a wall, by a kind of abstraction from reality it becomes a well-ordered composition of tones, textures, and visual masses. If the full tonal range of such a subject is to be carried into the print, correct exposure is essential. Photo courtesy of Aaron Siskind.

laroid Land materials. With Polaroid films, the plus and minus development procedures are somewhat less cut-and-dried, because the "normal" development time is affected by the ambient temperature. Since development is done not in a darkroom but wherever photographs are made, this temperature may vary uncontrollably over a considerably range. (See Ansel Adams, *Polaroid Land Photography,* in the Bibliography.)

African storyteller, 1946, by Nat Farbman. A beautifully lit, well composed photograph that effectively conveys the role of the storyteller in traditional society. Photo courtesy of N. R. Farbman, Life Magazine, © 1946 Time, Inc.

7
Lighting

ight is the very substance of photography, and its knowledgeable use is the basis of the photographer's craft. Light reflected from the subject is formed by the camera lens into an image, and the light of this image excites the chemical changes in the film that themselves become visible in light once the film is processed. In this chapter we examine different methods for applying light to a subject. We also consider the photographic qualities of light from different sources—natural, existing artificial, continuous artificial, and flash.

Lighting Contrasts

It is through the contrasts in lighting that we perceive the forms of things so readily: the play of light and shadow across an uneven surface, such as a human face or a landscape, determines our ability to see the shapes and textures of what lies before us. Contrast also affects exposure, as we saw in Chapter 6: unusually high or low lighting contrasts can affect the choice of film, exposure, and processing. Thus, controlling lighting contrast is of great importance in photography.

Variables of Contrast Effect

The harshness or softness of lighting contrast can depend on several variables, which are: the angular spread of the illuminating beam; the relative sizes of the light source and the subject, and the distance between them; the presence or absence of reflecting surfaces or secondary light sources near the subject; and whether the atmosphere is clear or hazy.

Figure 7-1 Variations in natural lighting. Above. *Dolls on the deck*, by Elizabeth Blaker. Direct sunlight coming from beyond the subjects provides naturally contrasty lighting with good modelling of three-dimensional subjects. Right. *Vedanta Society building, San Francisco*. The lighting is quite low in contrast on the shady side of this sunlit building.

A beam of light with a narrow angular spread produces harsh contrasts, whereas a broad angular spread produces somewhat softer contrasts. Dim, low-intensity lighting is sometimes seen or interpreted as being soft—that is, low in contrast—but this is not necessarily so. If the light comes from a small, distant source—a lightbulb, a window, or the like—it can produce quite a harsh lighting effect in which there is considerable contrast between light and shadow; for relative distance and size contribute to the apparent angular spread of a light source. The same light source, close up, would *appear* much larger, as perceived from the subject position, and would therefore give a softer effect of lighting. For in-

stance, the light-emitting head of a small electronic flash unit might be considerably larger than a small subject such as an insect or flower. When held very close to the subject its lighting effect would be similar to that of a large skylight (as used in some studio photography). But if it were moved a few feet away, as for normal flash photography of people, it would become virtually a point source, and consequently would substantially increase the lighting contrast.

When there are surfaces near the subject such as light-colored walls that reflect light into shadowed areas, overall lighting contrast is reduced. Nearby secondary light sources also tend to "fill," or lighten, the shadowed areas.

Figure 7-2 Captain Jacques Costeau and campus diving officer Lloyd Austin at a press conference at the University of California, Berkeley. The "chalk-and-charcoal" effect resulted when one of two television lights was turned off during the interview. Photo by A. Blaker.

And a hazy or dusty atmosphere, in which light is scattered by being reflected from airborne particles, makes even direct sunlight softer than it will be in crystal clear air, as on a winter's day or at high altitudes.

Directionality of Lighting

When we look at an object or scene, the direction of the light falling on it has a strong effect on our impression of contrast, and thereby on our impressions of form and texture. Direct frontal light—light falling on the subject or scene from the approximate direction of the viewer's line of sight—grossly lowers the apparent contrast, because shadows are being thrown only in places that the viewer cannot see. It is as if there *were* no shadows, no matter how harsh the overall lighting contrast would be if the subject were seen from other angles.

Lighting from a broader angle—from more to one side of the viewer—increases the apparent contrast; the harshness of contrast increases as the angle broadens. Light coming from an angle of 90 degrees to the viewer's position may have a "chalk-and-charcoal" effect: one side is brilliantly lit, and the other is a black shadow (see Figure 7-2). Backlighting, light directed toward the viewer from somewhere behind the subject, is characteristically extremely contrasty; the light is deflected toward the viewer, or camera, either by reflection from the edges of the subject, or by refraction from peripheral matter

pher's complete control, or it may be partially or entirely outside of it. Photography by artificial light, particularly color photography, must take into account the color of the light.

Color Temperature

All color reversal, or transparency, films are designed to be used with light sources that are calibrated for color balance, as measured by *color temperature:* that is, the predominant wavelengths of light emitted by an incandescent source. Incandescent light sources are those in which light is produced by heating a substance until it glows. The sun and filament-type light bulbs are incandescent sources. At different temperatures, different wavelengths of light—and therefore different colors—predominate. The *Kelvin temperature* of the light, as it is called, is derived from the Celsius temperature (formerly called centigrade and still abbreviated as °C) of the source by adding 273 to the Celsius temperature, which yields its Kelvin temperature, a scale of temperature measurement used by physicists. In photographic usage this temperature is written as so many "degrees Kelvin" or "°K."

Color Films

It is not possible to make a color film that yields correct-appearing colors with any and all light-source temperatures, so color films are made to match one of several standard light sources. The common color film types are Daylight (optimized, or "balanced," for a source temperature of about 5500°K), Type A (balanced for lamps that burn at 3400°K), and Type B (balanced for lamps that burn at 3200°K). If a color film must be used with an incandescent source other than the one for which it is balanced, correct-looking results may be obtained by using correction filters, as specified by the manufacturers of films and filters. (Such filters are described in detail in Chapter 8.) For accurate color rendition, then, you should use a film matched to the light source or filtered for correction to it. You cannot mix light of two color temperatures (say, daylight and tungsten sources) in one picture without badly upsetting the accuracy of the color reproduction. Also, color temperature theory in photography does not apply to fluorescent lamps, because their light-emitting phosphors have no true correspondence

with color temperature. For these sources, see the partial remedies described in Chapter 8.

Color negative films should also be used with due regard to color temperature, where possible. Although color balance can be corrected to a remarkable degree in the printing process, it is still theoretically best to use correct color temperature controls when taking the photograph. Moreover, if correct color rendition is a primary aim, it is no more practical to mix light of different color temperatures in a single color negative than it is in a color transparency.

None of this applies when color accuracy is not the important question. It is possible, by mixing sources of different color temperatures, by deliberately mismatching films to light sources, and by using odd and peculiar color filtering, to arrive at striking color effects. But to do it well you must understand the underlying principles. (See Color Plate 17 in the color section. See also the Color Printing chapter.)

Black-and-White Films

Although color temperature normally receives little attention in black-and-white photography, it nevertheless affects the film's tonal response. For instance, in daylight (color temperature about 5500°K), most panchromatic films reproduce relative brightnesses most accurately when a medium-yellow (for example, Wratten 8) filter is used. Photographing by tungsten or fluorescent lighting without a filter will subtly affect the rendition of relative brightnesses. Whether this is important is for each photographer to decide. The upset in tonal relations is usually too subtle to notice in black-and-white photography, but knowing that it can happen may give you a clue about what went wrong.

Existing-Light Photography

Photography by existing light, artificial light that is not under the photographer's direct control, produces some of the best pictures made each year—and many of the worst. It is perhaps the area of photography that most requires strong knowledge of the limitations of the medium. Unless you can previsualize (a process discussed in Chapter 16) particularly well, you will be held to purely chance successes.

Figure 7-8 *Nude with black stockings,* by Richard Oritt. This fine figure study is an excellent example of soft but directional natural lighting. The strong lighting contrast results from seating the model rather far from the window. Along with an unusually low camera angle, this lighting creates a graphically striking pattern of light and dark areas, providing a pictorial mood suitable to the subject. Photo courtesy of Richard Oritt.

Figure 7-9 Laboratory portrait of Dr. John H. Northrop, winner of the 1946 Nobel Prize in Chemistry. The lighting was by existing window light only. Having the subject stand quite near the window kept the lighting contrast lower and less dramatic than in Figure 7-8, as was appropriate to the subject's contemplative pose and to the context. Photo by A. Blaker.

Existing light—both indoors and outdoors—is notorious for being both dim and excessively contrasty. Outdoor lighting in public places is usually spotty. Various light sources are used in outdoor lighting, either alone or in combination with others—incandescent, fluorescent, mercury vapor, sodium vapor, and so on. Interiors of public and private buildings are also the despair of the careful photographer who is looking for easy good results. Lighting often occurs in pools, widely separated, or is so flatly even—especially in the many rooms lit by multiple fluorescent fixtures—that any striking pictorial effects are virtually impossible. But all this variety can

be a great challenge. There are no definite instructions for handling this sort of lighting, except perhaps to use a handheld meter to measure the light as accurately as possible, and to use your imagination.

Controlled Artificial Lighting

When you are in complete control of artificial lighting, as in studio work, you are really on your mettle, for there are no excuses for failure. Control begins with using the right types of lighting equipment. There are several types among which to choose.

Types of Lights

Lights for controlled artificial lighting are of three types: spotlight, floodlight, and light bank. Spotlights have a very narrow angle of beam spread, which is often adjustable. The simplest form of spotlight is the nonadjustable reflectorspot, a sealed-beam unit with a built-in condenser lens and reflector. More complex adjustable spotlights are built somewhat like a slide projector, use projection lamps (usually of a type that burns at either 3200 or 3400° K so as to balance to Type B or Type A color films), and have one or more condenser lenses that can be focused to widen or narrow the beam.

Floodlamps usually consist of an incandescent bulb mounted in an approximately parabolic metal reflector that throws a broad beam of light, typically with a beam spread of about 60° but sometimes as wide as 100°. A number of types of incandescent bulbs are used in floodlights; beginners will most commonly see the 500 or 1000-watt bulbs called photoflood bulbs. At rated voltage (115 V), these burn at 3400° K and are balanced for use with Type A color films. Sealed-beam reflectorfloods (constructed like reflectorspots) are also available. More sophisticated floodlights, offering a longer burning life at somewhat higher cost, use tungsten-halogen lamps, usually made with a quartz envelope instead of glass. There are many types of these that burn at either 3200 or 3400° K.

A light bank consists of several lights mounted in a rectangular array with a diffusing screen of some translucent material placed in front to make the array appear to be a single large light source. The light produced by it is like that of a skylight. Light banks can consist of a tightly packed row of fluorescent tubes or an array of incandescent bulbs of the photoflood type. Because their light is cooler, and because they are electrically very efficient (a bright light is produced with relatively little power input), fluorescent light banks are excellent for black-and-white photography. They are not recommended for use with color films because of color temperature problems.

Lighting Balance

The essence of controlled lighting is balancing light intensities, to carefully grade highlights and shadows so as to reveal detail and pictorially balance light and dark areas. Whereas with a single unmodified light source you can control contrasts only by altering the lighting angle, a second source, whether it is a lamp or simply a reflective surface, adds a tremendous degree of control over lighting contrasts. You can light evenly from two or more directions to obtain low overall contrast, or you can vary the lighting ratio to vary the contrast.

Lighting can be balanced by eye—that is, by judging the relative light intensities visually. A person who is well experienced in making such judgments can exercise very exact control—perhaps as much control as with any other methods, such as the ones described in this chapter. For however you work, the final results depend on previsualization; and if you can previsualize well you can probably also judge actual lighting well. The ability to do both is a product of analyzed experience. You must look carefully at the subject, decide upon and set up what you deem to be suitable lighting, and then critically examine your final result to assess your success or failure.

Light balance is usually a proportional matter. You simply balance to a known lighting ratio. There are two ways of working out lighting ratios: by adjusting relative lamp-to-subject distances and by metered measurement. Table 7-1 contains basic information for both approaches. The variable lamp-to-subject distance method requires understanding of the *inverse square law:* Because light from a light source of relatively small size radiates equally in all directions, the same amount of energy must cover an ever larger area as the distance from the source increases. Therefore, its delivery of energy to a subject decreases as the distance between subject and light source increases. The inverse square law states that this dimin-

Figure 7-11 *Ernest Hemingway,* by Yousuf Karsh. An example of triangle portrait lighting, done in the distinctive Karsh manner. The ratio between main light and fill was about 1:3 or 1:4. Additional lights came in from above and behind to delineate the hair and the shoulders. Photo © KARSH.

Figure 7-12 Small objects photographed with artificial lighting for catalogue illustration. Left. Eskimo doll made circa the 1930s by Ethel Washington of Kotzebue, Alaska. Because the doll is a portrait of an actual person, it was photographed with portrait lighting. There was an undiffused main light to the right and a little above, and a diffused fill light just to the left of the camera, with a lighting ratio of about 1:2. A view camera picture. (From the Kriger Collection. Reproduced courtesy of the Alaska State Museum, Juneau.) Right. An Oriental ivory carving; a tabletop picture, the subject being only 103 mm tall. It was lit by a high-intensity desk lamp placed above and to the left. A piece of white paper on the right served as a reflector to fill in the shadows and delineate the shadowed edges. An essentially colorless subject must have a moderately strong lighting contrast if sculptural detail is to show, but if a black background is used, the darkest edge tones must be sufficiently lighter than the background to avoid blending with it. Photos by A. Blaker.

If your flash unit has a calculator dial you need not go through all that. To figure a new guide number, or to obtain a guide number for a unit whose instruction book is missing, simply follow these steps:

1. Set the ASA film speed on the calculator.
2. Look for the f-number opposite the 10-foot distance mark.
3. Your guide number is equal to the f-number times 10.

When flash bulbs are used, guide numbers vary with the camera shutter speed as well as with the film speed, because in effect the shutter chops the basic light output into segments. Thus, the manufacturer of the bulb provides a table of information, printed on each package of bulbs.

Note that a guide number is just that—a guide. Guide numbers are usually calculated on the assumption that the full rated output is being received from power cells, and that subject distance is greater than about three feet. Using a flash unit under circumstances other than those assumed in the calculations—such as in an unusually close approach to the subject or when you have weak or worn out power cells—may render this information inaccurate as a guide. Do not be too quick to blame the manufacturer for poor results. Look first for conditions that differ from the standard, and correct them.

Calculating the Exposure

Once the guide number of the flash source is known, exposure calculation is simple. Measure, or estimate, the flash-to-subject distance, in feet. Although this distance need not be the same as the camera-to-subject distance, you can use the focusing scale of the camera as a rangefinder at normal distances. Then divide the guide number by this measured distance. The result is the f-number that will yield a correct exposure, assuming that the subject matter has normal reflective characteristics. Again, let us formulate it and provide an example (Formula 7-2).

If you decide at this point that a greater (or lesser) depth of field is needed, you can determine the f-number needed, and then reverse the formula. For an example,

Formula 7-2 Calculation of flash exposures with guide numbers (Solving for f-number)

Symbols	Definitions	Examples
GN	Guide number	45
FD	Flash-subject distance	8 feet
f	f-number	? (unknown, to be calculated)

$$f = \frac{GN}{FD}$$

$$f = \frac{45}{8}$$

$$f = 5.6$$

To use a pocket calculator, punch in as follows:

$$GN \oplus FD \ominus f$$

$$45 \oplus 8 \ominus 5.6$$

In either case, set the lens at f/5.6.

Formula 7-3 Calculation of flash exposures with guide numbers (Solving for flash distance)

$$FD = \frac{GN}{f}$$

$$FD = \frac{45}{11}$$

$$FD = 4 \text{ feet}$$

To use a pocket calculator, punch in as follows:

$$GN \oplus f \ominus FD$$

$$45 \oplus 11 \ominus 4 \text{ feet}$$

use the same terms, assume a need for f/11, and use Formula 7-3.*

* The metric system of measurement, in which the standard unit is the meter rather than the foot, produces different guide numbers. Referring to the calculator dial on a metrically calibrated flash unit, you can obtain a guide number by multiplying a given distance in meters by the f-number shown opposite that distance when the film speed is appropriately set. (Keep in mind that in countries using the metric system the film speed may be listed in the DIN system or some other system.) As an example, if a film of ASA 400, or DIN 2°, is used, the guide number would be about 200 in the American and English measuring system, but about 66 in the metric measuring system. It matters only in how you work it out, however; the exposure will come out to be the same.

If you are using an electronic flash unit that has a dial calculator on it, exposure calculation is very easy, since the calculator is direct reading. Simply set the speed of the film being used and, to find the correct f-number, look opposite the proper distance mark. No arithmetic is necessary. To find the flash-to-subject distance without calculation, reverse the process and use the distance that appears next to the desired f-number.

Automatic Flash Exposure

Many modern electronic flash units incorporate a sensing and electronic-feedback system that, within limits, permits flash photography without the need to calculate exposures. When such a unit is triggered it emits light, which travels to the subject and is reflected back toward the camera, just as with ordinary flash units. But this reflected light is recorded by a light sensor; when enough light has been emitted to produce a correct film exposure, the flash emission is cut off by the feedback circuit. This is a singularly convenient way to do correctly exposed flash photography.

Successful flash photography with automatic flash units requires several conditions:

1. The lens aperture must be set to a stated f-number (or, with the more complex units, to one of several) for a given film speed.
2. The flash unit must be placed within a given distance range from the subject; this range is specified for the f-setting and the film speed. Units that allow the use of varied lens aperture settings will have a distance range specified for each setting at each film speed.
3. The sensor must be placed where it will pick up the light that is reflected toward the camera. If the sensor is unit-mounted, the flash unit must be close to the lens axis to receive the reflected light properly; some units have a "remote sensor," an extension cord for the sensor, so that you can place the flash unit anywhere you want and still sense the reflected light properly.

Automatic flash units work in either of two ways. The earliest type simply read the returned light and quenched the flash tube, electronically dissipating the unused electric pulse from the capacitor without passing it through the flash tube. In the more recent units when the sensor signals the light emission to stop, a secondary circuit triggers a thyristor (a type of electronic switch) that cuts off the flash emission without further draining the capacitor. This conserves the unused electrical energy for use in the next flash exposure. Because the capacitor is thus already partly full, the unit can be more quickly readied for the next picture.

There are significant advantages to using automatic electronic flash units, even though they cost more than conventional units. First, f-setting and flash-to-subject distances need not be calculated in advance for each picture. Second, when thyristorized units are used at less than maximum feasible distances, the flash duration is shortened and the effective exposure time of the film is correspondingly shortened, increasing action-stopping ability. From a normal maximum duration of about 1/1000th of a second it can shorten to as little as 1/50,000th of a second at maximum quench, the exact figure depending upon the make and design. And because shorter flash durations conserve electricity, recycling times are consequently shorter, and batteries last longer.

There can be problems, of course. Automatic electronic flash units do not have an analytical, problem-solving brain; the photographer must provide that. If the main subject is only a small portion of the picture area, or of the area sensed, and is in the midst of a much lighter or darker area, there will be considerable under-exposure or overexposure, respectively, because the sensor will have tried to average out the light reflected from both subject and background. So you will have to make a correction. A few of the latest automatic units have a provision for "dialing in" a correction, but many do not.

A second problem may occur when automatic flash units are used at very short flash-to-subject distances, when flash duration is shortest—perhaps as short as 1/50,000th of a second. Such durations are excellent for stopping very fast action, but they also present the danger of reciprocity failure. If pictures so made seem a little underexposed, this is a possible cause. To correct, you may have to open up the lens aperture a little more than the manufacturer indicates.

Automatic-feedback electronic flash units, and particularly the fully thyristorized models, work very well in most photographic situations, as long you follow the manufacturer's instructions and frequently review those instructions to become fully informed about your partic-

Figure 7-18 Failure to synchronize electronic flash with a focal-plane shutter. The shutter speed, 1/250th of a second, was too high. The slit in the shutter curtain exposed only a portion of the film to light from the lens during the 1/1000th second duration of the flash.

Flash Lighting Methods

The use of flash lighting differs from the use of continuous lighting in that you cannot directly see the effects that you are creating, because they are by nature fleeting. Therefore, you must learn ways of assuring that your pictures will display the effects that you want.

Previsualizing Flash Lighting Effects

With a stationary or nearly stationary subject, there is a simple way of predicting the fall of light from flash sources. When you have decided where you want the light to fall, close one eye and move around until you can see only those parts of the subject that should be directly lit. As we have seen earlier, if you then place the flash unit where your eye was and expose, you will find in the final picture that everything you could see is lit, and everything you couldn't see is in shadow (for light travels in straight lines).

After doing this for a few practice runs you should find it possible to dispense with this makeshift method. You will then be able to place your light quickly and quite accurately without trials, except when placement must be extraordinarily accurate.

You can also teach yourself to be aware of and actually *see* the flash lighting effect. Just take advantage of your eye's natural lingering image. When your eye sees a flash exposure, it does not instantly fade from your retina, but lingers for a brief period. To use the lingering effect, flash the unit manually while you are looking at the subject. Concentrate, and be sure not to blink. You will be able to see the image well enough, even with high-speed flash units, to determine if the light fell as you wanted it to. This method works best if the surrounding continuous lighting is relatively dim.

Bounce Lighting

The harshness of off-camera flash is most often tempered by bouncing the light off a suitable reflecting surface. The resulting light is directional but soft and often pleas-

ant. Contours and surfaces are well modeled, shadow lines are indistinct, and shadow areas reveal detail. Background shadows are lighter and less disturbing to the eye.

The method used can be varied. The simplest technique is to use an existing light-colored wall or ceiling as a reflecting surface. A more versatile method is to use an umbrella with a white or silvered interior. The flash unit is pointed into the interior of the umbrella, and the umbrella handle is pointed toward the subject, from the desired lighting angle. This method requires a fairly strong flash unit because some light is dissipated and thus lost, as we will see. The primary advantages of umbrella flash are that you need not depend on the presence of a reflecting surface, or be subject to problems relating to the color of that surface; and, no matter what the lighting angle, you can place the umbrella so as to get maximum efficiency from the bounce lighting.

Bounce flash affects exposure calculation in two ways. First, unless you are using an automatic flash unit with a remote sensor pointed at your subject, you must consider the flash distance as extending from the flash unit to the reflecting surface, and from that surface to the subject. The flash-to-subject distance is the sum of the two, as shown in Figure 7-19. This obviously results in a longer than normal flash distance, and therefore a wider lens aperture, all other factors remaining equal.

The second exposure calculation problem is that the reflecting surface, because it also acts as a diffuser, diminishes the light intensity considerably. The light loss is equal to about two stops—depending on the surface, it could be slightly more or less. Allowance must be made for this effect in the final exposure calculation, or the picture will be hopelessly underexposed.

Other than light loss, the primary pitfall in bounce flash is the possibility of significant color in the reflecting surface. If that surface is noticeably tinted, light reflected from it will be similarly colored. It does not take very much tinting to destroy color accuracy.

Bounce flash with automatic flash units is self-correcting as to exposure, if the unit is so constructed that the sensor can be pointed toward the subject, from close to the camera position, while the light-emitting flash head is pointed toward the reflecting surface. For this reason, it is useful to have a unit with a jointed head, as shown in Figure 7-19B. Or the sensor could be located remotely,

at the end of a special extension cord. (Some units offer both alternatives.)

Diffused Lighting

As with continuous artificial light, flash lighting effects can be softened by placing a diffuser between the lamp and the subject. Wrapping a layer of thin white cloth or tissue paper around the flash head, an oft-recommended method, produces almost no effective diffusion, since the light source remains unchanged in its apparent size. For useful diffusion, hang a large sheet of white tracing tissue between the flash unit and the subject (as was recommended for continuous lighting sources, earlier). The control of contrasts offered by this method depends on the relative size and position of the diffusing sheet, which may be hard to keep stable outdoors if there is any wind.

Diffusion lighting methods always require increased exposure. A large sheet of tracing tissue placed between lamp and subject absorbs about two to three stops of light, depending on the relative positions of subject, diffuser, and lamp. In such situations, a flash meter would be useful, as would an automatic flash unit with a remote sensor positioned next to the camera lens.

Balanced-Ratio Flash

All of our flash calculations so far have ignored the ambient light and have been based solely on the effect of one flash source. Balanced-ratio lighting allows you to set up known lighting contrasts using two or more sources, one of which is a main light, the others, called fill lights, cutting shadow contrasts to printable levels. This technique allows great flexibility in choosing the basic lighting angle, and makes possible genuinely creative lighting effects. With this method two or more flash units can be used together, or one or more flash units can be balanced to one or more other light sources, such as sunlight or tungsten lights. Using one flash unit as a subsidiary source to lighten the shadows of a sunlit subject is called "fill-in" or "synchro-sunlight" flash, and is a commonly recommended technique. Of course, fill-in flash can be done in conjunction with any steady light source. "Balanced-ratio" is a more general term for a

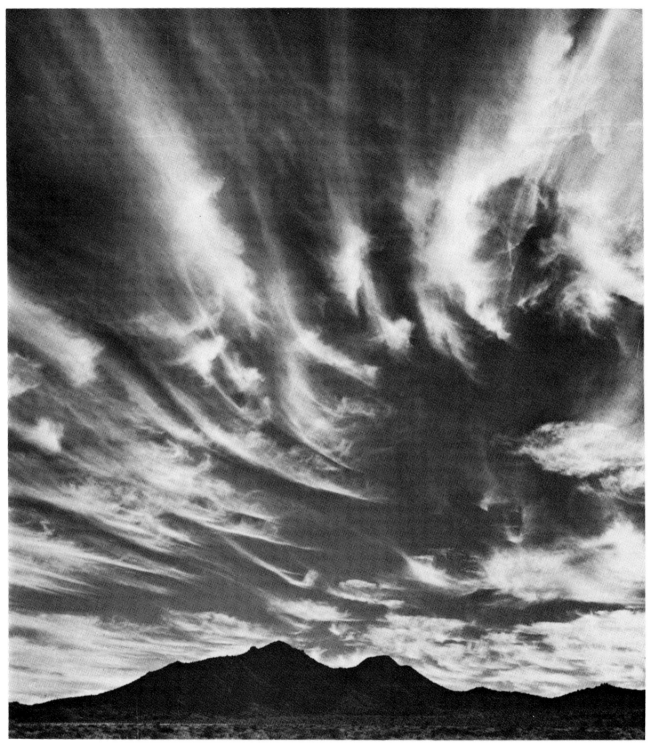

Landscape with clouds, by William A. Garnett. Much of the splendor of this photograph depends on the interplay of clouds against the sky. This essential contrast was brought out by a color filter, which darkened the sky. Photo courtesy of William Garnett.

8
Using Filters

As we saw in Chapter 6, light acts in two distinct ways in photography. When it strikes the film it behaves like a stream of particles (photons). But before it strikes the film, while it is passing through the lens or other transparent materials, it displays a wave motion. Visible light is a continuous spectrum composed of different wavelengths. In the visible spectrum, which is only a portion of the larger electromagnetic spectrum, we perceive the different wavelengths as different colors. Although light from a source such as the sun seems to be free of color and is therefore called white, it is in fact composed of all wavelengths of the visible spectrum, that is, of all colors. These differing wavelengths (or colors) as well as certain other wave characteristics, can be distinguished among by the use of filters.

Filters are translucent devices placed so as to transmit light selectively, with respect to color, wave motion, or amount, in order to affect the film in predetermined ways. In the following sections we examine in some detail the nature of light and filtration, and some of the methods of using filters in general photography.

Optical Nature of Filters

By nature, all filters are subtractive. That is, they remove some of the light passing through them and thereby modify what happens to the film during exposure. How they do so is determined by their absorptive and reflective character, and by their refractive capacity.

Figure 8-1 A. The electromagnetic spectrum. B. The visible-light portion of the electromagnetic spectrum.

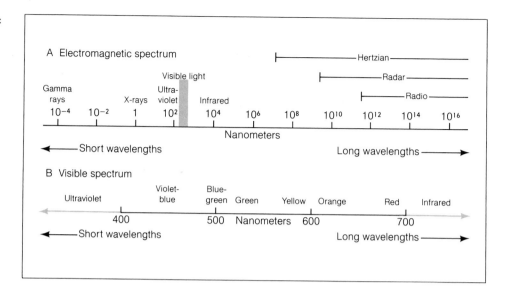

Figure 8-2 Radiation, including that of visible light, is emitted in wave form. A. Wavelength is the distance between two peaks or two wave troughs. B. Each color of visible light has its own wavelength.

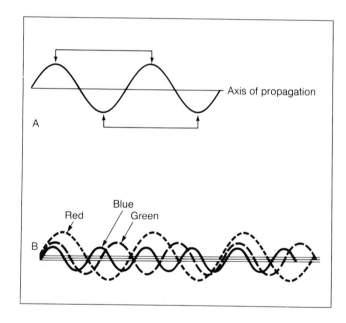

Color Effects

Filters that are visibly colored discriminate among wavelengths, by transmitting some and absorbing others. In subtractive color theory, the white light of the visible spectrum is divided into three sections: blue, green, and red. In this system yellow filters absorb blue light, green filters absorb red and blue light, and red filters absorb

blue and green (see Figure 8-3). In an outdoor scene photographed in black-and-white, a yellow filter over the lens will cause the blue sky to appear darker in the final print. Absorption of blue light will allow less exposure of the film in areas of blue sky tones. Therefore, the negative will have less density in those areas, and thus the print will be darker there than in areas of different color less affected by this filter. This selective absorption

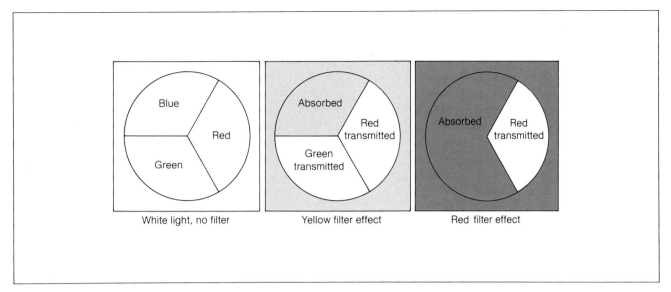

Figure 8-3 Color absorption by filters.

Filter Factors

of light is the basis for filter choice in all of the filter uses described in this chapter, except for polarization and neutral density filtering.

Since filters work by subtraction, it naturally follows that the use of filters carries with it an exposure penalty. The only exception is the ultraviolet-absorbing filter: since the radiation being absorbed by a UV filter is ultraviolet, and is not being significantly measured by most light meters, little or no exposure compensation is needed when using ultraviolet-absorbing filters. This penalty, however, is not entirely due to light absorption by the filter. A portion of it comes from the reflection of light from filter surfaces. Thus, the light transmitted by a given filter is the light that is neither reflected nor absorbed. The amount of light reflected from a surface of a filter is small in the center, but slightly larger at the edges, due to the different angles of incidence of the light rays involved. The difference is unimportant if only one filter is in use, but could become a problem if filters were "stacked."

The use of filters necessitates an increase in exposure to compensate for the light that is not transmitted by the filter. This exposure compensation is usually done by computing from a *filter factor:* a number related to the effective decrease in exposure caused by the particular filter. The numbering system follows the doubling plan of other exposure compensation methods, reflecting the fact that a one-stop difference in exposure either multiplies or divides it by two. Thus, a filter factor of 2, for example, requires doubling the exposure (opening the diaphragm by one stop, or slowing shutter speed by one stop); a factor of 4 requires four times as much exposure (opening up two stops, slowing the shutter two stops, or doing one of each). Or you multiply the exposure time calculated with your meter by the filter factor. Table 8-1 lists the degree of exposure change needed for various common filter factors. There are different factors for different light sources such as daylight and tungsten lighting. Since the percentage of the various wavelengths present in the light differs, the filters do not transmit the same percentages. You may have to make tests to determine the actual factors for given filters.

If you use more than one filter at a time, the filter factor is a multiple of the individual factors. Thus, if one filter has a factor of 2.5 and the other a factor of 4, the

Table 8-1 Exposure increases for common filter factors

Filter Factor	Number of Stops Exposure Increase[a]	Filter Factor	Number of Stops Exposure Increase
1.2	1/3	6	2 2/3
1.5	2/3	8	3
2	1	10	3 1/3
2.5	1 1/3	12	3 2/3
3	1 2/3	16	4
4	2	20	4 1/3
5	2 1/3		

[a] "Adjustments of less than a full stop should be made with the diaphragm, to approximate positions between *f*-number markings. Not all camera shutters will work correctly if set between speed markings.

combined factor will be 10. Using more than two filters, then, could require prohibitively long exposures.

Focus Shift

Filters of any considerable thickness present a minor focusing problem. They shift the focus of the lens by one-third of the filter thickness. Used in front of the lens they shift it toward the subject. In normal use this shift can be ignored, becoming significant only at close focusing distances, as in photomacrography.

The best solution to the focus shift problem is simply to make the final focus after the filters are in place, if it is possible. In high-magnification work it is best to avoid the problem entirely by filtering between the light source and the subject, rather than at the camera lens.

Optical Effects of Stacking Filters

Filters should not be "stacked"—that is, placed over a lens more than one at a time—for a number of reasons. Among these is the cumulative effect of one aspect of reflected light: light is reflected from surfaces according to its angle of incidence (i.e., the angle at which the light ray approaches a surface). When a light ray strikes a transparent surface—as when passing from air to glass—at the perpendicular, relatively little is reflected, but when it strikes at a lesser angle a higher percentage is reflected. With any one surface this effect is small, and it is not noticeable, in practice, with just one filter. But

if several filters are placed over a lens (each filter with two such reflecting surfaces) the resultant light loss upon exposure may become quite noticeable. Furthermore, there is a tendency for such light to be reflected repeatedly inside the filter, between its two surfaces. This light, now disturbed from its original image-forming path, may finally strike the film as internal flare that lowers image contrast. Because of the angles of incidence involved, these effects will be more noticeable with wide-angle lenses. Cumulative effects can be quite important.

Refraction of Light

Filters not only absorb light, they also refract or bend it. This has consequences that should be considered. Camera lenses are designed to operate best with no other objects between them and the subject. Filters placed in front of a lens can disturb the image formation. The amount and type of disturbance depends on the flatness of the filter, the parallelism of its surfaces, its thickness, and the accuracy of its placement in the optical path.

To a degree, a filter acts like an additional lens element. If the surfaces of a filter are not flat it indeed acts as a lens, bending the light according to the curvatures that are present, and definitely degrading the image. If the two surfaces are not parallel, it will act somewhat as a prism, dispersing light according to its wavelength. A glass filter also changes the focal length of the lens according to its thickness, tending to defocus the image slightly. Placing it in the optical path at an angle other than 90 degrees to the lens axis causes further image disturbances.

Desirability of Filter Use

Filters are not necessarily needed for every photograph; in fact, many if not most can be made without them with no loss. But if they are not used when needed, the quality of the picture will surely suffer. When first doing black-and-white photography, it is useful to look at your scene or subject through a succession of color filters to see whether any of them produces an apparent improvement in the separation of relative brightnesses. In scenic color photography, it is worth trying the use of a polarizing

filter to see whether it improves the rendition of the sky or whether it usefully cuts haze. In either black-and-white or color photography where there are reflections visible in the scene, it is worth checking to see whether the use of a polarizer will improve the picture. These points and others are covered in the sections to follow.

It may seem like a nuisance, at times, to dig out and use a filter, but, if it is correctly chosen, its advantages far outweigh the disadvantages. The following suggestions are worth adhering to:

1. A filter should be used *only* when it serves a positive purpose.
2. The type of filter must be properly chosen to suit that purpose.
3. At purchase, attention should be paid to quality of manufacture (cheap glass filters can be a poor bargain).
4. The filter must be correctly mounted on the lens.
5. With ground glass and reflex cameras, the final focusing should be done with the filter in place on the lens.

Choice of Filter Type

Filters are available as gelatin squares, gelatins cemented between glass, and glass filters. Gelatins might be the preferable color filter for most uses. They are so thin that optical problems are few. They will last quite long with ordinary care, and can be carried in large numbers with very little weight or bulk. However, they cannot be cleaned and can be easily damaged by fingerprints and scratching. Also, if you need to work in the wet, remember that gelatin is water soluble.

Cemented gel-glass sandwiches are both durable and cleanable, but they may break or separate if dropped, and if carried in quantity they may be noticeably bulky and heavy. Polarizing filters are nearly always in the form of glass sandwiches.

A few special filters are available only in glass with special qualities. In this case, there is no choice of type, except where the quality of manufacture or the thickness is involved. Only the best glass filters should be used, and they should be no thicker than necessary. To clean glass filters, lightly brush off all dust particles and then breathe on the glass and lightly polish it with a soft lint-free cloth or lens tissue—just as with lenses.

Color Filters with Black-and-White Films

The medium of black-and-white photography, viewed as art, puts a high premium on sheer photographic quality. Filters modify light in a wide variety of ways, and their correct and appropriate use is often what separates first-rate from mediocre photography, in both black-and-white and color. The following sections outline some of the appropriate uses for each of the major types of filters.

The major role of color filters with black-and-white films is to differentiate colors that would otherwise appear as the same tone of gray in a photograph. They also "penetrate" haze (by absorbing light scattered by airborne particles).

Relative Brightness/Contrast Effects

Black-and-white films, of course, translate the various colors of original subjects into shades of gray corresponding to the relative brightness, or reflective power, of those colors. There is no connection between a color, as it is perceived by the eye and brain, and the shade of gray that will be seen in a print except in relative brightness. Very frequently, two very different colors will reproduce as closely similar gray tones. For example, if photographed with no filter, a brown snail on a green leaf may blend with the leaf, if the two colors are of approximately equal relative brightness. Use of a green filter will darken the tone of the snail. The subject can thus be made to contrast favorably with its surroundings.

The photographer must learn to perceive colors according to their relative brightnesses, to relate these to the tone of gray that will represent them in a picture, and to know which filters will set them apart visually. The knowledgeable photographer can thereby emphasize or deemphasize almost any portion of a given scene or subject in which there are differing colors. Once you realize that you can and must learn to perceive colors as tones of relative brightness, you can learn to look through a given filter and accurately judge what its effect will be

Figure 8-13 Use of a polarizing filter to eliminate interfering reflections from a window. Right, no filter; below, polarizing filter, adjusted for maximum polarizing effect.

planes of polarization of the two reflections are parallel to the reflecting surfaces, only one at a time can be maximally absorbed by a polarizing filter. If the angle between the two surfaces is 90 degrees, the filter will be least effective for one reflection just when it will be most effective for the other, and vice versa. The best overall effect can only be partial.

Induced Polarization

Any material that can be used to absorb polarized light can also be used to induce polarization. Instead of using a polarizer only as a filter at the lens, you can use two—one to do the initial polarization of the light (the "polarizer"), and the other to make the effects visible (the "analyzer"). Either natural or artificial light can be polarized. Polaroid polarizing material is available in standard 16 × 20 inch sizes, and in other sizes by special order.

Reflection Control

Reflections can be eliminated from almost any surface if the incident light is polarized before it touches the subject. If natural light is used, interpose a sheet of polarizer between the source and the subject, being sure that it is large enough to cover the whole subject area. Place the usual polarizing filter on the camera lens, rotate it until the reflections disappear, and make the picture. If flash lighting is being used, and the angle of polarization of reflections can only be guessed at, line up the axes of the two polarizers. Most polarizers have the axis of polarization marked on them. If yours do not, look through them both while rotating one. At the point of maximum extinction of light the axes are at 90 degrees, as was shown in Figure 8-9. Mark the axes for future reference. The lamp polarizer axis should be at 90 degrees to the axis of the lens filter in order to gain maximum reflection control.

If you are going to use two light sources, both must be polarized. To align two such lamp filters visually, set them up separately. Place a polarizing sheet in front of one light source, and rotate the lens filter until all the disturbing reflections are gone, and turn off that lamp. Then turn on the second lamp. *Leaving the lens filter untouched*, rotate a second polarizing sheet over the second lamp until the reflections produced by that source are gone. Both sheets will now be correctly oriented, relative to the lens filter.

Reflection control using deliberately induced polarization is more versatile and complete than that done with light that has been naturally polarized by reflection. In this use the angle of the camera axis is not critical, as it is when neutralizing naturally polarized reflections.

It is not always desirable to eliminate every last trace of a reflection, or even to do any modification at all. Some reflections are desirable in themselves, for what they show and how they show it. If you are dealing with reflections that conceal detail on naturally wet or shiny surfaces, you may find it best only to weaken the reflection rather than eliminate it. By removing the impression of wetness or shininess, total elimination will alter the characteristic appearance of the subject. It may also be desirable to leave some trace of a covering transparent surface.

Exposure Compensation with Polarizers

Because polarizing materials are used both singly and in pairs, polarizers have two basic filter factors (more, if you combine unmatched materials). For commonly available materials, these are tabulated in Table 8-6.

Warning: The figures in Table 8-6 are the basic neutral density factors for polarizing material. They do not take into account the exposure effect of eliminating reflections on otherwise dark surfaces in the subject area. If important subject matter is in that area, exposure data may be measured using a handheld light meter, with a properly oriented polarizer covering its sensing cell. Or, with built-in meters of some types, exposure can be read with the correctly adjusted filter in place over the camera lens. Exceptions to this latter method are those cameras in which the meter is located behind a semitransparent mirror or wedge, as in certain Canons, Prakticas, and Mamiyas, and in the Yashica Electro AX, or the Leicaflex SL. With these cameras, use a separate hand held meter. Both of these methods eliminate the need to figure in filter factors. (These listed cameras are among those that require circular polarizers; if you use such a filter, you

Table 8-6 Exposure information for polarizing filters and sheet stock

Material	Maximum light transmission, percent		Filter factor (approximate)		Number of stops exposure increase	
	Singly	Paired[a]	Singly	Paired	Singly	Paired
Photographic filters[b]						
Polaroid	40	16	2.5	6	1⅓	2⅔
Hoya	25	6.25	4	16	2	4
Polaroid sheet						
HN-22	22	5	4.5	20	2¼	4⅓
HN-32	32	10	3	10	1⅔	3⅓
HN-38	38	14	2.5	8	1⅓	3

[a] It is assumed that paired filters are identical.
[b] Most, but not all, photographic filters approximate one of these two sets of figures. See the manufacturer's data sheet.

don't need to bypass the built-in light meter.) The figures in Table 8-6 are for the *least* exposure compensation that will be needed under any circumstances. No one can predict in advance the exposure effect of removing a reflection. However, sky-effect exposures are quite safely calculated from the tabulated figures.

Figure 8-14 Appaloosa horse on a cloudy day, Mendocino, by A. Blaker. Although many subjects benefit from the use of filters, some do not. There are no very significant colors in this example— the horse was gray, the building and fence were weathered gray, the grasses were virtually color- less, and the background trees were such a dark green that little color came through. Only a few green plants around the base of the building exhibited color, and filtering for them would not have benefited the picture. The tonal makeup of this picture, then, depended entirely on natural relative brightnesses.

Masonic Hall, Mendocino, California. This picture, made on a cloudy day with a large view camera, was a time exposure. Hence, the two walking figures are smeared across the image. The camera's elements were adjusted to eliminate the convergence of the building's lines. Photo by A. Blaker.

9
Camerawork

For each type of camera there are handling methods that tend to yield consistently good results. Some types of cameras—particularly view cameras—require specialized handling techniques.

Small single-lens reflex and rangefinder cameras can be handheld in a variety of ways, some methods being both faster and steadier than others—and being noticeably different from those for handling twin-lens reflex and press cameras. View cameras, because of their size and the individual adjustability of their parts, are neither convenient nor practical to handhold.

When you are photographing subjects that are motionless, or whose motion can be controlled, picture sharpness can usually be improved by using a tripod or other steady camera support. Some situations demand the use of a tripod; others simply make it advisable. Hence, tripod use is a basic part of camerawork.

Handheld Cameras

Steadying a Camera

A 35 mm SLR camera can be held steady by setting its body on your left hand, using the left-hand fingers to adjust the lens focus. The right hand holds the right end of the camera body; its forefinger presses the shutter release, and its thumb operates the film advance. For additional support, press the back of the camera against your face (Figure 9-1).

Figure 9-1 Hand-holding a camera steadily.

The choice of shutter speed is one of the most important factors in handheld camerawork. If you are in a location where there is no general vibration—standing on firm ground, as it were—it is usually safe to use a speed as slow as 1/100th or 1/125th of a second, if you hold the camera carefully. Any faster speed will of course also suffice. In a standing position, shooting at 1/60th of a second is a little dicey, though. And at that shutter speed it is advisable to make more than one exposure, usually several if possible, because one or more will probably show the effects of camera motion. Slower than that, expect nothing good to come of the attempt.

Some photographers say they can obtain sharp pictures quite routinely when handholding a camera—and perhaps even one that has on it a very long telephoto lens—at shutter speeds of 1/30th of a second, or even 1/15th of a second or slower. This assertion is difficult to credit, especially because the photographic examples shown are so frequently rather poor in quality. Perhaps persons who make such claims have low standards of quality in matters of image sharpness. The fact is that in handheld

photography camera motion is the primary cause of unintentionally unsharp pictures.

Detecting Camera Motion

Detecting camera motion, as opposed to other sources of image unsharpness (e.g., incorrect focus, lens aberrations, or atmospheric interference), is quite simple if you examine your negatives or slides with a magnifier of about four power or so. (This is quicker and less trouble than enlarging the image in a photo-enlarger or a slide projector.) Your camera's normal lens makes a very good magnifier for this use. Just remove it from the camera and reverse it so that you are looking into the front of the lens. Be sure that the lens diaphragm is wide open, or the field of view will be unduly restricted. If you do not have a lightbox to view against, hold your negative or slide so that it is seen against the sky, through a window, or—better—by artificial light reflected from a sheet of white paper.

Look closely at small points of detail such as reflections from a shiny surface, or at linear picture elements such as twigs, window edges, or the like. If you examine points of fine detail, look for dots stretched into short lines, all trending in the same direction. If you examine linear elements that are randomly or radially oriented, look for differences in line sharpness in subjects that are all in focus. If all the lines in a single general direction look sharper than the lines going in other directions, or if dots are extended in a single direction, you have found evidence of camera motion during exposure. The direction of this smearing is the direction of camera movement.

Minimizing Camera Motion

If you must use slow shutter speeds, and you lack a tripod or it cannot be used because you are on soft ground or a vibrating surface (e.g., the deck of a moving ship), you should work out some method that will at least optimize your chances of getting a sharp picture. Some suggestions are:

1. If you must stand, set your feet firmly and spread comfortably apart—possibly with one foot a little

Figure 9-2 Effect of accidental camera motion. *Church interior.* The dim existing light required use of a time exposure of several seconds. The camera, propped up on a pocket knife laid on the floor, slipped during exposure, resulting in diagonal camera motion. Note that subject lines parallel to the motion are rendered sharply. The effect is most clearly seen in the central archway. Meanwhile, all light sources have been smeared into elongated blobs.

existing firm object as a camera rest, either setting the camera on a horizontal surface, or pressing it sideways against a vertical surface. Suitable objects include boulders, stone fences, sturdy wooden fenceposts, building walls or doorposts, and automobile window ledges (with the car engine off, of course). A tree trunk is alright if the air is still or if the trunk diameter is large enough to resist swaying or vibrating from the wind.

The problems of supporting a camera are increased when there is no steady surface. When photographing from moving ships, aircraft, or other vehicles, do not touch or rest the camera against walls, window ledges, window glass, or the like; high- and medium-frequency vibrations will spoil picture sharpness. It is also a good idea to avoid resting your upper body, and especially your arms, against your seat. On a ship, stand.

In all photography with handheld cameras, the camera shutter must be released with care to avoid an abrupt lateral motion of the camera at the instant of exposure. However the camera is held, take up any slack in the shutter release while viewing and composing, and then, at the moment of exposure, just slightly increase your finger pressure to *squeeze* it off. You should also control your breathing during exposure. Take a good normal breath, let out part of it, and then hold the rest while pressing the shutter release.

Holding Single-Lens Reflex and Rangefinder Cameras

Handheld camerawork with a 35 mm or other eye-level viewing single-lens reflex camera offers speed of use and technical versatility, and can yield very high pictorial quality, if handled with reasonable care.

Most single-lens reflex cameras and most rangefinder cameras suitable for serious photography are designed to be held in a similar way. The most practical way of holding such small cameras is to support the weight of the camera body on the palm of your upturned left hand, using the left thumb and forefinger on the lens barrel to change f-settings and to adjust the focus. Meanwhile, the right hand grasps the right end of the camera body, with the right forefinger on the top-mounted shutter release. The right thumb can be used to operate the film advance lever, also top-mounted, without relaxing the general

ahead of the other—with your body directly facing the subject or scene. Keep your arms at least slightly away from your body (how much will depend upon the best posture for your camera type), so that breathing, heartbeat, or vibrations conveyed by your body from the surface you are standing on will not be transmitted to the camera.

2. When sitting, face the subject squarely. If the sitting surface is still, rest your elbows on your knees: if sitting in a chair, lean forward; if on the ground, draw your knees up. Steady the camera against your head, if practical, while viewing and exposing. This position is steadier than standing, but of course limits camera height. If the sitting surface is *not* still, stand.

3. If you can find something suitable at the correct location and height, and it is not vibrating, use an

Figure 9-7 *Okinawan villagers*, 1950. Although these people were aware of the photographer's presence, they were accustomed to him and took no notice of his picture-making because of his casual manner. Photo by A. Blaker.

Holding Press Cameras

In handheld use, a press camera is simply an oversized rangefinder design, and is operated for viewing and focusing in much the same way, being held up to the eye. When used on a tripod, a press camera is basically similar to a view camera, especially since most incorporate at least some view camera adjustments.

There are two basic types of press cameras: the conventional bellows-type folding models and the usually smaller box-body press cameras. On the left side of most boxy press cameras is a formed handhold, commonly a sort of large, elaborate knob, shaped to be firmly gripped. The left hand grasps this device and is responsible for nearly all of the holding action, with the right hand left free to operate the camera controls.

Most traditional folding press cameras (as illustrated in Figure 3-15) have an adjustable strap on the left side. To hold the camera, the photographer's left hand is slid forward under the strap, which lies firmly across the back of the hand, and the fingers curl around to grip the inside surface of the camera box. With the strap adjusted to proper tension this is a very firm grip, almost impossible to disengage accidentally. The right hand is then free to operate all of the camera controls, and to change film holders, flashbulbs, etc., as needed. An experienced press photographer can operate a 4 × 5 inch camera, with a multiple-sheet film holder on it, about as fast as a nonmotorized 35 mm camera can be used (thus gaining some advantages of both view and 35 mm cameras).

Using the View Camera

The adjustments available on view cameras are summarized in Chapter 3; they are, you will recall:

1. *Focus:* fore and aft movement of the camera front or back, or both, along the camera support rail or bed.

2. *Swing:* rotation of the camera front or back, or both, about the vertical axis.

3. *Tilt:* rotation of the camera front or back, or both, about the horizontal axis.

4. *Shift:* vertical or horizontal sliding movements of the camera front or back. (Vertical shifts are also called "rise-and-fall".)

These adjustments are illustrated in Figure 9-8. Swings and tilts differ only in the direction of the axis of rotation. Shift and rise-and-fall differ only in the direction of the motion, and are sometimes designated simply as horizontal and vertical shift. Although they can be used singly or in combination, the use of one adjustment may require the use of one or more others.

Full use of view camera adjustments other than simple focusing requires a lens, sometimes called a wide-field lens, that projects an image circle considerably larger than would otherwise be required to cover the given film format. Other lenses might give adequate coverage of the ground glass (and the negative) only when all camera elements are centered.

Object/Image Relations

View camera photography also requires understanding of the various object/image relations. Figures 9-10 and 9-12 through 9-18 demonstrate the effects of the various adjustments. View camerawork involves seven factors—five planes and two axes:

1. The *film plane* is fixed within the camera back, and is occupied by the ground glass viewing screen until the film holder is inserted.

2. The *lens plane* is an imaginary plane passing through the optical center of the lens at 90 degrees to the lens axis.

3. The *optical,* or *lens, axis* passes through the lens from front to back.

4. The *camera axis* is a line that coincides with the optical axis when all camera adjustments are centered, and establishes the camera angle before adjustments are made.

5. The *principal plane of focus* is a plane passing through the subject at the point where the lens is focused.

6. The *subject plane* is an averaging of the surface of the principal subject area; it may be convoluted or inclined to the camera axis.

7. The *image plane* intersects or coincides with the film plane when the lens is focused.

When all camera adjustments are centered, as in Figure

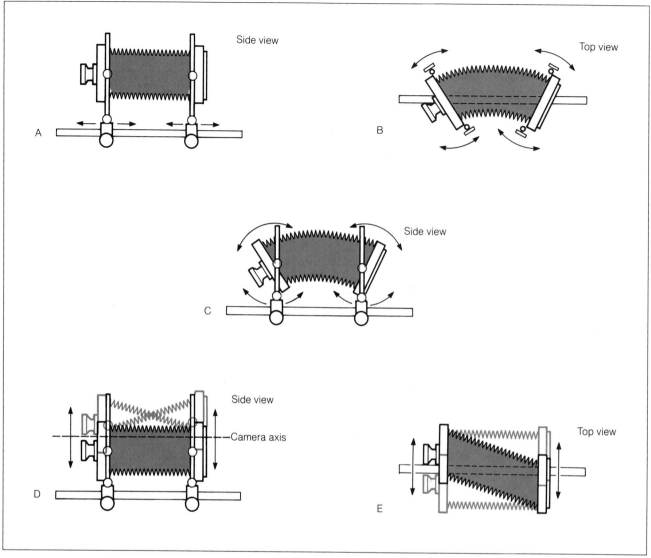

Figure 9-8 View camera adjustments. A. *Focus*: movement of the camera front or back along the supporting bed or rail. B. *Swing*: rotation of the camera front or back about the *vertical* axis of the camera. C. *Tilt*: rotation of the camera front or back about the *horizontal* axis of the camera. D and E. *Shifts*: vertical and horizontal sliding motions of the camera front or back (vertical shifts are also called "rise-and-fall").

9-9, the optical and camera axes coincide, are at 90 degrees to the film plane, and are centered on it; and the lens and film planes are parallel. These relationships are permanently fixed in nonadjustable cameras such as small single-lens or twin-lens reflexes.

If the subject surface is flat and is at 90 degrees to the

camera axis, and the lens is properly focused, the image plane coincides with the film plane. However, most subjects—whether outdoor scenes or human faces or other three-dimensional objects—do not have flat surfaces; the subject plane is, then, an imaginary averaging of the surface seen by the camera, so oriented that it represents

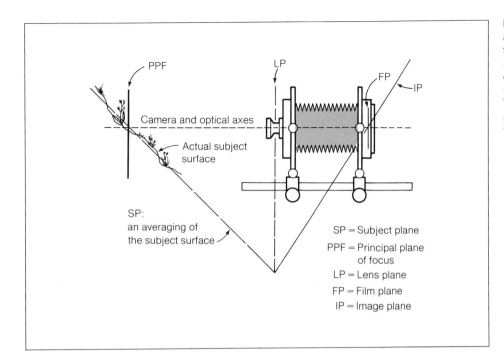

Figure 9-9 Optical alignments with all view camera adjustments centered but with an inclined subject. In such a situation, the image plane coincides with the film only in a narrow horizontal band as shown here. The abbreviations in this figure are also used in several that follow in the chapter.

Labels in figure:

PPF
LP
FP
IP
Camera and optical axes
Actual subject surface
SP: an averaging of the subject surface

SP = Subject plane
PPF = Principal plane of focus
LP = Lens plane
FP = Film plane
IP = Image plane

overall the least deviation from flatness. If the subject plane is inclined to the camera axis, as shown in Figure 9-9, the image plane will be inclined to the film plane. The image plane will intersect the film plane, and the camera's ground glass will show a sharply focused zone running across it, with the rest of the image more or less unsharp. The problem is compounded when the subject plane is inclined to the camera axis both horizontally and vertically, as often happens.

The use of view camera adjustments requires that there be a fixed camera position; therefore, view cameras are always mounted on a tripod. The camera is placed on the tripod with all of its movable parts centered, and they are thereafter recentered at the beginning of each successive picture-taking operation—partly because positioning the camera on the tripod establishes the field of view and the camera angle (or basic camera axis position), and partly because a photographer will find it very confusing to start out with any component off center. It should be evident that, until the camera is mounted, the direction of its axis is established, and the field of view to be photographed is initially composed on the ground glass, there is no basis for making camera adjustments. Once these steps have been performed, looking at the image reveals what corrective camera adjustments are needed.

The Ground Glass Image

You will first notice that the image on the ground glass is inverted. This is also true of the images created by the lenses of other types of cameras, but their viewfinders present an erect image to the eye. (Although there are mirror devices for view cameras that produce an erect image, they are bulky and costly and are seldom seen. They are most often used in studio work.) The inverted image is not that difficult to become used to. It often helps to turn your head somewhat sideways when viewing; an image that seems to be lying on its side is less difficult to interpret than one that is fully inverted.

It will also be apparent that depth of field is much shallower than what you are used to seeing in the viewfinders of smaller cameras, because of the greater image magnification of long-focal-length lenses. The larger the film format and the longer the focal length of the normal lens, the more obvious is the effect. (Contrary to what you might expect, you may find it actually easier to learn

Figure 9-18 Preventing image vignetting in view camera photography when the lens is far off center: A. Raising the lens to include the top of a very tall building may cause vignetting—here the upper corners of the image may be darkened (the image is shown inverted, as it is in the camera). B. The effect can be eliminated to some degree by tilting the lensboard backward slightly. This moves the edge of the image circle off the viewing screen without significantly shifting the image itself. However, the image will now be slightly unsharp, except for a narrow band across the center. The lens aperture must now be closed down to restore full sharpness.

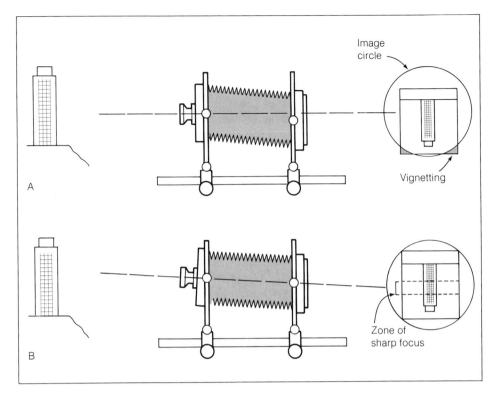

bed, and then refocus at the camera front, you will gain a little camera-to-subject distance, which will help somewhat.

Diopter lenses are discussed in greater detail in Chapter 13, on close-up photography. These lenses usually come in sets of three, in varying strengths. In the situation described here, the stronger the diopter value, the greater the wide-angle effect. There are disadvantages, of course. If your camera lens has a relatively small image circle, or if the diopter-value added is too great, there may be some vignetting in the corners of the picture. And the wide-angle effect achieved by this method will not be great in any case. But you may be able to just make the needed difference in a tight situation. (This trick works only with view and press cameras, because other types of cameras cannot be focused so that the lens retreats behind the normal infinity-focus position, as is required here.)

35 mm "View Camera" Work

Traditionally, view cameras have been relatively large, most early ones being 8 × 10 inches or larger. As photoenlarging became more practical, smaller equipment appeared, and most modern view cameras are of the 4 × 5 inch size. Smaller cameras have been produced, notably in the 2¼ × 3¼ inch size, often adapted to the use of 120-size roll film rather than the traditional sheet films (120-size roll film holders are also available for most 4 × 5 inch cameras).

However, until recently, 35 mm was not considered a film size well suited to view camera technique, and very few 35 mm view cameras were made. The early source of fascination with 35 mm cameras was their mobility, which took attention away from more contemplative uses of them. The relatively low magnification of 35 mm camera images made control of depth of field less of a

Figure 9-19 If view camera adjustments are not sufficient to correct perspective without impairing focus or causing vignetting, the fault lies in the picture concept. Instead of "fighting perspective" by trying to render the vertical lines parallel, you should point the camera sharply upward and record a dramatically diminishing perspective.

problem than it was with larger cameras, and the relative graininess of most 35 mm films made searchers for ultimate image quality look to the larger cameras.

In recent years, though, rapid advances in film technology and the popularity of single-lens reflex cameras, with their through-the-lens viewing, have altered the ideas of many photographers. As a result, perspective-control lenses were introduced that would allow you to do, in the 35 mm format, at least some photography of the view camera type. The first lenses of this sort were in wide-angle focal lengths (35 mm and 28 mm) and offered only a lateral shift, though the lens mount could be rotated so that the offset could be oriented in any direction.

The need to control depth of field by means of tilts and swings is not as great in 35 mm photography as it is with larger cameras, but the ability to shift off-center is a great convenience, in nature, architectural, and tech-nical photography. Still, it would be helpful sometimes to be able to swing and tilt to have some control over apparent depth of field and of perspective as well. There is a 35 mm lens on the market that offers an 11 mm shift to either side of center, an 8 degree tilt in a plane perpendicular to the shift, and a rotating mount. Appropriately, this wide-field, wide-angle lens has an image circle approximately 58 mm in diameter.

Another recent innovation is the bellows attachment that offers swings and tilts. These devices allow you to use nonshifting wide-field lenses on 35 mm cameras to good effect. But you must not exceed the image circle capacity of the lens in use, or there will be vignetting. These attachments work best with short-mount lenses (lenses designed specifically for use on bellows attach-ments; they will still focus to infinity while providing space between the back of the lens mount and the front of the camera for the placement of the bellows).

Figure 9-20 *Initials and symbols carved on an aspen tree, near Aspen, Colorado.* Since the carvings were rather high on the tree, a non-shifting lens would have had to be directed upward, causing the tree trunks to converge. To keep them parallel, the lens (a 35 mm perspective-control wide-angle) was shifted upward, with the camera (a 35 mm SLR) held level. Photo by A. Blaker.

Supporting and Steadying Cameras

There are a considerable number of devices used for giving cameras the stability needed to work at longer than normal exposure times, or to otherwise assure the sharpness of images. Some actually support the camera, others simply steady it.

Tripods

The best known camera support is the tripod, which, as most people know, is a three-legged camera stand. Most current models have three primary parts: legs of variable length; a centerpost for final height adjustments; and a pan-and-tilt head.

Tripod Use

For a tripod-mounted camera to stand, the center of gravity of the camera must be within the triangle formed by the tripod feet—otherwise, the assembly will fall over.

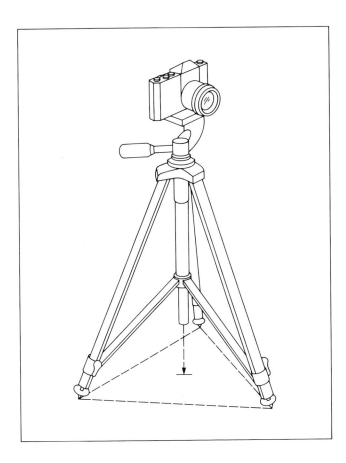

Figure 9-21 The center of gravity should fall within the triangle formed by the spread of the legs.

The larger the triangle and the more central the location of the center of gravity, the more secure the setup (Figure 9-21).

Since it is for directing the camera's viewpoint rather than for stabilizing the camera, I'll discuss the pan-and-tilt head first.

Pan-and-Tilt Heads

There are two basic functions to a pan-and-tilt tripod head: one lets you swivel the camera around a vertical axis—this is called "panning" (as in taking in a panorama); the other lets you tilt the camera to direct its viewpoint upward or downward. Good tilt heads have a mechanism that allows mounting the camera in either a vertical or horizontal position, while not affecting the tilt mechanism.

The most important quality of a pan-and-tilt head is that it should work easily, but lock well. A floppy tripod head is a real nuisance, and so is one that is simply unhandy to use. The best heads have a separate control and lock for each function. If motions are combined, things can go wrong if your attention slips. A generally good type of pan-and-tilt head is shown in Figure 9-22.

The most common combined-motion head uses a ball-and-socket joint, with a camera mounting screw at its top. Although they will do anything, if loosened they simply flop—so watch out. These items vary in quality from just plain junk to very good indeed. Prices range from several dollars to well over a hundred. The very best are at the top of the price range, but surprisingly good ones can be obtained at moderate cost. Although any good tripod will have a good pan-and-tilt head, a good ball-joint head is a useful auxiliary for putting cameras where tripods just won't fit, or for supporting ancillary equipment such as flash units.

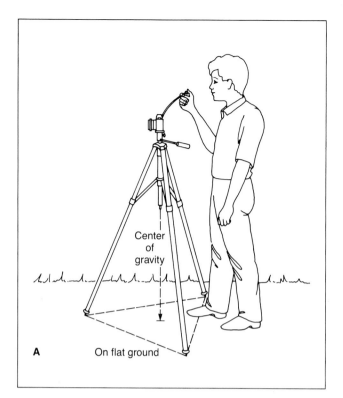

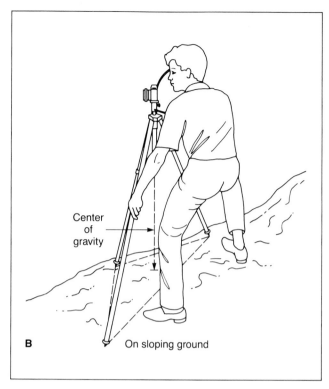

Figure 9-23 Setting up tripods. A. On flat ground. B. On sloping ground.

Getting Close to Vertical Surfaces

Suppose you want to have the camera firmly supported right next to a wall or a vertical cliff face, too closely for the whole tripod to sit normally. You can leave one leg folded next to the centerpost, extend the other two legs to the right height, and then lean the now bi-podded camera against the wall or cliff. If carefully done, the tripod will be quite stable. However, be *sure* that the two legs cannot slip. On smooth floors you can tape them in place, if need be. Many tripod legs have retractable spike tips in their feet. Outdoors, stick these into the ground, or catch them into rock depressions, for stability.

Low Viewpoints

Some tripods allow you to spread the legs out virtually flat, so that you can set the camera very low, but many have stops to prevent the legs from spreading too far. It

is a general safety feature. However, the majority of centerposted tripods let you reverse the post so that the head can be extended downward among the tripod legs. With the camera upside down, or tilted on its side, you can thus work right down to the ground (see Figure 9-24).

View cameras are generally too bulky for this technique. There are two basic kinds of view cameras: the flat-bed type, which has a rectangular base frame or baseboard; and the monorail type, where the whole mechanism sits on a single rod or tube.

With a flat-bed camera—most wooden field cameras are of this type—you can rest the front of the bed on the ground, at any angle of tilt, and then block up the back end of the bed with whatever is handy. I've simply stuck a rock under mine at times. Or you can set the bed flat on the ground, placing pebbles under the corners to shim it up if there is any tendency for it to wobble.

A monorail view camera would tip over if just set

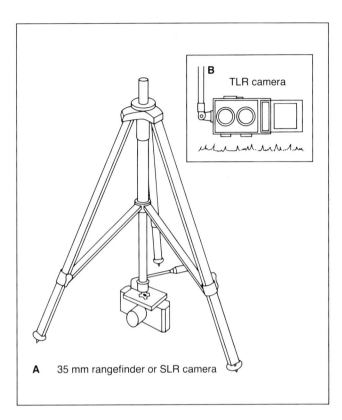

Figure 9-24 Working at ground level with a reversed centerpost.

B

TLR camera

A 35 mm rangefinder or SLR camera

down. One simple way to work at ground level is to invert the camera and rest it on the tops of its rectangular body parts. Of course you have to be careful here, but, if you are, this method is workable. If the particular camera is too delicate for this approach, you should use a sidearm.

Sidearms

For some tripods you can get sidearm attachments that fasten to one of the legs, and carry the tripod head and camera. You can then run the camera up or down the leg, for low viewpoints or to put the camera where the tripod itself won't fit.

Sidearms can also be fairly easily constructed. In a case where I needed a substantial offset of the camera (I wanted to support the camera over the center of a pit to photograph down into it), I used a length of aluminum angle stock (available at hardware stores) as a side exten-

sion, bolted at its middle to the tripod head, with the camera at one end and a counterweight at the other.

Keep in mind that any time the camera is supported outside the base triangle formed by the leg tips, whether on a sidearm or otherwise, counterweighting will be needed.

Other Stable Supports

You can use various methods to support cameras, other than tripods.

Clamps and Straps

You can get C-clamp devices that can be used to mount a tripod head and camera on a fencepost, a pipe or railing, or other available support. There is also a flat-jawed clamp made specifically for mounting a camera on

Figure 10-3 Reticulation in a negative (here highly magnified) is the result of temperature changes during processing. The emulsion swelled and became prunelike while wet.

because they would weaken or neutralize the developer's action and the images would be irretrievably damaged or even destroyed.

All chemicals, then, must be carefully handled and used in the right order during processing. Careless agitation or even too-vigorous immersion of thermometers in any solution can produce accidental splashing that might contaminate others. And any splashes that occur during chemical mixing or in the processing will dry by evaporation, leaving a residue of dust that can become airborne later and then contaminate other solutions or equipment. It is imperative, when measuring temperatures of formulas, that the thermometer be washed with water between immersions in different chemicals.

Developer

In the first step, the latent image formed by the action of light on the film is rendered visible by physical and chemical means; the silver halide crystals that were ex- posed to light are converted into clumped grains of metallic silver that form the developed image. Processing must be done in total darkness to avoid exposing and developing portions of the emulsion that were not affected in the camera. Unlike the now rare orthochromatic films, which could be developed in the presence of a red safelight, panchromatic films require total darkness. Roll films, however, can be loaded, in darkness, on spiral reels and placed in lighttight cylindrical tanks. Processing can then be done with the lights on.

Short Stop

In the second step, the action of the developer is stopped. This can be done by chemically neutralizing the developer with an acetic acid stop bath, generally called a "short stop." However, most films do not actually require an acid stop; a simple water rinse is sufficient. If an acid stop is required, this information will be listed in the processing directions for the particular materials. Short

Figure 10-4 *Mill at Port Angeles, Washington.* Excessive film grain can have a variety of causes, among them the use of fast films or vigorous developers, overlong development, high-temperature film processing, and excessive enlargement in printing. Graininess is not always a fault, however, for its texture can add a hint of abstraction to an image, as here. Photo by A. Blaker.

stop is usually purchased as a liquid stock solution, and diluted for use. It can be compounded, also by simple dilution, from glacial acetic acid, which is itself a liquid at room temperature, although it "freezes" at a considerably higher temperature than water.

Fixer

Fixation removes from the emulsion silver halides that were not exposed and developed, thus rendering the image permanent. At the end of fixation, the wet film can be examined by normal room light. Overall cloudiness in the negative emulsion, or the presence of reddish or pale purplish staining, indicates insufficient fixation time or insufficient agitation in fixing, or both. This is a particular problem with Kodak Technical Pan film, which requires very vigorous agitation in fixing to remove the pinkish antihalation dye. If any of these indications are present, repeat the fixation step with fresh fixer. Fixer is often called *hypo*, a term derived from an early name for its primary constituent, now called sodium thiosulphate. Most commonly, the fixer is a premixed powder that is dissolved in water.

Washing Aid

After fixation, the film emulsion contains various chemical compounds that, if allowed to remain for any great length of time, are likely to cause degradation of the image. These compounds are soluble in water, but only with excessively long washing times. A washing aid—a chemical that converts these relatively insoluble compounds into others that readily dissolve in water—can be used to reduce washing times and increase the permanence of the image.

Washing aids are not needed unless the negatives are to be stored for very long periods of time. They are less necessary with films than with prints, where bonding of the relatively insoluble compounds with the fibers of the paper is a particular problem. But if some of your photography is of great long-term value, washing aids are worth consideration.

Wash

After fixation, the film is washed to remove from the emulsion all significant traces of the processing chemicals, thus making the image even more permanent. The primary material to be removed at this step is the fixer. Significant amounts of fixer remaining in the emulsion will eventually bleach the image.

Film washing is a leaching process, and does not actually require running water. It can be done very effectively by repeatedly filling and emptying the developing tank or tray if running water is not available, or if maintaining the water temperature is difficult. Films require about 20 to 30 minutes of washing in slowly running water or about five to six complete water changes. In still-water washing, the container is filled and allowed to stand for about five minutes. Then it is emptied, refilled at once, and allowed to stand again. This action is repeated five or six times.

Wetting Agent

Many photographers immerse the washed films in a detergent solution called a *wetting* solution, which reduces the surface tension of residual wetness. Thus, when the films are hung up to dry, the water will sheet off evenly without forming discrete drops that might leave spots when they evaporate. This is a valuable practice, although some photographers choose not to do it. Ordinary dishwashing detergent will do the job, but the material most commonly used is one of the photographic detergents, such as Kodak's Photo-Flo. It is important to use very little detergent. For a 32 oz/l liter quantity of solution, use the smallest drop that you can get out of the stock bottle. Thoroughly mixed, this is sufficient. Too much leaves a gummy surface film on the dried negative. This in turn tends to hold dirt and dust particles, and, once dried, is itself difficult to remove even by extensive rewashing. Do not immerse the film until the detergent solution is thoroughly mixed. Do not reuse the solution.

Choice of Chemicals

Photographic chemicals—that is, the complete formulas—come in a variety of forms and for a variety of purposes. Most of these chemicals are compounded of several basic constituents, combined so that each one contributes its special qualities to the whole.

Wet Mixes

Many chemicals are supplied either as premixed liquid solutions, or as a liquid "stock" solution needing only a last-minute dilution with water for use. These are very convenient, but can be more expensive than equivalent dry mixes.

Dry Mixes

Many developers, fixers, and other chemicals come packed as dry powders. Before use, they must be mixed with water, usually at elevated temperatures. Where a choice exists, these may be a little cheaper than wet mixes, particularly in the smaller sizes generally used. It does take some time and effort to do the mixing, but not enough to get excited about. The resulting mixture, after the initial process of dissolving, may be used directly, or as a stock solution with an additional specified dilution before use.

There is a myth about developers mixed from powders. Some photographers believe that mixes designed for repeated use are too vigorous or "raw" to use for important work immediately after being mixed and that the photographer should run a junk roll of film—that is, exposed but bearing no images of any worth—through them to "take the edge off." The perpetuation of this story can probably be attributed to repeated failures to cool the solution adequately after mixing and before use. It is not a good idea to use hot developer. Allow the solution to cool and then follow the manufacturer's time and temperature instructions for the film and developer combination being used.

Scratch Mixes

Often the cheapest way of operating is to mix formulas "from scratch," from standard listings or personalized recipes, using individual dry chemicals. However, this process suffers from three limitations. You must have the particular raw materials available; you must have a suitable, accurate measuring scale; and you must take the time to measure and mix. The major advantage is not cost, but the fact that (given the raw materials) you can mix any formula that you desire from the vast literature of photographic chemistry. If you have nonstandard needs, the value of this is obvious. Generally, however, this practice should be limited to those few formulas that cannot be purchased as mixes.

Usage

One-Time Use

Some chemicals, particularly developers, are used only once. Their advantage is that each use is exactly like the last, without the complications that can arise from the accumulation of developer by-products and from gradual weakening. However, since a single use often fails to exhaust the solution chemically, there is some chance of waste. The choice does not always exist. Developers diluted from stock solutions cannot be reused.

Repeated Use

Some chemicals, particularly fixers, are used until exhaustion, without the addition of new material. Follow the printed instructions on the packaging concerning capacity and testing for potency.

Replenished Use

A number of common developers can be used repeatedly while maintaining development quality, by using a replenisher: a stock solution chemically related to the original developer. Replenisher is added after each use to maintain the same amount of solution (since each film takes along some developer to the next processing step) and to keep the correct chemical balance by restoring the part of the solution's chemical potential used by previous film. In replenished developers there may be some slight change in negative contrast or density from batch to batch. These differences will be important only in circumstances requiring very rigorous quality control.

Film-Processing Equipment

You do not need elaborate facilities for processing moderate amounts of film. A darkroom is handy, but is not actually necessary; an ordinary kitchen or bathroom will

Step 15: Fix the film to make the image permanent—pour in *fixer* (at the same temperature as the developer). Agitate the tank, with its central cap back on, just as for development—do it constantly for 30 seconds; then do it at 30-second intervals. When done, pour the fixer back into a storage container, for later reuse (Figure 10-26).

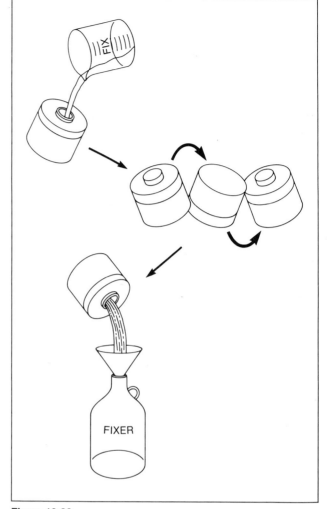

Figure 10-26

Either

Step 16: Wash the film in water *at the same temperature as the developer*. To do so, remove the entire lid from the tank. Then, either

1. Position a hose to pour water into the center of the film reels in the tank, letting it run at moderate speed for 20 to 25 minutes (Figure 10-27); or

2. use a still-water wash—pour water in, let it set for 3 to 4 minutes, pour it out; then repeat this cycle, until a total of 20 to 25 minutes has passed (Figure 10-28).

Figure 10-27

Or

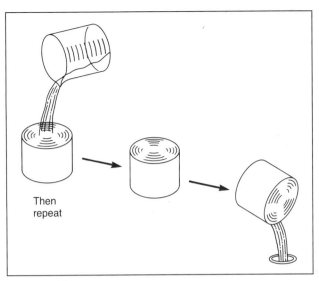

Figure 10-28

Step 17: Give an anti-water-spot rinse.

1. To 1 quart of water (*at developer temperature*) add 1 *drop* of Kodak Photo-Flo or similar photo detergent; stir vigorously.

2. Empty the film tank of wash water; pour in detergent mix; let it set for 30 seconds; then discard the detergent (*do not* save it for reuse) (Figure 10-29).

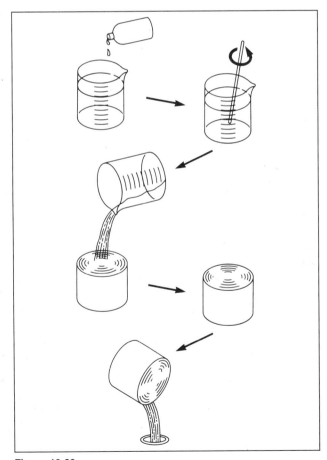

Figure 10-29

Step 18: Hang the films up to dry.

1. Remove the rolls, one at a time, from the reels.

2. Hang each roll on a spring clip, vertically.

3. Immerse a split (book-form) photo-grade synthetic sponge in detergent solution (made as in Step 17).

4. When it is thoroughly soaked, squeeze out the sponge till damp; open the split; close it gently over the top end of the developed film; then squeegee down the whole length of the film strip, *once*.

5. Hang another spring clip on the bottom of the film strip for weight, to keep the film straight.

6. Leave hanging in a dust-free location to dry (in still, dry air it will take 20 to 30 minutes). When the film is thoroughly dry it is ready for printing (Figure 10-30).

Figure 10-30

Clean Up

After the film has been hung to dry, do the following cleanups:

1. With warm water, thoroughly wash out the sponge, opening the slit and washing the interior especially well; leave to dry in a clean space.

2. With hot water, thoroughly wash all parts of the tank.

3. With hot water, thoroughly wash all film reels.

Processing Sheet Films

In some types of work, and especially where the Zone System is in use, it is desirable to use sheet films so that one or a few exposures are developed at a time. As with roll films, there are several handling methods.

Tray Processing

The quickest and most convenient method of handling small numbers of sheet films is by tray development. In this practice, developer is discarded after one use. Doing one film at a time offers few problems, but ganging them requires great care. The primary dangers are that the films will stick together in entering the first solution, before they are thoroughly wet, and that the corner of one film will dig into the emulsion of another during agitation. These problems can be avoided, however, by a set method of working that produces very consistent results with little likelihood of damage.

Film Handling Procedure

Working in the dark (unless orthochromatic films are being used, with a suitable safelight), fan out the exposed films, playing card fashion, all with the emulsion side facing you. Corners are touched and counted to be sure that all the films are fanned out face up. (Sheet films have notches cut into one corner for identification; when you feel the notches at top right, the film emulsion is facing you.) Then a single film is taken from the bottom of the fan and placed, face up, in the tray of developer. It is pressed under. (Be sure to thoroughly wet the fingertips of that hand at this point—if they are only just damp they may leave prints on the film.) Then, at a leisurely but regular pace, it is picked up and placed face down, turned face up and then again face down. This allows the emulsion to become thoroughly wet. The other films are then put in, one at a time and following the same sequence of turning as each goes in. At the end, all the films are in and all are face down, with the most recently entered film on top. Films are counted as they are entered. Then, for the whole period of development, a sequence of agitation is followed, counting through the series each time, so that the same film is on top at the end of each cycle. If this is so, and the transfer into each new solution is carried on at the same regular rate, each film will be in each solution for the same amount of time.

Any tendency of negatives to stick together at entry is reduced by using a tray one size larger than the films (for instance, an 8 × 10 tray for 5 × 7 inch films), and by using fairly large amounts of solution. And the more films that you develop at once, the larger should be the quantity of solution in the tray. For 6 sheets of 5 × 7 inch film in an 8 × 10 inch tray, half a tray of solution is quite sufficient, but for 10 to 12 films a full tray is needed. The larger the film, the fewer should be done at one time. In 11 × 14 inch size, for example, the limit should be 2 or 3; for 8 × 10, 4 or 5; for 5 × 7, 8; for 4 × 5 inch or smaller, 10 to 12. When first learning this process, keep the number of sheets low until you are sure you can develop the films evenly and without damage. Uneven development usually occurs because the films stuck together when placed in the developer, or because they received insufficient initial agitation. The former accident produces straight-line demarcations, fairly obviously edged, between areas of lesser or greater density. The latter accident results in a mottled appearance.

Agitation

Agitation is accomplished by lifting one corner of the film bundle and drawing out the bottom film. It is held up by a corner momentarily, to drain, alternating corners each time it is pulled from the tray. (You know when to alternate by knowing how many sheets are in the tray and thus knowing when you have gone through the bundle completely and are starting a new cycle.) After draining, the sheet is again placed face down in the tray—take care to avoid digging into the top film with a corner. This action is continued for the whole developing time. Similar intermittent agitation is done during the rinse (usually no acid short stop is used in the development of sheet films) and in the fixer. During washing, it is desirable to keep adjacent sheets from touching: place each film in a metal frame hanger, and suspend it vertically, with the washing being done in a deep tank.

If these instructions are followed, there should be no damage to the emulsion side of the negative. Having the films face down throughout processing assures that any slight scratching that might happen will occur on the base side of the film. It will not be visible in a contact

Figure 10-31 In preparation for processing (and in total darkness), sheet films should be removed from the film holders and fanned out in the hand, like cards. The corners should be spread apart so that they can be counted and the notches properly located. (The emulsion side is facing you if the notches are on the upper right when the short edge is facing upward. (Here the long edges are horizontal, but the emulsion side is still facing you.)

print, or in an enlargement made on a diffusion enlarger. Only rarely will such scratches show in enlargements made with a condenser enlarger—if such scratches show, smear over them with Edwal No-Scratch, an oily substance (clean them before storage).

Compact Tanks

If you prefer to do tank development of the smaller sizes of sheet films, compact tanks are available in which the basic development technique is similar to that used in roll film work. Some tanks are designed specifically for sheet film use only. In other cases, sheet film holders of various sorts are made that will fit into standard stainless steel roll film tanks. At least one make is adjustable for various sheet film sizes up to 4 × 5-inch size (and will accept metric as well as inch sizes). These devices normally hold up to 12 films at a time. Either a one-time developer or developer-replenishment methods can be used. See your supplier for details of design, price, availability, and use.

Compensating for Exposure Errors

Murphy's famous law, "If anything *can* go wrong, it will," applies to photography as well as to life's other concerns. Errors in exposure can occur for many reasons, such as improper setting of the film speed on your light meter, or mistaking the type of film as you load your camera; however, some compensatory measures are possible. If you discover the error before processing the film, you can compensate during development; discovery after processing requires *intensification* or *reduction* of the negative's density by post-development chemical means.

Altering Development Time

As stated earlier, increasing the exposure time increases the density of the resulting negative; decreasing the time decreases that density. If the film has been accidentally overexposed, the negative will be abnormally dense; if underexposed, the negative will be lacking in density, or "thin." Within some limits, it is possible to alter the final negative density by altering the development time.

Following overexposure you can compensate by shortening the development time by about a third. This may or may not be enough, but in the worst case it is better than nothing. The need for compensation will depend on how extreme the error was, and on what type of film was used. Fast films have lower basic contrast than slower ones, and thus have less critical exposure accuracy

Figure 10-32 Agitation for tray-processing of sheet films (done in darkness). The group of immersed films is lifted, and the bottom one taken out (the position of the notches shows that the emulsion is face-down).

Figure 10-33 The film is held by one corner and allowed to drain briefly (the corner drained is alternated through the cycles to follow).

requirements. *Very* fast films can be overexposed massively, with relatively little change in negative density. (I once accidentally exposed an ASA 1250 sheet film by a meter reading set for ASA 50, developed the film normally, and was able to print it normally.) But slow films will benefit from shortening the development time after overexposure.

Conversely, you can compensate for underexposure to a minor but not negligible degree by increasing the exposure time by about 50%. Underexposure is more critical than overexposure for any black-and-white film; even one stop of underexposure will probably cause loss of important shadow detail, which cannot be regained by development. But you can increase both the density and the contrast of what does remain, by increasing the development time, which makes the negative easier to print.

Intensification and Reduction of Negatives

Should you discover, upon examining your negatives, that some are either too dense or too thin because of exposure errors, you can increase their printability by further chemical treatments called *intensification* and *reduction*. Both of these processes can be carried out in ordinary light.

materials, and facilities required for making them; the variables involved and the techniques used in transforming the image on the negative into a positive paper print; and the means used to display it. A few sessions in the darkroom will persuade you that black-and-white printing is in itself a fascinating exercise, with many variations possible for every image. Its practice can easily occupy a working lifetime without exhausting its challenges. You should also come to realize that anyone who entrusts the printing of his or her negatives to another is both abdicating control over many of the major aesthetic decisions in photography and foregoing many of photography's most satisfying moments.

Print Quality Standards

There are exceptions to almost any rule in any field. However, for most purposes it is reasonable to say that a photographic print should have just-discernible detail in both its lightest and darkest areas—exclusive of those that are intended to be pure white or pure black—as this makes the fullest use of the available range of tones in the printing paper. Important detail should not be lost in blazing highlights or submerged in deep shadows; the middle tones should be clearly differentiated, except where they represent a continuous gradation. If the full reproduction range of the paper is not used, the print will look "muddy" unless a limited range of delicate, primarily light tones is being used, for instance, to give the impression of mist or fog. On the other hand, the tonal range of the paper should not ordinarily be exceeded: the main subject area should be kept within approximately 90% of the full range of the paper, without entering the nearly-white or nearly-black tones, unless you wish to create an effect of extreme high contrast— one of "chalk and charcoal." Nearly all images look best when printed to these standards; a few exceptional images look best printed otherwise.

The most practical way of developing a feel for quality in printing is to examine the work of acknowledged good photographers—the prints themselves, not reproductions. For, even with the best will and the finest available reproduction quality, the illustrations in this and other books can carry only a portion of the visual impact of an actual photographic print. Go to as many exhibitions of fine photographs as you can get to; compare what you see with your own work; if you can, collect a few prints to serve both as inspirations and as standards for comparison.

Variables in Printing

Prints of a given image can be exposed to be darker or lighter in tone and lower or higher in contrast. They can be made on paper that is glossy or is rough or soft in texture. The appearance of the print can also be affected somewhat by variations in development. Nevertheless there are only two really significant variables in printing: exposure time and paper contrast.

Exposure Time

The basic overall lightness or darkness of a print is determined by exposure time during printing. More exposure makes the print darker, less makes it lighter. As in the camera, exposure is a function of two factors: lens aperture and exposure time. In printing, however, neither action stopping nor depth of field matters; the lens aperture is chosen to place the exposure time within a convenient range. Paper responds best to exposure times of less than a minute. At very long exposure times, paper, like film, suffers from reciprocity failure. But very short times are not a good idea, either, because they allow too little time for manipulation in printing, such as "dodging" or "burning-in" (giving different lengths of exposure to different portions of the image, as described later). Thus, if you find that the correct exposure will be over a minute you can shorten it by opening the lens aperture; if it will be less than, say, 10 seconds, you can close the lens down to make it longer.

Paper Contrast

As we saw in Chapter 5, photographic printing papers come in a variety of contrast grades; some papers are variable in contrast if used with suitable printing filters. Since negatives can vary quite widely in their range of contrasts, the overall contrast of the resulting print is adjusted by use of a complementary grade of printing

Figure 11-1 *Umiak, a wood-frame hide-covered open boat built by Eskimos.* The photograph was made to illustrate a museum catalogue. To show details of the skin boat's internal construction, the print was made to "normal" standards, with just-discernible detail in the brightest highlights and the deepest shadows. There are no total blacks or, in the original negative, absolute whites (the white area beyond the prow is actually the result of opaquing the negative to eliminate distracting background detail). Photograph courtesy of the Alaska State Museum, Juneau, Alaska. Photo by A. Blaker.

Figure 11-2 *Child in a flowered dress*. Left. In this print, made to normal standards, the backlighting leaves the features and clothing too dark. Right. Giving less exposure time to the print lightens these areas so that they look better, and nothing significant is lost in the highlights.

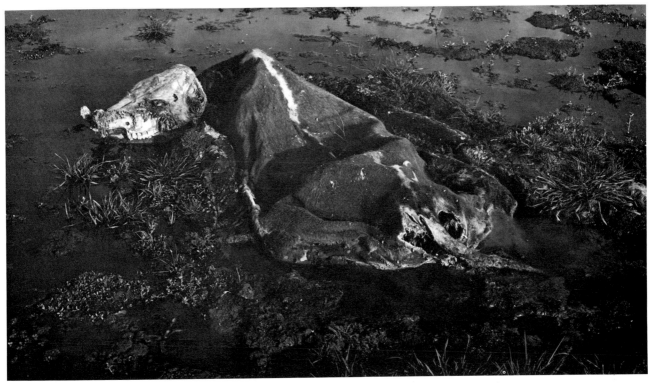

Figure 11-3 *Mired cow.* This is a straightforward photograph in that during exposure and development there was no manipulation to achieve an expressive intent. Yet the final print has emotional force—drawing visual beauty out of death and decay. Because virtually everything of interest is in the highlight and middle-tone area, a paper contrast one grade higher than normal was used to emphasize those areas while letting the darker areas lose contrast. Photo by A. Blaker.

paper; high-contrast negatives are usually printed on low-contrast papers, and vice versa. The contrast of the negative and the desired final image contrast are the criteria by which to choose a paper grade. Testing for the choice is done at the same time that exposure is being calculated.

Paper Surface

The choice of a paper surface for a given print depends upon both the intended use of the print and the way the photographer wishes the viewer to perceive the image. Because of their smoothness, glossy prints are preferred by publishers; they provide the highest image resolution and have no texturing that will interfere with reproduction. Glossy prints also offer the greatest range of print contrast: because of their shininess, whites reflect more light and therefore look whiter; and blacks, being smooth surfaced and therefore mirrorlike, reflect less light to the viewer (under proper viewing circumstances) and thus look blacker. Because of this very shininess, however, glossy prints cannot be too large without offering viewing difficulties. Because light reflected from a glossy print surface toward a viewer's eyes obscures the image, such prints require that lighting be more carefully placed than for prints on other paper types. And because very large prints make it difficult to place lighting so that part of the image does not reflect it into a viewer's eye, textured surfaces are preferable for those larger than 11 × 14 inches.

Textured print surfaces are also preferred when a muted, low-key tonality is wanted and the hard, brilliant appearance of a glossy print may seem inappropriate. This choice of surface—whether glossy, smooth or rough matte, canvas or silk, regularly pebbled or irregularly roughened—is a matter of taste, not rules.

A more elaborate method involves the use of a printing box: a box containing one or more light bulbs under a glass window over which a hinged top closes. You place the negative on the glass emulsion side up, the paper on top emulsion side down, and close the hinged wood or metal flap top to apply pressure. Closing the top also closes a light-switch, and makes the exposure.

All these methods work about equally well, and none offers significant advantages over the others in small-volume work. If you are making large numbers of prints from single negatives, an elaborate printing box is best, because it is quick and easy to make exactly similar prints; such boxes have many light bulbs in them—by turning some off, as needed, you can provide uneven lighting to correct for uneven negative densities.

A contact print is itself the end product of large negatives. With small negatives, the whole roll is ganged and is printed at the same time, to provide a series of small positive prints for appraising results, and for making selections for enlargements and decisions on image cropping. It is very useful to contact print each roll or sheet of film, and store a copy with the negatives, for future reference.

If you use a contact printing box, with its relatively bright lighting, you should use contact printing paper, a photo paper of slower speed made for this purpose; if you use a print frame, a proof printer, or any other method in which the exposure is made by light projected from an enlarger, use enlarging paper, which is fast enough to record the image in a reasonable length of time. If you use contact paper under an enlarger, you will have to use excessively long exposure times, running into many minutes.

Projection Printing

Enlargers

Making prints larger than the negative size requires a photo enlarger. However they differ in complexity and details of construction, all enlargers are basically similar in operation. An enlarger has three main sections: the enlarger head; the support column; and the baseboard. The baseboard supports the rest of the mechanism and forms a platform on which the easel for holding printing paper is placed. The support column allows the enlarger head to be raised and lowered for increased or decreased image magnification. The enlarger head has a lamphouse that provides the light for exposure, a negative carrier to hold the negative in place, and a lens for projecting the image (the head resembles a slide projector set up to project straight downwards: see Figure 11-9).

There are three basic types of enlarger lamphouse: a condenser type and two diffusion types. Each has its own way of evenly illuminating the negative. In a condenser enlarger, light from an incandescent bulb is focused by two or more condenser lenses, placed just above the negative. As the light rays thus focused pass through the negative, they converge toward the projection lens. As long as the various lenses are correctly aligned and focused, with the negative close to the bottom condenser lens, the light will be evenly distributed in the image.

In diffusion enlargers, light is evenly distributed by being diffused, or scattered, by a sheet of ground glass just above the negative. In simple diffusion enlargers, the incandescent bulb is placed well above the ground glass—within practical limits, the higher it is, the more evenly the light will be distributed. In more complex diffusion enlargers, called cold-light enlargers, the light source is a folded-grid cold cathode tube, a white neon-like tube closely folded zigzag in a rectangular pattern. The grid, which occupies an area slightly larger than the intended negative size, is placed just above the ground glass diffusing screen. The light emitted is distributed very evenly—more so than in simple diffusion enlargers—and is highly actinic: that is, a brightness equal to that of an incandescent source produces greater exposure. Thus, cold-light enlargers are generally better than simple diffusion enlargers; their light is more even, and exposure times are generally shorter. All three types of enlarger head are shown in Figure 11-10. All are made in various sizes to handle various negative sizes.

Condenser vs. Diffusion Enlargers. Among photographers there has long been a continuing argument about the comparative merits of condenser and diffusion enlargers. The diffusion enlarger is said by some eminent photographers to be superior for retaining fine print values. This has been experimentally tested and refuted (by Dr. Richard Henry, in his book *Controls in Black-and-White Photography*—see the Bibliography), the difference in appearance of prints being simply an approximate one-stop difference in print contrast, and correctable by changing

Figure 11-9 A typical photo-enlarger.

Support column

Lamp house

Enlarger head

Negative

Negative carrier

Lens

Carriage for moving the enlarger head vertically along the support column

Focusing knob

Lock knob for vertical movement

Expanding cone of light rays making up the image

Enlarger easel

Baseboard

contrast in printing. However, the claim is still being made by some photographic writers.

Although myth has it that diffusion enlargers do not produce as sharp a print as condenser enlargers, the differences are negligible in any but the most specialized uses. An advantage of diffusion enlargers is that minor dust or scratches on the negative are less likely to show on the print. A small disadvantage is that print contrast is slightly lowered. Therefore, it may be necessary to use paper grades one level higher in contrast, or to develop your negatives a little longer to increase their basic contrast. A negative that produces good contact prints on number 2 paper may require number 3 paper in diffusion enlarging.

Condenser enlargers are usually recommended when the ultimate resolution of fine image detail is needed. The condenser enlarger does not in fact project a sharper image than the diffusion enlarger's; rather it gives a superficial impression of doing so by aligning light rays in a tight pathway. There is thus less stray light to produce optical flare than with a diffuser enlarger. Consequently, there is less likelihood that small tonal differences and fine textures in the negative image will be enveloped in flare effects and thereby lost in printing.

Enlarger Lenses. Lenses made for use on cameras are designed to offer their best performance when the subject is relatively distant. Enlarger lenses must work best at

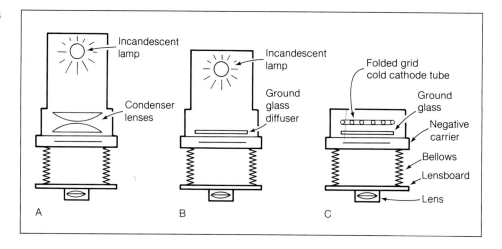

Figure 11-10 The three basic types of photo-enlarger head. A. A condenser enlarger. B. A ground glass diffusion enlarger. C. A cold-light diffusion enlarger.

closer focusing distances; most are designed to perform best when the projected image is about 10 times the size of the negative image. Additionally, a good enlarger lens should project an unusually flat-field image of the negative—that is, the lens should be corrected for curvature of field so that the projected image will be approximately as sharp in the corners as at the center. For these reasons, most camera lenses are not very satisfactory for use on enlargers. (Notable exceptions are macro lenses designed for close-up work and copying; these have corrections exceeding those of most enlarging lenses, are designed for the requisite 1:10 reproduction ratio, and so are excellent for high quality enlarging. Adapters for mounting them on enlargers are commercially available.)

For a given negative size, the best focal length of an enlarger lens is the same as is normal on the camera (that is, about 50 mm for 35 mm negatives; 85 mm for $2\frac{1}{4} \times 2\frac{1}{4}$ inch negatives; about 165 mm for 4×5 inch). Longer focal lengths would result in less image enlargement at a given distance between enlarger head and easel, and so are not used. Wide-field lenses of short focal lengths are sometimes used to obtain unusually large images.

Like camera lenses, enlarger lenses are subject to the economics of manufacture, and so are rarely perfect. But fortunately, most are entirely satisfactory in the aperture range offering optimum lens corrections—from about f/5.6 to f/11—usable with most negatives in the common range of enlargement.

Steps in Enlarging

Dust Control

Dust and lint are an ever-present problem in photo enlarging. Any particles present on a negative in the enlarger will be projected and enlarged as unsightly white traces on the print. These traces must then be removed by retouching, a tedious and time-consuming process requiring considerable skill. Thus, dust control is a necessary prerequisite to projection printing. Indeed, a clean darkroom is the first requirement. All surfaces should be regularly vacuumed clean. Enlargers should be sheathed in a plastic cover when not in use, and should also be periodically vacuumed, inside and out. Darkroom ventilators should be filtered to keep dust out.

The final step in dust control is the first step in enlarging: you must clean the negative as you load it into the enlarger. Because it is static electric charges that cause dust to stick to negatives, such charges must be removed from the dust and from the negative. This is best done by using a brush (such as the Staticmaster®) containing a polonium element that emits minute quantities of harmless alpha radiation that ionizes nearby air. The ionized air dissipates the static charges, so the brush can then easily remove nearly all of the surface dust. To remove the few grains remaining, which usually cling to the base, or nonemulsion, side, place the negative in the enlarger's removable negative carrier emulsion side down, and in-

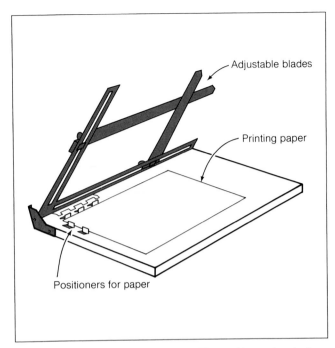

Figure 11-11 A typical enlarger easel. The positioners locate the paper on the easel. The image is framed by two fixed edges and two adjustable leaves.

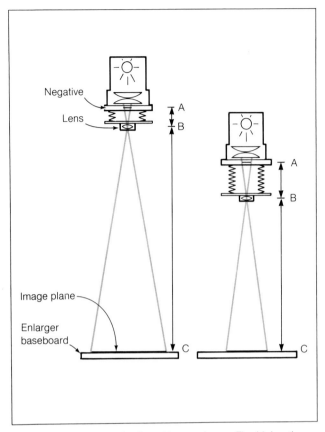

Figure 11-12 Image projection with an enlarger. The higher the enlarger head is raised, the greater the image magnification. As the head is lowered to make a smaller print, the distance between the lens and the negative (A–B) increases, and that between the lens and the enlarging paper (B–C) decreases.

sert it part way into its slot in the enlarger head, with the enlarger lamp on. The light glancing off the surface of the base side of the negative will reveal even very small dust or lint particles. Use a pressurized can of inert gas or air (such as Omit® or Dust-Off®), which has a long, thin nozzle that can reach into the slot. Aim the tip of the nozzle at each dust or lint particle in turn, and give it a short, quick shot of gas. In moments you can remove virtually all remaining dust. Insert the negative carrier all the way into the enlarger head and you are ready to project the image.

Projecting the Image

The next step in enlarging is to decide upon the basic print size. You adjust the enlarger easel (see Figure 11-11), placed on the enlarger baseboard, for the size of printing paper to be used (e.g., 5 × 7 or 8 × 10 inch), setting the margins to the width that suits you. Insert a focusing sheet—a sheet of waste photo paper or a discarded photograph blank side up—in the easel; this pa-

per helps you to see the image for focusing and composing. For maximum focusing accuracy, use paper of the same thickness as the paper you will print on.

Turn off the roomlight and turn on the safelight and the enlarger lamp. Open the enlarger lens to its widest aperture, so that you can see the image well. Since, with any given lens and negative, the image size is determined by the height of the enlarger head above the baseboard, raise and lower the head until the image roughly fills the focusing sheet. (Move the easel as needed to center it under the projected image.) Using the enlarger focusing knob, focus the image, changing image size and refocusing as needed to fit the image into the chosen area (see Figure 11-12).

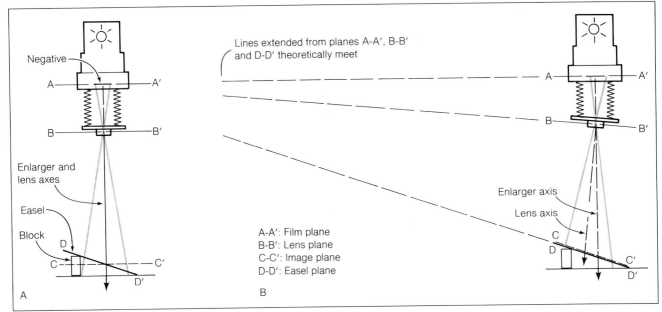

Figure 11-20 Perspective adjustment in projection printing. Tilting the enlarger easel changes the image magnification over the length of the picture. Tilting the enlarger lensboard then restores overall image sharpness. A. Easel tilted: distance B–D is less than B′–D′, giving less image magnification at the raised end. B. Lensboard tilted to bring planes C–C′ and D–D′ into coincidence, affecting focus just as view camera adjustments affect apparent depth of field.

9). Tilting the lensboard may shift the image a little to one side, if the axis of rotation does not coincide with the optical center of the lens. If so, the easel may also have to be moved sideways to restore the image composition.

It may be quicker and easier to bring image lines parallel if you place in the easel a piece of scrap printing paper that has been ruled with a grid. These grid lines, which can be pencilled on, spaced about ½ inch or 1 cm apart, will make visual comparisons much easier.

Because the image will have to be trimmed to eliminate the keystoning effect at its outer edges, you will have to allow extra space around the main subject matter in the original composition if you are not to lose possibly essential pictorial material in the cropping—a point to be kept in mind when you are making pictures that may need this subsequent treatment.

Since the two ends, or the two sides, of the projected image have different image magnifications, there will also be a difference in the projected light intensity. To obtain an evenly exposed print, then, you will have to test for the exposure difference, or at least make an educated

guess at it. The lighting intensity will, of course, fall off evenly across the print, with the strongest intensity at the less magnified end or side. This does make the printing exposure a little more complex, especially if there is already some differential exposure necessary to correct for uneven exposure of the negative. But the problem is not insurmountable. You just have to take some additional care. This technique is of such great potential value that it is more than worth the relatively slight extra trouble in learning and applying it. (For greater detail, see my article, "Brick Work," in *Darkroom Photography*, December 1987.)

Experimental Techniques

Two experimental techniques in printing—making photograms and "painting with chemicals"—are of both artistic interest and practical help in understanding the printing process: photograms are images made in the darkroom, with no negative. They are made by modifying the light projected by the enlarger or any other

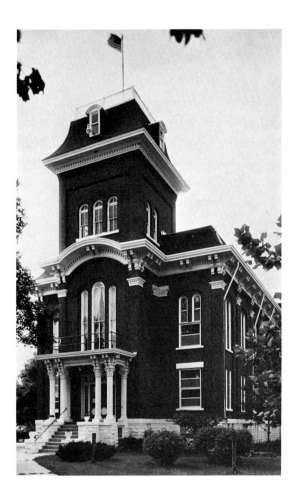
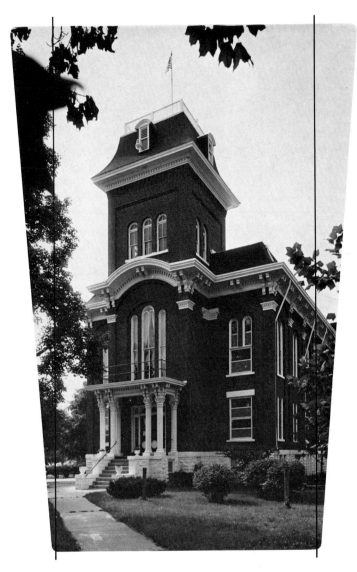

Figure 11-21 An example of perspective adjustment in projection printing: two pictures of the former Iroquois County Courthouse in Watseka, Illinois (now the Iroquois County Historical Society). Left. This photograph, which also appears as the rightmost image in Figure 9-14, shows the effects of vertical lens shifts in view camera and in 35 mm "view camera" work using shifting lenses. The camera lens was shifted upward to keep the vertical lines parallel. Right. This photograph demonstrates how those lacking such equipment can adjust perspective in enlarging. The camera was tilted back to include the top of the building in the picture. Because the camera lens was normally centered, the vertical lines converged in the image. The perspective was adjusted by tilting the enlarger easel until the lines became parallel. The enlarger lensboard was then tilted to restore the overall sharp focus. Note the "keystoning" effect: one end of the picture is enlarged more than the other; this can be corrected by cropping the image to the applied black lines. This photograph was printed from the negative from which the center image in Figure 9-14 was made.

light source, and then developing the photo paper normally; in painting with chemicals, you can modify the light, but the main process is a matter of applying photo chemicals to the paper between exposures to light.

Making Photograms

A photogram is made by selectively applying light to photographic paper without the use of a photographic negative. After processing, a pattern is produced that is strongest and blackest where the light was strongest, and lightest, or white, where little or no light struck. It can be a highly creative art form in itself. The photographer and artist Man Ray, working in the early decades of this century, claimed to have invented the form, which he called the Rayogram. However, although his work had a more abstractly artistic appearance, it was technically little different from the work of Fox Talbot, done in 1839 and thereafter, with lace, feathers, and other materials used as light modifiers (see Figure 1-3). Man Ray can be credited, however, with accommodating the method to twentieth-century art theories.

Many photography courses begin with the making of photograms, to make students conscious of the properties of light-sensitive materials, and to teach them the basics of photographic exposure and processing. You can trace light patterns with small, discrete sources such as a pencil flashlight; or you can use your enlarger or an overhead lightbulb to transmit light through or around substances or objects placed upon the paper. The pictorial possibilities are limited mainly by your imagination. (See Figure 11-22 for an example.)

Painting with Light and Chemicals

You can also learn enjoyably by painting with chemicals—with a wet finger or a brush or by the dribble method—on progressively exposed photographic paper. You may be surprised by the versatility of the method. Allowing the passage of time between exposure and painting and final fixation will produce some limited but interesting color effects, as the photochemicals and the constituents of the emulsion progressively oxidize. The colors that can be produced, running through yellows and reddish tones, are not very subject to control. But they can be quite lovely to look at. Normal fixing and washing will render all patterns and colors permanent (see Figure 11-23).

Processing the Print

Prints are processed in much the same way as films, being passed through a basically similar series of chemical baths. Print developers are somewhat more vigorous than film developers (for instance, developing a film in paper developer would probably produce enlarged film grain in most films). The short stop, fixer, and washing aid are either similar or identical in formulation to those used with films. The sequence of the process is the same as for films, but with some differences in timing.

Prints are processed either singly or in small batches of up to six sheets. Normally they are processed in a series of trays set in a row in a darkroom sink, an elongated affair. (However, at least one new paper, intended for high-quality art photography, must be processed *only* in single sheets, right through the wash, because processing in groups would result in either uneven development or physical damage to the delicate print surface.) See the instruction sheet packed with your chosen product for any special requirements.

Development

Developers can be varied according to one's desires, but most photographers do the great bulk of their work with one of the standard proprietary compounds. Perhaps the best known is Kodak's Dektol, which can also be mixed from scratch by following Kodak formula D-72 (listed in Kodak's *Processing Chemicals and Formulas*, J-1; in the *Photo-Lab-Index*; and in *The Print*, by Ansel Adams). Various other manufacturers offer a number of quite similar mixes, such as Agfa's Neutol, Duotol, or Eikonal, or Dupont's 53-D or 55-D paper developers. Some paper developers are used straight from stock, others are diluted with water. Check the specifications of your chosen product. Dektol and D-72 are usually diluted: one volume of developer to two volumes of water. Printing is carried out under safelight illumination (except when you are using a panchromatic paper to make black-and-white prints from color negatives). Use a "universal" safelight, or check the specifications of the individual paper being used for the proper safelight designation.

To be processed, the sheet of exposed paper is slid into the solution so that the developer flows over its entire surface quickly and completely, as shown in Figure 11-

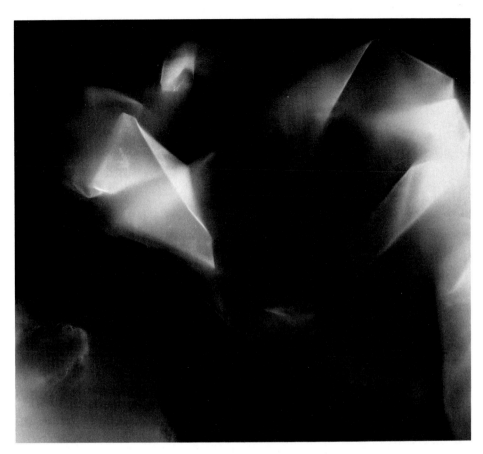

Figure 11-22 A photogram. Objects placed on printing paper under an enlarger lamp can create fascinating images and patterns. Opaque objects and those with varying degrees of translucence can be used alone or together. This image was made by placing a crumpled sheet of translucent plastic on the photo paper, and shining light from an enlarger on it.

24. Agitation can be accomplished by rocking the tray so that the developer sloshes gently back and forth across the face of the print. An irregular rocking pattern is needed to prevent standing waves (gentle, regular waves that move across the developer without actually circulating it on the surface of the print). You can also pick up and turn over the print at frequent intervals, resubmerging it carefully each time. Avoid splashing chemicals while turning the print over; chemical splashes dry out and form chemically active dust that can affect other materials. Again, as many as about six sheets can be processed at a time, if each one is kept well separated from the others and adequately agitated. Drain each print well before transferring it from one solution to the next.

Developing time is important. Too little, and the print will be low in contrast, lacking in blacks, and very likely mottled from uneven development. Too long, and unexposed portions of the emulsion will tend to develop, causing highlight values to be muddied. Contact printing papers should be developed for a *minimum* of 45–60 seconds. It is pointless to develop them longer than for about two minutes. Enlarging papers need more time. They should never be developed for less than one and one-half minutes, and can be left in for as long as three minutes. More is pointless. If a print becomes too dark in those times, less exposure is indicated, and vice versa. Standardization of development times eases reprinting. (Some paper manufacturers suggest different times in some uses. See the instruction sheet packed with the paper for details.)

Short Stop

As with films, a simple water rinse will wash off most residual developer and effectively stop image change, but an acid short stop abruptly arrests developer action, thereby easing the making of exact duplicates. It also

Figure 11-23 A painting with chemicals, light, and time on photo paper. Although black and white here, the original print shows various colors, caused by oxidation of the chemicals over time and during exposure to light. Chemical painting by A. Blaker.

Figure 11-24 Method of immersing printing paper in the developer.

protects the fixer from developer contamination, thereby extending its useful life.

Fixation

Fixation does the same thing to papers as it does to films. In fact, the same solution can be used for both paper and film. If there is a difference, it is that fixers for film have a higher percentage of an additive that hardens the film emulsion, as some workers prefer, in order to guard against scratching. Too much hardener is detrimental to papers if the surface is to be glossed or if color toning is to be done. The length of fixing time is very important. The paper base absorbs fixer, which must be washed out if the print is to be really permanent. Conventional papers should fix in five minutes, with adequate agitation and reasonably fresh fixer; but they should not be left in the fixer longer, or washing will be made more difficult, more time-consuming, and possibly less thorough. Resin-coated papers should be fixed for only 30 to 60 seconds. (See the instructions for your paper for the correct fixing time.)

Washing Aid

Washing time can be reduced, and print permanence probably increased, by using a washing aid after fixing and before washing (as it is used in developing films). This agent acts to change the residual fixer into a form that is more readily soluble in water. All prints intended for indefinitely long storage or display life should have this treatment, except resin-coated (RC) prints, which wash easily and don't retain fixer in the paper.

Washing

Conventional black-and-white papers require a one-hour running-water wash for single-weight papers, and double that for double-weight papers. The use of a washing aid reduces these wash times to 10 and 20 minutes, respectively, or less. Resin-coated (RC) paper has a water-proofed base material, and so it does not absorb chemicals. This paper washes quickly—in two minutes—and dries very rapidly. This material offers a major opportunity to sharply reduce your water use without loss of quality.

Drying

After washing, conventional papers are dried in any of several ways. In a moderately large operation it is useful to use a mechanical dryer. Previously these were all fairly sizable, but remarkably compact types have been introduced recently. See your dealer for information concerning types, sizes, and capacity.

Prints can also be air dried. You can simply hang them on a line with clothespins, or place them face down on fiberglass mesh screens. Some prefer to put them into blotter books or rolls, but this method is slow, and the blotters are likely to become contaminated and thus contaminate later prints. Squeegeeing them onto ferrotype tins is another method (see the next section). Papers other than the RC type tend to curl when air dried. They can be smoothed and flattened after drying by being pressed in a warm drymount press, or they can just be placed under a stack of books or other flat, heavy objects. RC papers lie very flat after simple air drying.

Glossing

For purposes of display or publication it is often desirable to gloss your print surfaces to a high shine. This requires that a glossy-surfaced printing paper be used, and conventional papers must be dried on a highly polished metal plate or drum. Mechanical dryers usually incorporate a

cans to apply an adhesive to the mounting board. Applying a protective mask of tape and/or paper makes it possible to restrict the application of the adhesive to a predetermined area of the mounting board. Thus, provision can be made for a wide border. The spray should be applied to the board, not to the back of the print, where it may cause wrinkling.

Double-Stick Tape

In moments of need, parallel strips of double-stick tape can be applied to the back of a small or moderate-sized print for temporary mounting on almost any smooth surface. Do not overlap the tape, or it will make edge lines visible from the front of the print. Avoid wrinkles. Be sure to carry the tape all the way to the edges of the print, to keep the edges from lifting. Watch out for air bubbles when applying the print to the selected mount board. Prints mounted in this manner will eventually lift off, but they will last long enough for most temporary purposes—at least several months, in most circumstances.

Ordinary cellulose tapes are frequently used to fasten photographic prints to surfaces. This is a poor practice because the adhesive deteriorates with time: it oozes out around the tape, causing surfaces in contact to stick together; discolors the print surface and the underlying page; and eventually loses all holding power.

Glue-Mounting

Never mount photographic prints using rubber cement as an adhesive. It contains compounds that will migrate through the photo paper to the surface of the print, where it will cause severe early deterioration of the image.

Report Illustrations

When you just need to "tip in" a photo print for a report, the quickest and simplest permanent method is to apply white glue (such as Elmer's Glue-All®) to the two top corners of the back of the print, or to all four corners, and stick it directly to the typing paper. Use only the sparsest possible application or severe wrinkling will result. The glued points will show through in most cases, but this should not matter in this context.

Very Large Prints

Very large photographs intended for permanent or semi-permanent wall display present a considerable problem in mounting. It is best done using water-soluble adhesives, such as white glue or ordinary wheat paste (available in hardware and art supply stores). Dry mounting is difficult to achieve without unsightly surface markings when the print is substantially larger than the platen of the mounting press. The most suitable substrate for very large prints is hardboard, such as Masonite®, although plywood can be used where greater thickness is needed.

Although not especially difficult to do, this method requires a little know-how if the result is to appear professional. The substrate surface must be sealed with a sizing compound, and the print to be mounted must be soaked with water and then sponged off to remove the excess. The adhesive is then brushed or rolled onto the back of the print, and the print is squeegeed onto the substrate. Care must be exercised to avoid damaging the print surface by abrading or scratching it while it is wet.

Print Spotting

It is impossible to entirely avoid dust and lint marks on prints. These print blemishes can be removed by *spotting* with one of the commercially available retouching and spotting compounds, which come either as liquids or as pigments deposited on a card. The liquid forms are used by brushing some of the liquid onto a small glass plate and allowing it to dry. The residue (or the dry pigment from a card) is then picked up in minute quantities on the tip of a finely pointed, damp brush, and appropriately deposited on the negative or print. (It may sound unsanitary, but the best solvent for these dyes and pigments is saliva.)

Enough skill at spotting to remedy most minor blemishes can be acquired with only moderate practice. For a beginner, the dry-pigment type of spotting compound is the most practical, since it forms only surface deposits on the print, and these can be readily removed in case of error. Most of the liquid forms are dyes that penetrate

Note that filter changes also affect the exposure; the second part of Table 12-2 will help you calculate a correction.

Both Tables 12-1 and 12-2 are divided into separate sections for slide printing and color negative printing. The two systems are basically opposite in their responses to color and exposure changes, but there is another important difference. Slide printing materials generally have greater latitude, so you will have to make stronger changes in exposure and filtration than you would with color negative-to-print materials.

At first it may require two or three cycles—exposure, processing, evaluation, and corrected reexposure—but once you have achieved a satisfactory print of the standard image (see Figure 12-28), you are set to start making prints of more general subject matter.

Record Keeping

Record your final test print data carefully, because you will use the same aperture, exposure time, and filtering as a point of departure for making other pictures. Every image prints a little differently, and you will seldom make a perfect print on the first try. A film image that is denser than your standard image will need more exposure, and a thinner one will need less; refer frequently to Tables 12-1 and 12-2 to fine-tune your colors. But, in general, your basic test print exposure data will continue to be a good starting point with new images, assuming you are printing the same type of film at the same degree of enlargement and on the same batch of color print paper.

As you move beyond your standard image and work with other pictures, keep a log of all your color printing. Record all significant variables, e.g., film type, enlarger height, filtering, exposure time, lens aperture, dodging and burning-in, paper batch number, processing chemicals, etc. In this way you will gradually build up a data base that will allow you to refine your basic exposure and filtration settings. It is one thing to establish data for a standard image and use them as starting points for future work, and quite a different matter to have a practical, time-proven starting point based on dozens of first-class images. It will give you solid grounding for all your work, until one of your variables changes.

Fortunately, keeping good records also makes it easier when you have to switch to a new paper batch or when

Figure 12-26

Figure 12-27

Figure 12-28

Table 12-3 Trouble-shooting guide to color print processing

Problem	Probable cause
Fingerprints, scratches	Careless handling of unprocessed paper
One edge of print OK, opposite edge splotchy	Drum not level or insufficient solution
Streaks or stains (localized)	Insufficient rinse between chemical steps (some 2-step kits require additional stop bath after developer)
Low contrast & overall stain, abnormal appearance	Cross-contamination of chemicals, e.g. failure to clean mixing or measuring utensils
Dark spots or specks	Rust or grit in water supply
Localized fogging	Paper struck with room light or safelight
Yellow or greenish highlights (neg-to-print papers)	Prewash too hot
Flat, lackluster image	Chemistry outdated or diluted
Image faint and reversed left for right	Paper emulsion-side down in easel during exposure

you blow an enlarger bulb. Either occurrence will call for some significant alteration in your basic printing data. To deal with such changes efficiently, reprint an image you have done before, preferably your standard image. Fine-tune the exposure and filtration by trial and error until you match the earlier print. Then, by comparing the previous data for that image with your new data, you can readily work out correction factors for both exposure and filtration. Adjust your basic starting data by the correction factor and you are back in business again.

Some color paper manufacturers give you a headstart on paper batch changes by providing correction data right on the packaging; the instruction sheet tells you how to use it. Some arithmetic is needed to figure out the practical printing differences between the new and the old paper, but that becomes the correction factor to give you your new starting points. Again, you may need to modify it slightly, on the basis of data from continued use.

Zeroing-In on Exposure and Filtration

The basic color printing methodology that has been described is a great way to learn the ropes. However, once you have understood these basics, you may find that determining exposure and filtration by trial and error is time consuming and can be costly in materials. Fortunately, there are some accessories on the market that will help you to predict the best exposure and/or color filtering for each new image, with much less expenditure of time and paper.

Enlarging Meters

Although not as practical and convenient as a color analyzer, an enlarging meter can simplify your choice of f-number and exposure time. Enlarging meters use a light sensor to detect relative changes in the brightness of the enlarger image, usually at the easel level. Some read the overall brightness of the entire image by means of a frosted-plastic integrator (diffuser) placed under the lens; this breaks up the image to produce an overall and smoothed-out general light level. Others have a small sensor that can make "spot" readings of highlights, shadows, or typical flesh tones.

Before you can use any enlarging meter you must first calibrate it to a perfect print from your standard image. The electronic circuitry of the meter stores the intensity reading of the light that makes this image, and when you later read the light from an unprinted image you will be comparing its brightness to the stored reference data. Some simple meters work with a constant exposure time: you vary the lens aperture setting until the image brightness matches the stored standard, and then use the same exposure time as was used to make your perfect print. More costly meters display a suggested exposure time, allowing you to choose an advantageous time/aperture combination.

If you intend to meter a specific tone in your untried images, such as the whitest highlight, you must first have calibrated the meter to the same sort of tone. If you intend to make integrated readings, you must have integrated the standard image during calibration. Many enlarger meters have numerical calibration scales; with these you can write down different calibrations (e.g., for integrated readings or for spot readings of highlight, shadow, and flesh tones) and return to whichever you choose to use at any later time.

The meter's ultimate accuracy depends directly on how well you use it. By itself, it can do nothing. To get useful readings, you must compare comparable things; otherwise, you will not receive accurate information.

Color Analyzers

Color analyzers are similar to enlarging meters, except that they have multiple channels that read all three filtration colors in addition to overall brightness. Like enlarging meters, they must be calibrated or programmed before you can use them to analyze untried images.

Again, you start by making a perfect print from your standard image. Then, with the enlarger settings exactly as they were for the perfect print, you place the analyzer's sensor probe in the projected image under the enlarger. (Here, too, you can calibrate to a spot reading of a highlight, shadow, or flesh tone, etc., or to an integrated average of the whole image.) Using the analyzer's control knobs, you null or zero-out the cyan, magenta, and yellow channels, and then set the density channel for the perfect print's exposure time. Now that particular combination of color and brightness has been stored in the

analyzer's memory and can be used later to compare to untried images. To analyze an untried image, you must, of course, use the probe to read in the same way. With the new negative or slide in place in the enlarger, you adjust the enlarger's filtration until the filtering causes the analyzer's three color channels to zero-out; finally, you adjust the enlarger's aperture to obtain a convenient exposure time (some units work only with a constant exposure time). These adjustments set up the enlarger to make a print, and if the way you are reading closely matches the calibration, you should get a good print on the first try. It may not be absolutely perfect, but it should be very close. Getting close is better than starting from scratch each time.

Color analyzers are very useful, but they are not a guaranteed quick and easy shortcut to perfect results under all circumstances. For one thing, they must be recalibrated for each paper batch. For another, they are more appropriate for printing color negatives than they are for printing slides. To begin with, you can readily assess the color of a slide image with your eye; you are making a positive-to-positive image where there is no confusing reversal of the colors. Further, most color analyzers cannot handle the more highly saturated dyes of a color slide, so there are accuracy problems. Thus, many color analyzer owners use only the density channel when printing slides, just to determine the exposure. You do not really need a color analyzer with slides. If you plan to work exclusively with color slides, you would be better off just buying a good quality enlarging exposure meter.

Filter Grids

An inexpensive, low-tech alternative to an electronic color analyzer, and a good supplement to an enlarging exposure meter, is the filter grid. As the name suggests, a filter grid is a grouping of tiny color filters arranged in rows of differing colors and in columns of different strengths; some brands have exposure-determination aids as well. Filter grids work equally well with slides and color negatives. To use a grid, the negative or slide for testing should have the image of a standard neutral gray card. You lay the grid directly on the color printing paper and expose through it. After processing and drying the test print so exposed, you evaluate it to find the spot that is closest to a neutral gray tone. This tells you the color and strength of filter required for a good color balance. Other negatives exposed under the same conditions as the test target will print well with similar filtering.

The Neutral Gray Reference Method

Color analyzers and filter grids are often used with an integrator under the enlarger lens to diffuse the image. This can work well where there is a full range of colors in the image, but it presents problems where one color predominates (such as a nature scene that is predominantly green). This effect is called *subject failure* or *scene anomaly*, and one good solution, as indicated above, is to make a neutral gray reference image.

Many color printers find it useful to expose a full-frame image of a neutral gray card on each roll of film, or at least one for each particular lighting condition found in a given photographic session. This provides a reference standard for use with a color analyzer or filter grid. When the gray-card frame is printed and a correct exposure and filter solution is found with an analyzer or grid, the same data will apply (at least in theory) to all other film frames exposed under the same conditions. In practice, it is often necessary to fine-tune the color and density of each image. But at least you start off well within the right ballpark.

Processing Alternatives

Although drum processing is possibly the best method of developing color prints for beginners, there are a number of alternatives. These range from processing in ordinary darkroom trays to automatic processing machines.

Tray Processing

At first glance, processing in ordinary darkroom trays might seem to be the simplest approach. It will work perfectly well, but the method has several drawbacks: it requires relatively more of each chemical; the large exposed surface area leads to rapid heat loss, as well as to the emission of chemical fumes and to more rapid de-

Color Plate 1. *Color wheel.* The colors opposite one another are complementary. In black-and-white photography a color filter will generally lighten its own color and darken its complementary color; the deeper the hue of the filter, the greater the effect.

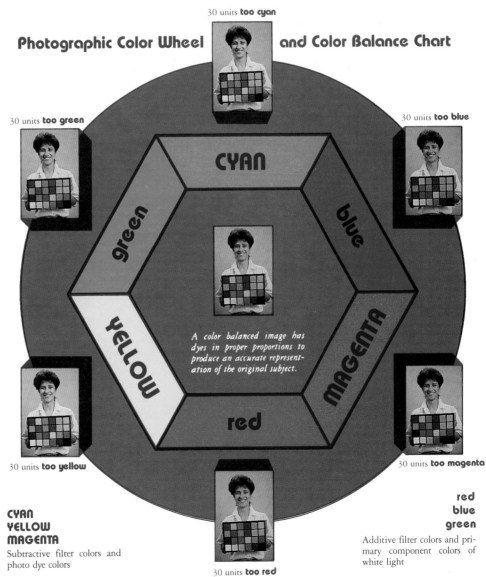

Photographic Color Wheel and Color Balance Chart

30 units **too cyan**

30 units **too green**

30 units **too blue**

CYAN

green

blue

YELLOW

MAGENTA

A color balanced image has dyes in proper proportions to produce an accurate representation of the original subject.

red

30 units **too yellow**

30 units **too magenta**

30 units **too red**

CYAN
YELLOW
MAGENTA

Subtractive filter colors and photo dye colors

red
blue
green

Additive filter colors and primary component colors of white light

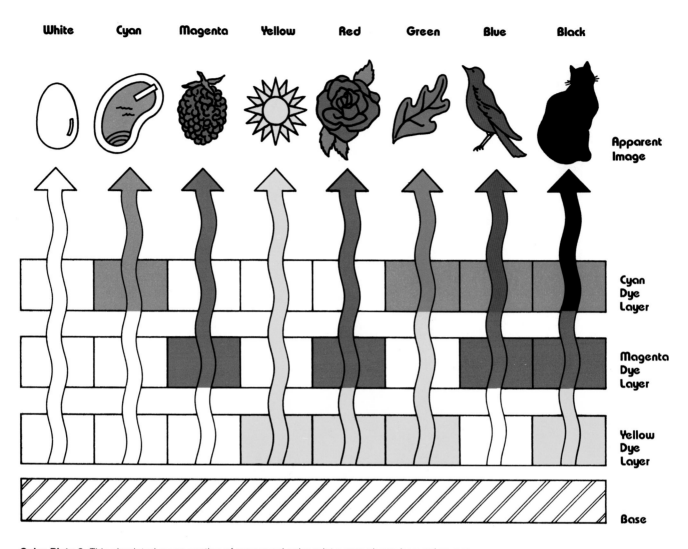

Color Plate 2. This simulated cross section of processed color print paper shows how colors are formed by the three dye layers. Note that cyan is a color that does not commonly appear in nature; we have approximated it with "swimming pool blue." For simplicity in presentation, we have shown the light emanating from the paper base; in an actual color print, the light travels through the dye layers to the base and then is reflected back.

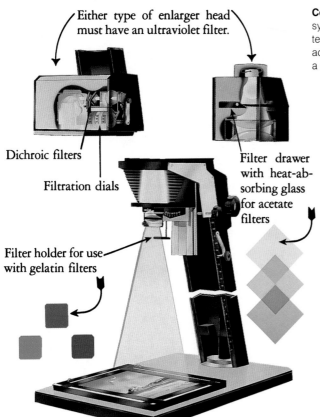

Either type of enlarger head must have an ultraviolet filter.

Dichroic filters

Filtration dials

Filter drawer with heat-absorbing glass for acetate filters

Filter holder for use with gelatin filters

Color Plate 3. Color filtration is needed in the enlarger's optical system to match the color of the light beam to the color characteristics of the print material. This can be done either by adding acetate or gelatin filters to a condenser system (right), or by using a color head with built-in dichroic filters (left).

Color Plate 6. *Tulips outlined in red* and **Color Plate 7.** *Anthurium with a photograph of a tattooed man,* both by David Lebe, demonstrate a very up-to-date view of still life work. *Tulips,* with its added-during-exposure tracery of light, shows how a relatively mundane subject can be made to take on a visual life of its own. Photo © 1982 by David Lebe.

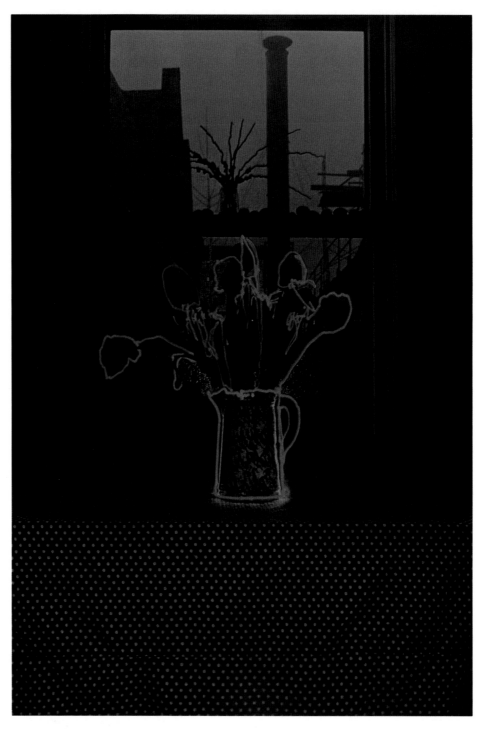

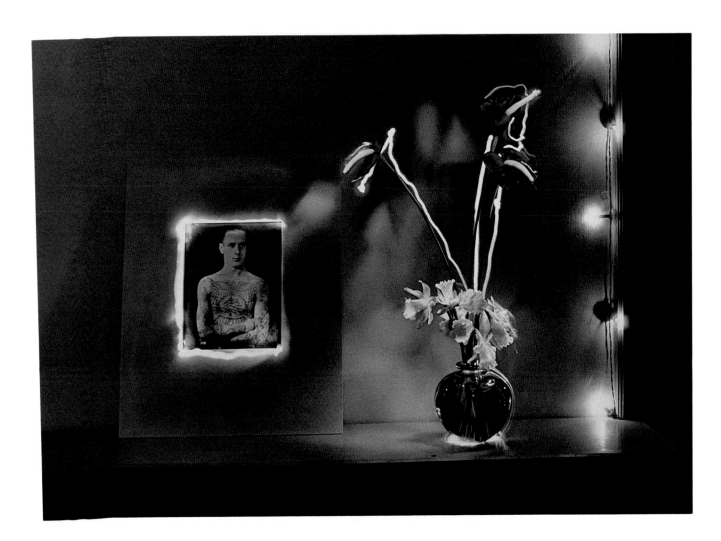

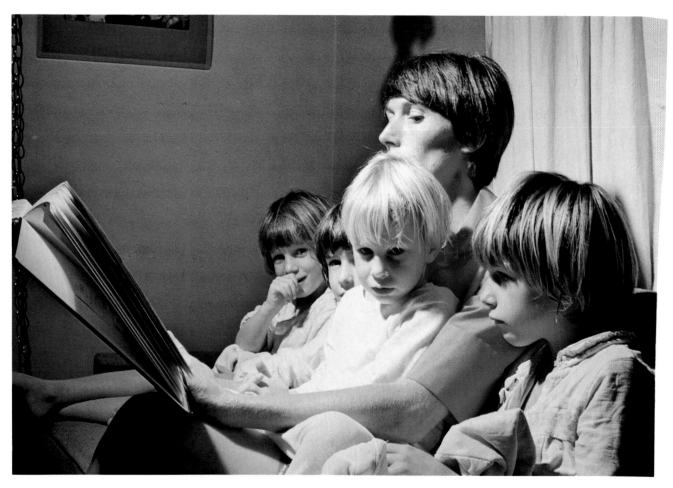

Color Plate 11. *Sally reading to the children,* by A. Blaker. This picture was made by the light of a single flash unit placed to the left of the camera at 90 degrees to the lens axis. The division of the children's attention, and their various responses to the camera, add visual interest to the picture.

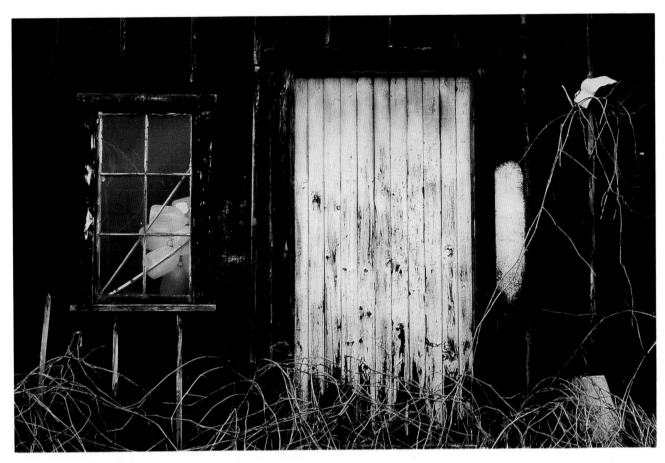

Color Plate 12. *White door and bottles, Vermont, 1982,* by Dorothea Kehaya. Here the color is so subtle that the image is virtually black and white. And yet it is not. Brilliant color is not necessarily a prerequisite for brilliant color photography. Photo © 1982 Dorothea Kehaya.

Color Plate 13. *Chateau Chevalier Winery, St. Helena,* by A. Blaker. A 105 mm telephoto lens slightly compressed the image perspective. The very sharp focus on the building emphasizes its structure as it is seen through the less sharp vegetation. The foreground framing relates the building to its surroundings and adds compositional complexity.

Color Plate 14. *Sand verbena, Ten Mile Dunes,* by A. Blaker. A 35 mm wide-angle lens was used (on a 35 mm camera) to increase the size of the foreground with respect to the distant dunes. The overcast sky provided subtle, even lighting.

Color Plate 15. *Salt ponds, from Coyote Hills,* by A. Blaker. A 105 mm telephoto lens compressed the perspective, reducing the difference in size between nearer and farther parts of the scene.

Color Plate 16. An architectural study by Elinor Stecker. It is a combination of a purely photo-
graphic tone-line transformation, with hand coloring applied afterward. © 1985 Elinor H. Stecker.

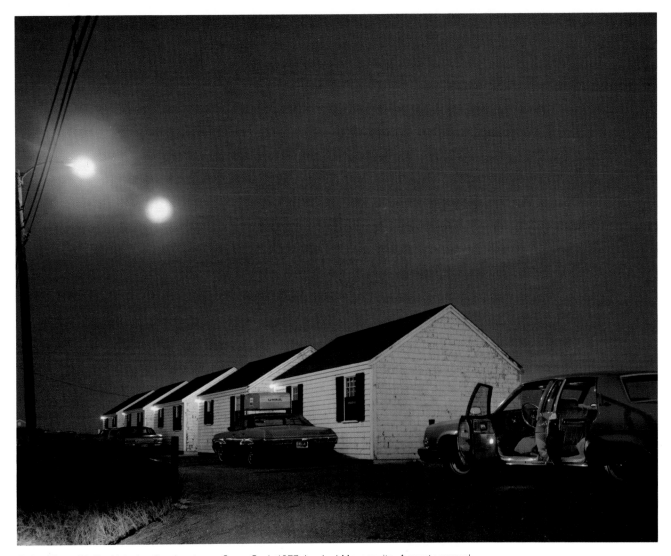

Color Plate 17. *Red interior, Provincetown, Cape Cod, 1977,* by Joel Meyerowitz. A most unusual color photograph very effectively using a mixture of existing light sources of different color temperatures. The car interior is red because the existing low-voltage incandescent lighting within is of a low color temperature. The eyes adjust quite well to color temperature variations, but color film cannot. Photographed on 8 × 10 inch color negative film, using a 250 mm wide-field lens. Photo © by Joel Meyerowitz.

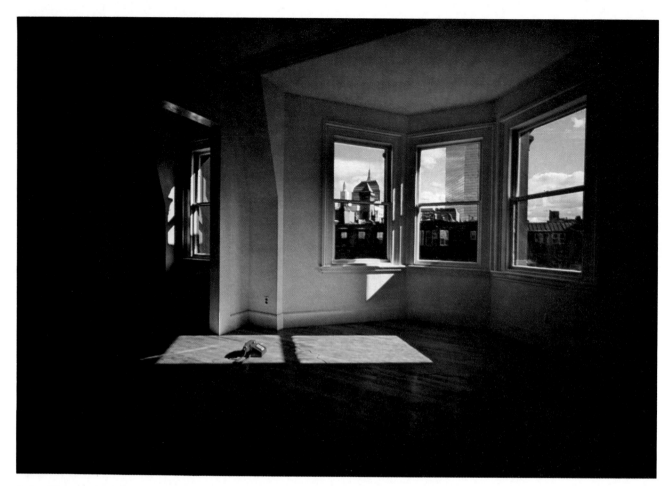

Color Plate 18. Advertising photograph made by Jay Maisel for the American Telephone and Telegraph Company. The repeated rectangles of the windows and of the patches of sunlight on the floor are very effective. The composition is quite subtle in that the eye is first attracted to the framed cityscape and only later finds the telephone. But once found, it is immediately recognizable as the real subject of the picture. Photo © 1979 by Jay Maisel.

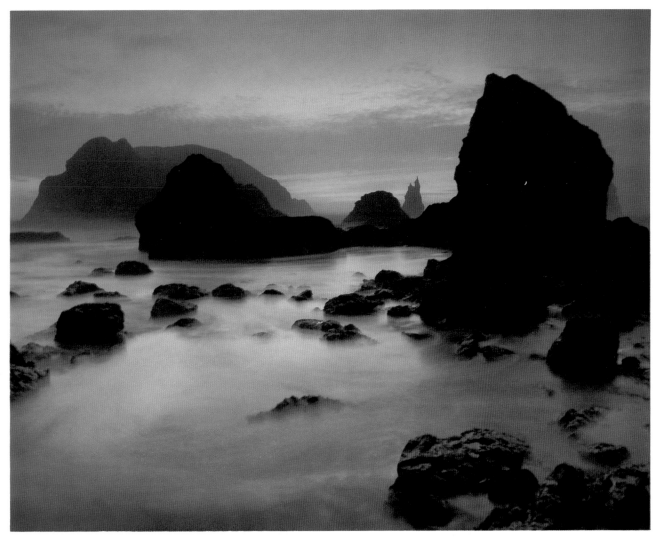

Color Plate 19. *Bruhel's Point,* by Thomas Styczynski. In this after-sunset view, the low light level required a long exposure time. That, in turn, averaged out the wave motion of the sea to produce an unreal, dreamy impression. Photo © 1985, Thomas Styczynski.

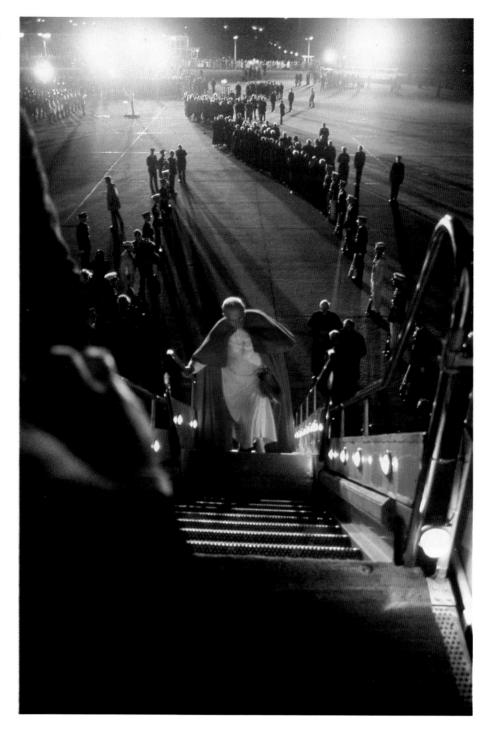

Color Plate 22. *Pope John Paul II ascending stairs into an airplane,* by Chris Sorensen. Since virtually all of the rest of the image is essentially colorless, the red and white figure of Pope John Paul, with the cape rendered translucent by strong backlighting, dominates the center of the picture. Photo © 1978 Chris Sorensen.

Color Plate 23. *Couple picnicking on the bluffs, Mendocino,* by Alfred A. Blaker. Seeing the couple enjoying a summer lunch, the photographer stopped his car and made this quick photo. The way to catch such odd moments is to always carry a camera.

Color Plate 24. *Strolling ladies, Empire Mine,* by Alfred A. Blaker. State park volunteers in costume lend period color to the grounds of a Gold Rush-era mine/country-manor in California's Sierra foothills. This is an unplanned candid moment.

Color Plate 25. *The view from Bracque's window*, by Thomas Rigney,
is a beautiful example of a carefully composed architectural photo.

Color Plate 26. *Flesh flies (Sarcophagidae).* Photographed by close-up flash at X 2 on the film, using a macro lens set at X 2/3 and supplemented by a 3 X tele-converter. It is shown here enlarged to X 7.2. The very shallow depth-of-field is evident in the wood grain.

veloper oxidation; and you have to do the entire process in total darkness.

Daylight Trays

A step upward are daylight trays. These have lightproof covers and chemical spouts, and once the exposed paper is inside, it can be processed in full room light. With ordinary trays, you move the paper from tray to tray to change chemicals. With daylight trays you drain each solution from a tray as it is spent, and then pour in the next one, just as with drums. Some models have an accessory motorized agitation device.

Processing Machines

Various color printing processes can be done with machines of a variety of sorts, however these tend to cost much more than drums and are really intended for use by professionals doing, more or less, mass production.

Resin on pine bark, Mt. St. Helena, California. This is an example of handheld close-up flash photography, using a macro lens set to an image magnification of × 1 and exposing with a very small electronic flash unit. Shown here enlarged to about × 7.

13

Close-up Photography and Photomacrography

All photographs in this chapter are
by the author.

Space expands for the observer of small subjects. Most of us will see only a finite number of grand views. But the person who sees the small vistas finds in an acre of woods or weeds as many possibilities as a good-sized state or national park may offer to the seeker of larger sights.

Whether the photographer wishes to record these vistas of the miniature world solely for the pleasure of its beauties, or from some serious concern with recording a new geography of details for science, the technical approach is the same. In this chapter, the methods of *close-up* photography (that is, of working at initial image magnifications of actual size or less) are explained, as is *photomacrography* (photography with image magnifications greater than actual size).

Close-up photography and photomacrography are no more difficult than any other kind of photography. They can be done by anyone willing to read and follow brief, simple instructions. Finding and recording things that others have not seen is an open-ended challenge, because you can find new images throughout the rest of a long life. Every household, business office, and workshop is full of subjects that would make impressive pictures, and the very small size of such subjects makes their images new and strange. As a tool for examination, analysis and recording, close-up photography is unrivaled.

Postage stamps, paper currency, and other forms of fine engraving and printing reveal much additional detail if examined closely. Coins, medallions, and jewelry are full of fine forms, patterns, colors, and textures. Coarse

Figure 13-1 Typewriter type, photographed at ×1, using a macro lens, and printed here at ×4.8.

and fine-textured fabrics can be seen with heightened clarity, and the structure of a weave or the sequence of a knit can be analyzed with ease, if an enlarged image is made. Most people who enter the world of the small turn sooner or later to nature subjects, for, with all the ingenuity of our kind, nature outdoes us for sheer variety.

Close-up photography and photomacrography differ, again, in the scale of magnification. The former ranges from images made at the closest normal focusing distances of ordinary camera lenses to images that on the film are the same size as the subject. In photomacrography (in Europe sometimes called macrophotography), image magnifications on the negative range from the same size as the subject to between 50 and 80 times as large as the subject. In this book we will deal primarily with the lower photomacrographic range, between life size and magnifications 20 times the subject's size. But similar techniques, used with special lenses and ever more careful (but no more difficult) technique, can be used for the higher magnifications.

In both close-up photography and photomacrography we are concerned with image magnification—the relation between the size of the original subject and the size of the image on the film. This relation can be expressed in any of several ways; two common methods are by pro-

portion and by multiplication. In the proportional method, for example, an image that is the same size as the subject has the relation 1:1; an image half the subject's size has the relation 1:2. In the multiplication method, an image is identified as being the same size as the subject by the notation ×1; an image half the subject's size is ×½.

In this chapter, magnifications are given by the multiplication method—for example, ×¼, ×½, or ×1 (pronounced *times* one-quarter, *times* one-half, and *times* one) —on the grounds that proportions tend to confuse. (The proportions 1:2 and 2:1 are less easily differentiated from each other than are the equivalent ×½ and ×2.) This chapter also avoids referring to a close-up lens that "lets you approach to within four inches of the subject," a notation that gives no idea of object/image relationships.

Close-up Photography

Close-up photography can be done in any of a variety of ways. We will first consider the lenses and attachments with which close-up images can be achieved, then setups and lighting sources, and finally the full technical details on how to do the photography.

Figure 13-2 *50th anniversary U.S. Air Mail stamp*: Top. The whole stamp photographed with a macro lens at ×.8, and enlarged here to ×3.62; Bottom. A detail, photographed at ×2, using a 50 mm normal lens on a bellows attachment, and enlarged here to ×16. The fine detail of the printing is clearly visible.

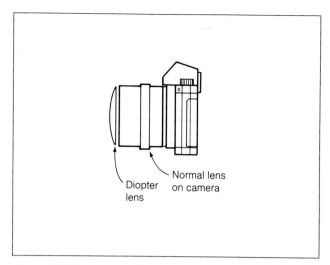

Figure 13-3 Diopter lens. Placed on the front of a lens of normal length, a diopter lens allows a closer than normal focus and thereby a higher than normal image magnification.

Lens Setups

The various approaches to close-up photography differ primarily in the types of lenses used and their methods of use.

Slip-on Diopter Lenses

The least expensive approach to close-up photography, once you have a basic camera and lens, is to use single-element lenses mounted in slip-on or screw-in rings that attach to the front of your camera lens. Called *diopter* lenses, they allow you to focus more closely than you could with the camera lens alone (see Figure 13-3). The term *diopter* is a measure of the refractive power of a lens—that is, its ability to change the direction of light rays. Diopter lenses are often sold in sets of three of varying strengths. In most sets there are lenses of +1, +2, and +3 diopters, the numbers designating relative power of magnification—the higher the number, the greater the magnification.

Plus-diopter lenses (the "plus" meaning that it is a magnifying lens) do not produce a great deal of image magnification, but are of real use in marginal close-up photography where all you need is a somewhat larger than normal image. Using diopter lenses with prime lenses of longer than normal focal length yields somewhat greater magnifications than with normal lenses. (A *prime* lens is the camera lens, as opposed to a supplementary lens attachment.)

Although it is frequently more useful to have image magnification figures, the instruction sheets that accompany sets of diopter lenses normally give the size of the field of view only. Table 13-1 lists the effects of using diopter lenses from +1 through +6 with 55 mm and 105 mm prime lenses that are focused at infinity and at one meter (39.4 inches). The effects are given as *image magnification* and *field length*: the maximum length of the subject visible along the long dimension of the 35 mm frame. To make up a similar table for each of your own prime lenses, set each lens, focused on a ruler, at its closest focusing distance. Note the field lengths by looking through the viewing screen with each diopter lens in place and recording the amount of ruler seen. Then determine the image magnifications by dividing the number of millimeters encompassed in the long dimension of the viewing screen into 36, the approximate length in millimeters of the viewing screen. If, for example, you see 72 mm of ruler, 36 ÷ 72 = .5, or a magnification of ×½. Record all of the relevant figures in tabular form for future use.

Diopter lenses require no exposure compensation. However, they do slightly impair image sharpness by introducing substantial curvature of field and other optical aberrations, particularly toward the edges of the image. Closing down the aperture of the prime lens reduces these effects.

Diopter lenses rated at +10 are also available. They provide a quick, easy method of achieving substantial magnification without the need for exposure correction. A +10 diopter lens is a very strong add-on lens, yielding an image magnification of from approximately ×.75 to ×1 or more, depending on the focal length of the prime lens. Such a lens, however, introduces extreme off-center optical aberrations. Closing the lens to its smallest aperture controls such aberrations to a degree, but not completely. Thus, their use is not recommended when important subject detail extends very far from the image center. They can be used with great success when you want an impressionistic type of picture; they are not really satisfactory for more literal uses, such as photographing postage stamps.

A useful variant of the diopter lens, the *split-field* lens, allows you to focus at two distances on separate parts of

Figure 13-4 *Feet*, photographed by existing window light, using a normal focal length lens focused at 1 meter, supplemented by a +3 diopter lens.

Figure 13-12 Pencils, photographed with a 70 → 150 mm macro-zoom lens, supplemented by its own matched 2× tele-converter. The image magnification was ×½ on the film, and is enlarged here to ×2.5.

you are reading through the converter. But in flash photography, or when you use handheld light meters, you must correct by a number of stops equal to the power of the converter.

Available-Light Close-up Techniques

Exposure

In the simplest form of close-up photography, exposures are made by available light. There is no exposure difficulty in such a situation, no matter what the lens setup, if a through-the-lens metering system is used, and if the light is strong enough to be read by the meter. You simply set the meter for the proper film speed and make a reading by the normal procedure. However, minor problems can crop up with certain subjects. If a subject is relatively small or spindly and is seen against a much darker or lighter background, the meter may not give an accurate reading. It will be best, then, to take a reading of something similar to the subject's tone and lighting, or to back your subject during the reading with an 18% gray card.

Readings with a separate, handheld light meter do not take into account the special exposure requirements of most close-up setups, so you will have to calculate the necessary compensation as follows:

1. Diopter lenses require no compensation.

2. Tele-converters require an exposure increase of the number of stops equal to the power of the converter: for example, two stops for a 2× converter, three stops for a 3×. Make the correction by any of three methods:

 a. Open the lens aperture the required number of stops.
 b. Slow the shutter speed by the required number of settings.
 c. Do a combination of a and b—i.e., for a 2× converter, open the lens by one stop and slow the shutter one speed.

3. Macro lenses and normal lenses on tubes or bellows require an exposure adjustment based upon the image magnification factor (see Table 13-2). A very few types

exhibit some flare at wider apertures—especially when pointed at or near a light source. Flare at wide lens apertures is a problem with zoom lenses generally, but can be corrected by closing down (and, of course, watching out for potentially troublesome light sources). For most photographers, the zoom's speed of use and versatility more than make up for any disadvantages.

If a macro-zoom lens is used with any form of tele-converter, exposure correction becomes necessary. Reading light with a through-the-lens meter is self-correcting:

Figure 13-13 *Champagne bottle being checked at a winery for sedimentation.* (The bottles are placed in a pierced wooden holder called a riddling rack—a lightbulb, whose cord can be seen here, transilluminates the bottle, allowing the sediment to be seen.) The image, made by existing lighting and with a macro lens, is enlarged here to a little over actual size.

of macro lenses have a built-in self-compensating lens aperture requiring no corrective action. If present, this feature is noted in the manufacturer's instructions.

4. Most macro-zoom lenses require no compensation. If they do, it will be only when the image magnification is ×.25 or over (see the manufacturer's instructions for details). Any compensation needed will also be based on magnification, so consult Table 13-2.

Motion Control

Photographers doing close-up work face motion problems from two sources: the subject and the camera. Either type of motion will blur the picture, and this is often undesirable. Subject motion in available-light photography is controllable at least in part by using a high shutter speed. It may sometimes be possible to take advantage of moments of stillness to use slower speeds. High shutter

Table 13-2 Compensatory exposure adjustments for close-up photography

Image magnification	Open lens (or slow shutter) by:
× ¼	½ stop
× ½	1 stop
× ¾	1½ stops
× 1	2 stops

speeds pose the disadvantage of requiring relatively wide lens apertures—even when fast films are in use—and thus result in shallow depth of field in the picture. However, shallow depth of field is not necessarily bad: you can use it to isolate a small subject from a "busy" background—one in which there is so much detail that it would be visually distracting if sharply focused.

Most unsharp pictures are the result of camera motion. When the camera is handheld it is best not to use a shutter speed slower than $1/125$th of a second. If you must use slower speeds, rest the camera or the bottom of the lens mount on a rock or a stump or, if you are indoors, on a table. If you *must* have maximum depth of field, you will probably have to use a tripod, which severely limits the speed and ease of your work. Handheld work with small lens openings is best accomplished through the use of flash photography, discussed later.

Clamp Bars and Framers

Some easily constructed attachments can greatly ease the problems of working with existing lighting, and of dealing with some types of rapidly moving subjects. A device of staggering simplicity makes it possible to do close-ups of inanimate subjects while using slow films, small lens apertures, slow shutter speeds, and any type of existing light (so long as it is correct in color; see Chapter 8, on filters), and still have sharp pictures. The only requirement is that the subject not be too flimsy, and that it be something that you can place in a small clamp.

In this method, the subject is connected to the camera by means of an adjustable clamp bar, so that there is no relative motion between the subject and the camera during exposure. Fastened to the base of the camera is a bar fitted with a sliding joint that holds a vertical arm up in front of the lens. On the arm is a clamp to hold the subject. You may want to incorporate a small ball joint

for ease of manipulation. Focusing is done by moving the vertical arm along the support bar. With the subject properly positioned and in focus on the camera viewing screen, you can handhold the whole assembly and turn about so that the existing light falls on the subject in any way that you want. Or you can average the lighting, similar to light painting (see Chapter 7), by constantly moving the assembly relative to the light source throughout a time exposure.

A clamp bar can be easily made from wood dowels, obtainable at lumber yards or hardware stores; see Figure 13-15 for the details of construction. Or you can build or buy a more elaborate version made of metal.

When wind makes it difficult or even impossible to keep flowers or other outdoor subjects in the camera viewfinder, a simple wire framer can help you follow the motion. This framer can be made in one piece connecting directly to the camera, or it can be attached to the clamp bar mentioned above. See Figure 13-16 for details.

The framer is made by bending a piece of utility wire to an L-shape the size and proportions of the subject area at your working magnification. It is supported in front of the camera so that it is in focus and so that it delineates the bottom and one side of the picture area. Adjust its position while looking at the camera's viewing screen. In use, you need not look into the camera to frame and focus on a subject. Just hold the camera/framer assembly so that the subject is kept within the frame boundaries, moving the assembly as necessary to follow subject motion, and expose when ready. You will need a fairly high shutter speed—it may even help to use flash—but at least you'll be able to see what you are doing.

Close-up Flash Photography

The most versatile method of close-up photography is close-up flash technique, which can be used with any small subject, live or inanimate, indoors or out. It combines complete control of lighting, great depth of field, and the ability to completely stop both subject and camera motion in a single, easily learned handheld camera method. You hold a 35 mm SLR camera in your right hand (few cameras are built to be operated with the left hand) and a small electronic flash unit in your left hand, the two being connected only by the flash-synchronization cord. The camera, set in advance to the desired

Figure 13-14 *A honeybee visiting a teasel flower.* Photographed by natural sun backlighting; the handheld camera was set at 1/125th of a second at f/11. Depth of field was therefore quite shallow. Photographed at ×1 and enlarged here to about ×6.

image magnification, is focused by being moved toward or away from the subject (see Figure 13-17).

The most practical lens is a macro lens of normal focal length. You can also use any other normal focal length lens on auto-diaphragm extension tubes. Long-focal-length lenses, such as 90 mm and 135 mm close focusing lenses, can be used to obtain longer working distances with shy subjects, but you may need a more powerful flash unit.

Handholding the camera makes for versatility and speed of operation. Tripods slow up close-range photography and tend to inhibit one's vision through enforced immobility. Because the flash unit is mobile, you can change the lighting angle at once, even as you are focusing the camera, to meet last-second changes in the subject's position.

With its extremely short duration, electronic flash can stop any but the most extreme subject or camera motion. With the flash unit placed very close to the subject, the light is locally very strong—overpowering even direct sunlight—and allows closing the lens aperture down to its smallest opening to gain depth of field, even when slow, fine-grain films are used.

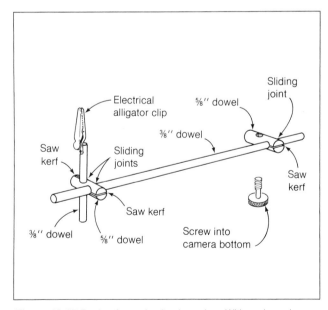

Figure 13-15 Design for a simple clamp bar. With a clamp bar, you can fasten the subject to the camera so that there can be no relative movement; thus, with suitable subjects, you can do handheld close-up photography in any lighting and at any shutter speed, without the risk of unsharpness.

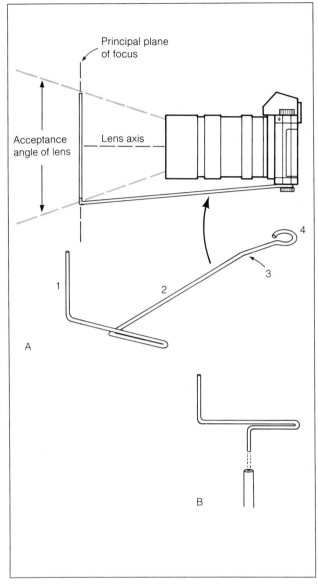

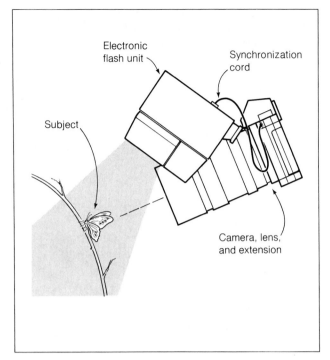

Figure 13-17 Close-up flash photography: the camera and the flash unit are handheld, and are connected only by the flash synchronization cord.

Flash Sources

Close-up photography can be done with ordinary flash equipment. Flashbulbs and flashcubes can be synchronized with the shutters of most 35 mm SLR cameras to speeds as high as 1/1000th of a second. The most useful flash equipment for this purpose, however, is a small electronic unit with a flash duration of 1/1000th of a second. This is fast enough to stop all ordinary subject and camera motion. With fresh alkaline batteries, such a unit will give about 150 flashes or more before the batteries need replacement.

In close-up flash photography using automatic flash units, it is often best to turn off the feedback circuitry and use the manual setting, which draws the unit's full power for each exposure. This allows you to use the slowest, highest-quality films, and to use the small lens apertures that provide the most depth of field.

Figure 13-16 Framing and focusing devices for close-ups. A. A typical framer: an L-shaped frame (1) outlines the field of view on only two sides. To avoid having its shadow cast on the subject the L is the same height and width as the subject area covered in the optical setup—the dimensions will vary with image magnification. The support section (2) is just long enough to place the L-frame at the exact plane of focus, and is bent down slightly (at point 3) to allow for the wider viewing area as the lens-to-subject distance increases. A loop (4) allows the framer to be attached to the base of the camera with a standard camera screw. B. A design for a framer that fits into a hole in the end of a reversible vertical post in a clamp bar assembly as shown in Figure 13-15.

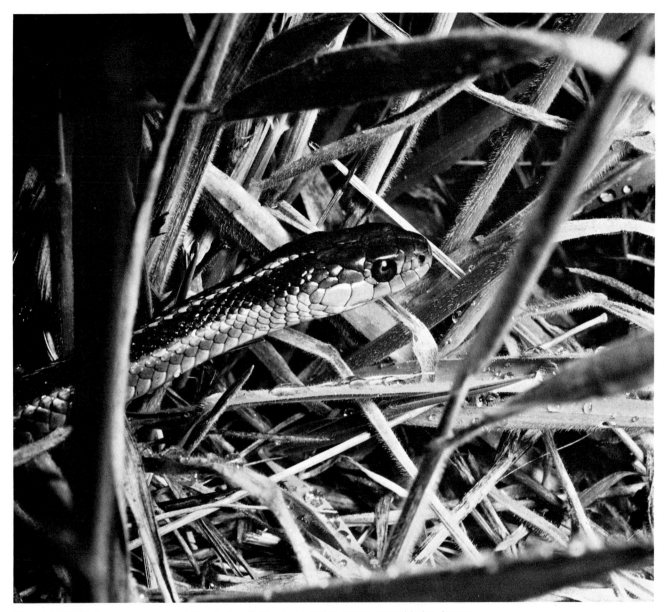

Figure 13-18 *Western garter snake at Mendocino, California*, in motion among grass blades. It was originally photographed on Kodachrome at a magnification of ×½, and is reproduced here at ×3.25. Close-up flash technique was used, with an M3B flashbulb synchronized at 1/1000th of a second to stop the motion, and a lens aperture of f/32 used to obtain good depth of field.

Close-up Flash Technique

The best method of learning and applying the close-up flash technique is a by-the-numbers sequential approach. These are the steps, and each will be explained in detail after the listing.

1. Determine the desired image magnification (m).
2. Set the lens aperture, as you choose.
3. Determine the effective aperture (EA).
4. Determine the effective flash guide number (GNe).
5. Determine the correct flash-to-subject distance (FD).
6. Choose both the camera angle and the lighting angle.
7. Hold the flash unit at the correct angle and distance.
8. Focus the image by moving the camera toward the subject while viewing.
9. Expose.

All this is less time-consuming and difficult than it initially seems. It can all be done in seconds.

Image Magnification

Usually, you decide the image magnification to be used by measuring or estimating the size of the subject or subject area, and dividing that figure into the known dimension of the film frame (in 35 mm work, this is 24 × 36 mm, or about 1 × 1½ inches). Thus, a subject just under 36 mm long would fit onto the film at ×1; and a subject area of 4 × 6 inches would require a magnification of ×¼, or ×.25.

Here we are dealing with *linear magnification*, and not area magnification. Linear magnification is the relationship between the length of a subject dimension and the length of its image on the film. It is a matter of multiples.

In print, a given magnification figure is preceded by a multiplication sign (×), as was mentioned earlier. When spoken, a magnification of ×1 is pronounced "times one" (it is an error—often heard—to call it "ex one"). This same term will also be used in photomacrography, as will be discussed.

Lens Aperture

There are two choices here: you can opt for maximum depth of field by using the smallest lens aperture (f/16, 22, or 32) on your lens; or you can use some larger aperture in order to limit depth of field, thereby visually isolating your sharply focused subject within a less sharp foreground and background—this is called *selective focus*. Most times, though, one main reason for using flash lighting is to gain maximum depth of field.

Effective Aperture

Since the lens has been moved out unusually far from the film to gain image magnification, the f-number designation no longer serves to give correct exposure information. Although the aperture remains the same diameter, however set, the ratio between its open diameter and the distance between the lens and the film has changed. So you need to determine an "effective" aperture designation, both to figure exposures and (as will later be reviewed) to deal with image diffraction in photomacrography. To find the effective aperture, use Formula 13-1:

Formula 13-1 Determining effective aperture

$$EA = f \times (m + 1)$$

Key:
- f = lens f-number
- m = image magnification
- 1 = a constant
- EA = effective aperture

To use a pocket calculator, follow this punch-in sequence:

$$m \oplus 1 \otimes f \ominus EA$$

Suppose that you use a lens setting of f/22 and an image magnification of ×.75 (×¾):

Key:
- f = 22
- m = .75
- EA = ?

$$.75 \oplus 1 \otimes 22 \ominus 38.5$$

The effective aperture here is, close enough, EA 39.

A further point: if you are using a macro lens with an automatic diaphragm, or a regular lens with an auto-diaphragm extension tube, the lens aperture does not actually close down when you set it. It does close, however, when you press either the "preview" button (which lets you examine its effect on the ground glass image) or the shutter release.

Effective Guide Number

Low-power electronic flash units are usually the best choice for closeup work. When you use small lens apertures (for maximum depth of field) and slow films (for best image quality), low-power units will require short flash distances—usually well under a foot. Short flash distances give soft lighting without harsh shadows. Why? Because, relative to small subjects, the flash emitting head of the unit is large and when only a few inches away is very like a skylight in normal photography. The same unit used at normal distances, e.g., 6 to 12 feet, would be virtually a point light source, from the subject's point of view, and would light more harshly.

The effect is enhanced because of a design "problem" that actually helps you here. Flash unit reflectors are designed to produce their maximum light output at the long normal distances. Used very close to the subject, they are less efficient. Small flash units, however, work just fine at short distances if you simply halve the normal GN. This is so with virtually all small flash units. And the lighting produced is then softer and better.

It is simple to find the figure. See the instruction booklet for your flash unit, or set the unit's calculator dial for your chosen film speed and then look to see what f-number falls opposite the 10-foot distance marker. Multiply that f-number by 10 and you have the normal GN for that film. If, for example, f/5.6 falls opposite the 10-foot marker, the normal GN is 56. Cut that in half and you have a GNe of 28. (This GNe is for closeup use only.)

Flash Distance

Once you know the effective aperture and the effective guide number, you can use Formula 13-2 to find the flash-to-subject distance (FD) that will result in a correct film exposure.

Lighting Camera Angles

The lighting angle will depend on the camera angle (which is simply the direction from which you will want to view the subject) and on how you want the subject to appear. The latter will depend on the shape of the subject and the features you want to emphasize.

A good beginning rule is to hold the flash unit near

Formula 13-2 Determining closeup flash-to-subject distance

$$FD = \frac{GNe}{EA} \times 12$$

Key: GNe = effective guide number

EA = effective aperture

12 = a constant that converts the FD into inches (using a foot GN)

FD = flash-to-subject distance (in inches)

To use a pocket calculator, follow this punch-in sequence:

GNe \oplus EA \otimes 12 \ominus FD (inches)

(Changing the constant to 30, by the way, would give the FD in centimeters, from a foot guide number.) The following is an example, using the precalculated figures:

Key: GNe = 28

EA = 39

12 = constant

FD = ?

28 \oplus 39 \otimes 12 \ominus 8.6

In this case, the correct flash-to-subject distance will be 8.6 inches.

the lens axis (somewhat above it), pointed toward the subject. Keep in mind that lighting in nature virtually never comes from below the subject. If the subject is an insect or other small creature, position the light so that it particularly illuminates the head end, unless you have a special interest in some other part of it. This will give generally good overall lighting.

Holding the Flash Unit

Hold the flash unit in your left hand and the camera in your right hand. Most cameras are constructed so that they require right-handed holding, for one-handed operation. The flash unit should usually be connected to the camera only by its synch cord, so that you can move the camera and the flash unit independently. This will promote fast, flexible work.

Place the flash unit at the right lighting angle and at the correct flash distance, as nearly as you can judge. Then keep it still while focusing and exposing with the camera. If in doubt about the results, make several exposures, varying the lighting angle and/or the flash distance each time.

Figure 13-19 Close-up flash picture of a cat, made with a 70 → 150 mm macro-zoom lens set at ×¼, and shown here enlarged to about life size.

"Fooling" Automatic Flash Units

The general instructions for close-up flash method assume that your flash unit does not have automatic feedback exposure control, or that it is shut off and the "manual" mode is being used. You can stop exceedingly fast subject movement by requiring the feedback control of an automatic unit to cut the flash to its shortest possible duration. With most flash units this is 1/30,000th to 1/50,000th of a second—quite sufficient to stop most actions such as the movement of a bird or insect wing.

With OTF/flash equipment, all you need to do to get ultra high speed flash is to work at the short end of the flash-effective range of the FD (see Table 13-3). For example, using ISO 25/15° film and an effective aperture of 32, place the flash head about 3 inches from the subject and you will get, with the Olympus T-32 unit, a flash duration approaching 1/40,000th of a second.

With more conventional auto-feedback electronic flash units, it is a little different. If the subject is part of a larger object or if it is very close to its general background, so that the sensor picks up the reflected light in a way that results in correct exposure, you can simply set the unit on its automatic mode and work normally— if the f-number used with the automatic mode suits your needs, and if the degree of image magnification imposes no need for exposure compensation. But if there is significant magnification or if you need maximum depth of field, you will have to work differently. You will have to calculate the effective GN of your unit when it is set for minimum normal working distance. For example, assume that an automatic flash unit indicates that, with a film rated at ASA 64, an aperture setting of f/8 should be used for distances between 2 and 10 feet. At two feet, the flash duration would be at its shortest. You can use this information to derive a guide number by simply multiplying the distance (2 feet) by the aperture (f/8), which equals 16, the effective GN at the shortest flash duration normally usable. Dividing this effective GN by the EA, as in step 4 of close-up flash technique, will give the correct flash-to-subject distance for stopping very fast subject motion at close distances. If the EA were f/32, this distance would be .5 feet, or 6 inches.

If the flash unit is to operate correctly, the flash emitted must be picked up by the sensing element from no more than two feet away, for if it senses at a greater distance the light output will be greater and of longer duration than you calculated. "Fooling" the unit is accomplished by placing a suitable reflecting surface within that distance, located so that it is struck by the emitted light and

Figure 13-20 Close-up flash picture of the woven pattern of a necktie, made with a macro lens set at ×1; the image shown here is enlarged to ×4.

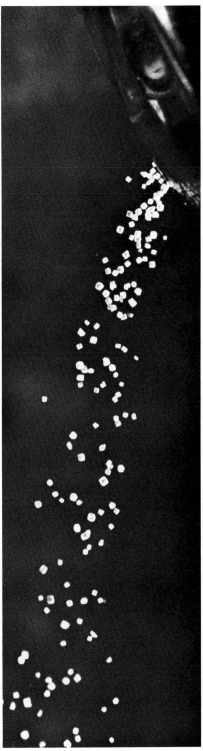

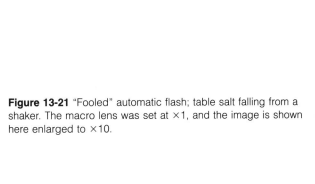

Figure 13-21 "Fooled" automatic flash; table salt falling from a shaker. The macro lens was set at ×1, and the image is shown here enlarged to ×10.

Close-up Flash Photography **359**

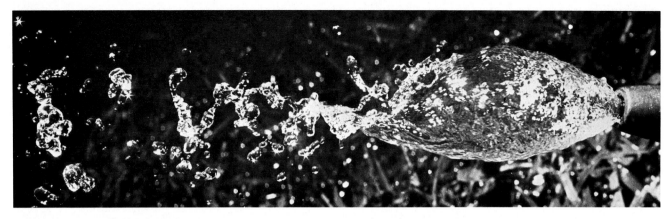

Figure 13-22 "Fooled" automatic flash: a water jet from a sprinkler. The effective aperture was f/22. The image, here enlarged to ×1, was made with a 70 → 150 mm macro-zoom lens set at ×¼.

is in a position to be "seen" and sensed by the flash unit's sensor. This method may at first glance seem like a bit of trouble to go through, but it really isn't difficult, and there is no cheaper or more convenient way to get very short flash durations.

Flash Synchronization

Most 35 mm SLR cameras use focal-plane shutters that expose film by passing a slit in a moving curtain across the film. Shutter speed is varied mostly by changing the width of the slit. Since electronic flash durations are so very short, the whole film frame will be exposed to the light of the flash only when the width of the slit equals the full width of the film frame. And this occurs only at the slow shutter speeds—usually no faster than 1/60th of a second and rarely faster than 1/125th of a second. Thus, to correctly expose the full film frame in close-up flash photography using electronic flash, you must use the correct flash synchronization setting of your camera.

Photographers new to close-up electronic flash work sometimes worry that the necessary slow shutter speed will not adequately stop subject motion, or that ambient light on the scene will overexpose the film. Neither matter is a problem, for in this technique the effective exposure time is the duration of the flash. The shutter serves only to limit the effect of ambient light. It is helped in doing so by the use of slow films and small lens apertures. With a film speed of ASA 64, an effective aperture of f/32, and a shutter speed of 1/60th of a

second, even a subject lit by direct sunlight will be underexposed several stops. Effectively, the only exposure is that produced by the flash—and it is brief enough to stop all ordinary motion.

Many cameras have two sockets for connecting the flash synch cord: one is labeled X; the other, M or FP. Electronic flash synch cords should always be plugged into the X socket. Cameras with a single socket have some sort of switching device with similar markings. Be sure to set it for X synch. (On a few cameras it is designated FX, but an "X" in the marking is the indication of electronic flash.) On a few cameras, the shutter setting for electronic flash is usually between 1/60th and 1/125th of a second, and is marked only by a miniature symbol of a lightning bolt.

The M or FP socket (or the other designations that may be found on single-socket cameras) are for synchronizing the shutter to the ignition of flashbulbs or flashcubes. With X synch the shutter opens, the flash unit fires, and the shutter closes. But flashbulbs require a significant time to ignite and reach proper brightness before the shutter opens; then they burn for a longer duration, usually about 1/50th of a second, before extinction. (Refer back to Figure 7-17.) Flashbulb cartons display instructions for use, and your camera instruction booklet will tell you what synchronization setting to use for each recommended type of bulb, if there is more than one possibility.

If you connect either electronic flash or flashbulbs to the wrong socket, you will get no picture: plug electronic

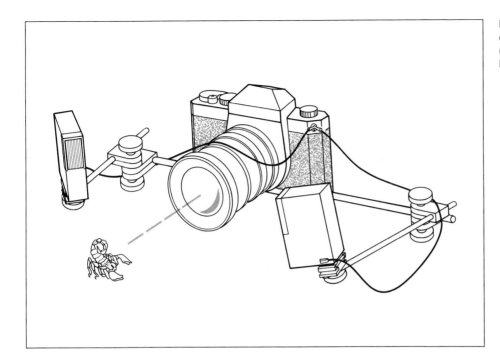

flash into the M or FP socket and the flash will fire before the shutter opens; plug a flashbulb unit into the X socket and the flash will fire after the shutter has closed. With electronic flash, if you use a shutter speed higher than is specified you will expose only a portion of the film frame—the higher the shutter speed, the less picture you will get. (Refer back to Figure 7-18.)

Flashbulbs and flashcubes are more versatile than most electronic flash units in that they can be synchronized at any shutter speed. The shutter acts to chop the available light output into shorter segments of your choice. Therefore, you will have a choice of guide numbers (only electronic flash units with varying power settings offer a choice of GN). If you decide that you need more light, you need only choose a slower shutter speed.

With OTF/flash cameras you can usually use other flash equipment, both electronic flash and flash bulbs, in the normal manner and with ordinary flash synch cords, simply by following the manufacturer's instructions. However, to use the dedicated flash unit in the OTF metering mode you *must* use either the camera's own "hot" (electrically active) shoe mount or a special synch cord meant for the OTF connection. Ordinary synch cords have a two-wire coaxial connection. OTF cords have, usually, a three-wire cord with a multiple-pin or multiple-flat-contact connector. Be *sure* you use the right cord, with OTF camera/flash equipment.

Flash-to-Camera Brackets

When doing close-up flash photography by the two-handed method described, you may discover that there is some uncertainty about whether a negative will be properly exposed. The great flexibility and speed in changing the lighting angle exacts the cost of occasional overexposure or underexposure. Flash brackets are devices that can help to increase exposure certainty in two ways. (See Figure 13-23.) Each involves a compromise—one method affects flexibility; the other, quality of lighting.

If you are doing repetitive work that requires that the lighting angle always be the same, or if you just cannot get the hang of working two-handed, it will be useful to use a bracket to hold the flash unit at the correct distance and angle. Keep in mind, though, that changing the lighting angle will be a little slow. In most repetitive-

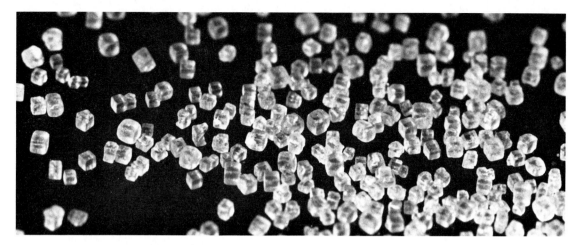

Figure 13-24 Table salt, photographed at ×3 with a macro lens set at ×1 and supplemented with a 3× tele-converter. The image is enlarged here to ×25.

photography situations, this limitation should not be a major problem.

For subjects that are likely to move around unpredictably, you would do well to use a two-light, double, articulated bracket. Place one flash unit on each side of the camera, each pointed in and down at the subject. Thus, no matter which way the subject turns, it will be well lit. This method, however, often results in rather flat, uninteresting lighting effects. But at least one unit lets you switch the flash units off or on separately.

OTF/flash cameras usually provide some way of doing closeup work with the dedicated flash unit sitting in the camera's hot shoe. Thus, a flash bracket is built in. For example, the Olympus OM-2N camera has a hot-shoe connector atop the prism housing. When the T-20 or T-32 flash unit is put on it, you can swivel the flash-emitting head downward to point it at a close subject or, alternatively, you can swivel it upward for bounce flash lighting. This will provide good general lighting for most subjects.

Photomacrography

The optical setups for photomacrography are primarily extensions of the close-up methods already described. They are no more difficult to learn or to do, but they require a little more care. As image magnification is increased, both depth of field and field size decrease. Focusing therefore becomes more critical, and it becomes more difficult to keep the subject within the viewfinder frame in handheld photography. Beyond about ×3 magnification, it is more practical to work on a table or other flat surface, usually with the camera mounted on some sort of focusing stand.

Lens Setups

There are several ways to set up a camera for photomacrography. Two methods are very suitable for beginners.

Tele-Converters

When doing close-up photography there is often an urge to try for just a little more image magnification. One of the simplest and quickest ways to do so is to add a tele-converter to an already existing close-up setup. Assuming that you are starting with a macro lens, set at ×1, you need only insert between the camera body and the lens a 2× tele-converter to have a ×2 setup, or a 3× converter to have ×3. You can even "stack" the converters; a 3× converter added to a 2×, behind a basic ×1 closeup arrangement, will produce a ×6 image magnification.

Table 13-4 Photomacrography with tele-converters; image magnification and exposure correction

Power of converter	Image magnification[a]	Number of stops for correction
2×	×2	2
3×	×3	3
2× + 3×	×6	5

[a]With prime lens set at ×1.

Table 13-5 Progression of high f-numbers[a]

32	128
45	180
64	256
90	360

[a]Note that each second one doubles.

This method is simple and direct. It requires an exposure adjustment, but so does any other method of increasing magnification. The exposure adjustment is easy to work out. You can adjust the exposure by opening up the prime lens aperture the number of stops equal to the power of the converter, when using a single tele-converter. A 2× converter requires a two-stop correction, and a 3× requires three stops. With stacked converters you add the powers together; thus a 3× used with a 2× will require five stops of exposure correction. (Note: to calculate magnification, *multiply* the powers; to calculate exposure correction, *add* the powers.) See Table 13-4.

Should you want to keep the prime lens aperture closed down to maximize depth of field, you can adjust the exposure by lengthening the exposure time, moving the shutter speed dial one setting slower for each stop of correction needed. If you are using flash, you can adjust exposure by shortening the flash-to-subject distance. If you have already worked out a flash distance for ×1 magnification, cut that distance in half when you add a 2× tele-converter, to about one-third with a 3×, and to about one-fifth when using 2× and 3× converters together. These will result in very close approximations.

As image magnification increases—whether through the use of tele-converters or other means—there are practical limits to how small the aperture setting can be without significant loss of image sharpness through diffraction (a lens aberration, described in Chapter 4, in which a small aperture causes light waves to interfere to some degree, at the expense of image sharpness).

To determine when diffraction is likely to become a problem, it is useful also to figure out the EA of a photomacrographic system incorporating tele-converters. We have seen earlier that a lens set at f/11 has an EA of f/22 at an image magnification of ×1, using either a macro lens or a normal lens on extension tubes or bellows. If you add two extra stops of correction, for a 2×

tele-converter, the EA will then be f/45 (or f/64 with 3×). Using both converters, stacked, requires five stops correction, and this would raise the EA from f/22 to f/128. (Table 13-5 lists the progression of high f-numbers, beyond the normal range.)

These are not impossibly small EAs for acceptable exposures. You can work to a practical top limit of about f/128 with moderate diffraction. Beyond that, there is an unacceptable loss of image sharpness. Thus, if you start with a small marked lens aperture, you cannot add too many exposure corrections before it becomes necessary to correct at least in part by opening up the prime lens aperture.

In addition to simplicity and speed of operation, there is one excellent reason for using tele-converters to increase magnification. Inserting a converter between the camera and the lens increases image magnification while leaving lens-to-subject distance unchanged. But when you accomplish the increase in magnification by simply extending the lens farther out, working distance rapidly decreases. Any method that preserves the working distance is welcome, because this retains room for lighting the subject. (Moreover, a tele-converter, unlike a bellows, allows the diaphragm to operate automatically.)

With a 55 mm macro lens set at ×1, the lens-to-subject distance is about 2¼ inches. You can increase magnification to ×6 by using stacked tele-converters and still retain that 2¼ inches. But, as we will see later, if you use the same macro lens on a bellows, extending it out to a magnification of just ×4.2 will reduce the working distance to only about ⅜ths of an inch. Going higher would place the subject at or within the lip of the lens mount (macro lenses have unusually deep built-in hollow-cylinder lens shades housing much of that focusing mechanism, as a necessary consequence of their extended focusing range).

You may have read that stacked tele-converters impose

Figure 13-25 Image diffraction at high magnification: a dandelion seed, photographed at ×6, using a macro lens set at ×1 and supplemented by both a 2× and a 3× tele-converter. The image was enlarged to ×43.5. Top. The effective aperture was f/90; sharpness in the principal plane of focus is good. Bottom. At EA f/256, diffraction has degraded the image. Although depth of field is greater, there is diminished sharpness.

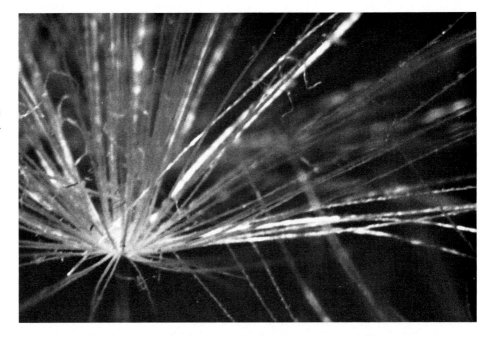

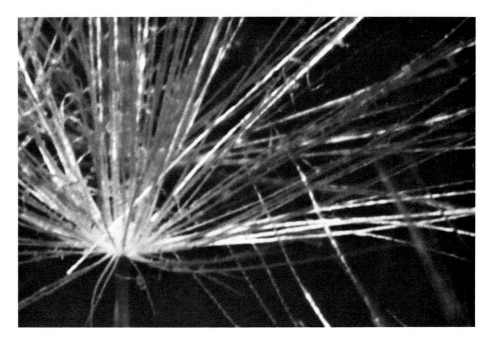

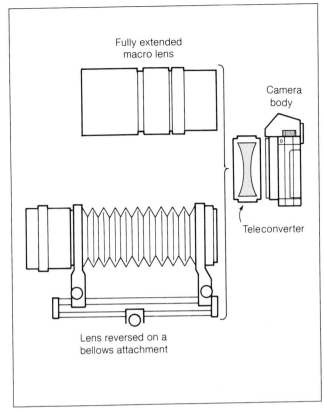

Figure 13-26 Adding a tele-converter increases image magnification into or within the photomacrographic range. Any basic optical setup can be so augmented.

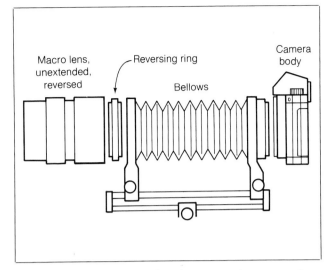

Figure 13-27 Photomacrography using a macro lens reversed on an extended bellows attachment.

image quality loss, but, if you start with a good prime lens, if you see to it that the effective aperture is not too small, and if no motion problems creep in, the image quality will be surprisingly good.

Lenses on Bellows

The classic photomacrographic method is to use a bellows to extend the lens well out from the camera, and then use the EA method of calculating exposure. Any lens of reasonably symmetrical optical design can be used. (Telephoto and wide-angle lenses are not generally recommended, because they introduce problems in precalculating magnifications and in working out exposures by flash.) See Figure 13-27 for a diagram of the setup.

The maximum image magnification that can be achieved with a given lens can be closely estimated by measuring the overall length of the camera-bellows-lens system (from the film plane to the approximate center of the lens) and dividing this figure by the lens focal length, and then subtracting 1. Thus, if you have a total lens-to-film distance of 175 mm, and the lens has a focal length of 50 mm, the achieved image magnification will be ×2.5 (175 ÷ 50 = 3.5 − 1 = 2.5). The result is approximate, because you cannot usually locate the lens center with complete accuracy.

The best, most practical lens to use for relatively low-magnification photomacrography is a macro lens of short focal length, such as 55 mm. (Macro lenses of longer focal lengths seriously limit image magnification.) When used with a bellows to obtain image magnifications greater than ×1, the lens should be reversed (see Figure 13-27). Otherwise, the very deep built-in lens shade, which houses much of the extended-focusing mechanism, will extend out almost to the subject plane, interfering with the lighting. Fortunately, at image magnifications much above ×1, the lens will perform slightly better in the reversed position anyway.

You can, of course, use other lenses. Many lenses of normal focal length and some wide-angle lenses of mod-

erate focal lengths (e.g., 35 mm, or perhaps even 28 mm), can be reversed to obtain good photomacrographic results. Wide-angle lenses of very short focal length are not recommended for photomacrography; they are likely to have substantial residual aberrations that result in relatively poor image structure.

Camera and lens makers have available lenses of various focal lengths, some as short as 16 to 20 mm, especially designed for bellows photomacrography. These are generally excellent in quality, but they do lack automatic diaphragms. See your dealer for listings and availability.

Basic Photomacrographic Technique

The basic method of photomacrography is quite simple and is just an extension of that used for closeup work, as described earlier. Any difficulty arises only from a greater need for care in focusing and exposing. The best approach for the beginner is to follow a number of steps in fixed order:

1. First determine the image magnification needed by comparing the size of the subject area with that of the film. In photomacrography the subject is smaller than the film. For example, knowing the dimensions of 35 mm film (24 × 36 mm, or 1 × 1½ inches), if we decide to photograph a subject area 2 × 3 mm, we divide the film dimensions by those of the subject to determine that the image magnification will be ×12.

2. Set up the camera, bellows, and lens to achieve the calculated magnification. The pragmatic approach is both quickest and most accurate at first. Place a ruler in front of the lens, perpendicular to the lens axis, and adjust the bellows length while watching the image in the camera, refocusing as needed. When you see the right number of millimeters across the screen length (for our example it would be 3 mm), lock the bellows adjustment knob. For each image magnification, measure the bellows extension. Record it and the lens focal length, and make up a table for future use. Once the extension is set, altering it changes the magnification, so you must focus by moving the entire camera assembly. For this purpose, mount the camera on a focusing bar, a rack-and-pinion or screw-focus device that carries the camera and allows very small increments of motion.

3. Choose a lens aperture. This will usually be a compromise between depth of field and image diffraction, and the more so as magnification increases. It is usually best just to watch the image while slowly closing the aperture. There will come a point where overall image sharpness suddenly decreases. You then reopen slightly and reclose to just short of the critical point. (You can also anticipate the onset of diffraction by calculating the EA, as in the next step. Avoid an EA smaller than 128. At ×30, a set aperture of only f/4 will become an effective aperture of 124.)

4. Determine the exposure by one of two methods:

 a. With a through-the-lens meter, you can read directly if you are using continuous lighting. (As mentioned earlier, if the subject is small or spindly and seen against a contrasting background, use an 18% grey card.) If the meter will not read because the image is too dim, open the lens aperture and read again; then reclose it, doubling the exposure time for each stop that you close down.

 b. You can calculate exposure by using the effective aperture method if you are using flash. To get the EA, multiply the f-number of the chosen setting by a figure one number higher than the image magnification. (See Formula 13-1.) Thus, if you set the lens at f/8 while working at ×5, multiply 8 by 6. The EA will be 48. You can then determine the flash-to-subject distance by dividing the flash unit GNe by the EA (see Formula 13-2, in close-up flash technique). Be sure to bracket exposures when first working this way. This method will get you into the close neighborhood, but fine tuning exposure often requires a little experimentation.

You can use OTF/flash equipment and methods in photomacrography as easily as in closeup work. Just set the FD roughly according to the EA figure, as in Table 13-3.

Motion Control

Vibration, which can be a major problem in photomacrography done by continuous light sources, can have a variety of causes. In the single-lens reflex camera the most obtrusive one is "mirror flop": the jarring of the

Figure 13-28 1941 Australian shilling, photographed with a macro lens reversed on a bellows. The image is enlarged here to × 7.52.

Table 13-6 Color temperature of common projection lamps

Lamps burning at 3200°K				Lamps burning at 3400°K
BCK	CYC		DMS	DEL
BVE	CZX/DAB	DFW	DPT	DHT
CAL	DAG	DGF	DYP	EJL
CBA	DAK	DHN	DYR	EKD
CLS/CLG	DAR	DLH	DYS/DYV	EKG
CLX/CMB	DAY	DMH	FAL	
CWD	DFH	DMK	FBG/FBD	
CYB	DFR	DML	FCS	

Source: After GE publication P4-61P.

camera body when the mirror reaches its position of full retraction. With cameras in which the mirror can be locked up, the solution is to get everything ready and then lock the mirror up just before exposing. This method works perfectly as long as there is no subject movement in the interim.

If the camera mirror cannot be locked up, there is another method. Work in somewhat dim ambient lighting, and, when all is ready, place an opaque card in the light beam and open the camera shutter. When vibrations have ceased, lift the card out of the beam for the period of exposure, replace it, and then close the shutter. Thus, the card becomes the shutter. The method works well with exposures longer than one second.

Use of flash lighting avoids the whole problem. Electronic flash is desirable because the very short flash duration will stop any likely subject motion. But even open flash with flashbulbs will stop a considerable amount of motion, since the duration of most flashbulbs is about 1/50th of a second.

Lighting for Photomacrography

Incandescent Sources

For most photomacrography with continuous lighting, the most practical light source is a slide projector, which offers a reasonably concentrated beam of evenly distributed high-intensity light. Before doing color photography you should check the color temperature of the particular projection lamp. Table 13-6 lists projection lamps burning at either 3200°K or 3400°K. Lamps that burn at

temperatures significantly different from these will need correction by filtering. The 3400°K lamps are matched to Type A color films, the 3200°K lamps to Type B. See Chapter 8 for information on corrective filtering.

Photo spotlights are another good choice of lighting source. And of these, minispots are especially useful, because they burn at either 3400°K or 3200°K (most use one or another of the listed projection lamps), making them suitable for Type A or Type B films. Unusually delicate subjects, especially small living organisms, may need protection from the heat of the lamp, which might be injurious or even fatal to them. You can provide such protection by placing a heat-absorbing filter between the lamp and the subject, or you can use a water cell—a transparent, optically neutral container filled with water. The most effective water cell would be a small, straight-sided aquarium. Such a tank is relatively inexpensive.

Flash Sources

Ordinary blue flashbulbs or flashcubes are well balanced for use with Daylight-type color films. They are an especially good source of high-intensity illumination when used in the "open flash" method. No wired connection is needed; you just open the camera shutter, flash the bulb manually, and then close the shutter. The entire light output of the bulb is thereby used, thus providing the highest possible guide number. Even small bulbs or cubes when so used emit considerably more light than the common small electronic flash units.

Electronic flash can be used in photomacrography in either of two ways: at very short flash distances, as with close-up flash technique, or, if more light is needed, with a lens to concentrate the beam.

You can determine the correct exposure for a concentrated flash beam by measuring the size of the light spot produced, before and after concentration. Although the flash is very brief, your lingering vision will allow you to see and measure it. Suppose that your flash unit projects a square flash pattern about 300 mm on a side, at a 300 mm distance. If you use a beam-concentrating lens that reduces this to a 150 mm square, the light energy will be spread over only a quarter of the area and the light spot is thereby two stops brighter. If you further reduce the spot to a 75 mm square, it covers only one-sixteenth of the normal area and the light spot is four stops brighter.

Figure 13-29 *Plant galls, one opened to show the interior structure.* The lighting was by flash, and the correct lighting angle was found by using a penlight flashlight as a trial lighting source. When I had found a lighting angle and position that showed the interior structure well, I replaced the penlight with a flash unit and made the exposure.

Lighting Control

There are three factors to bring under control when lighting small subjects: lighting angle, contrast between highlights and shadows, and overall softness or harshness of the light.

A satisfactory lighting angle may be most easily found by playing a pencil flashlight beam over the subject while looking through the camera viewfinder. When you find the most satisfying position, establish it as your basic lighting angle, for either continuous or flash lighting.

Lighting contrast is controlled in part by using a reflector, such as a small piece of white card, crumpled aluminum foil, or a mirror opposite the light source and close to the subject, to fill in the shadows to the desired degree.

Softness or harshness is determined by the presence or absence of a tissue paper diffuser between the light source and the subject. A diffuser can further lower lighting contrast as well as soften the lighting.

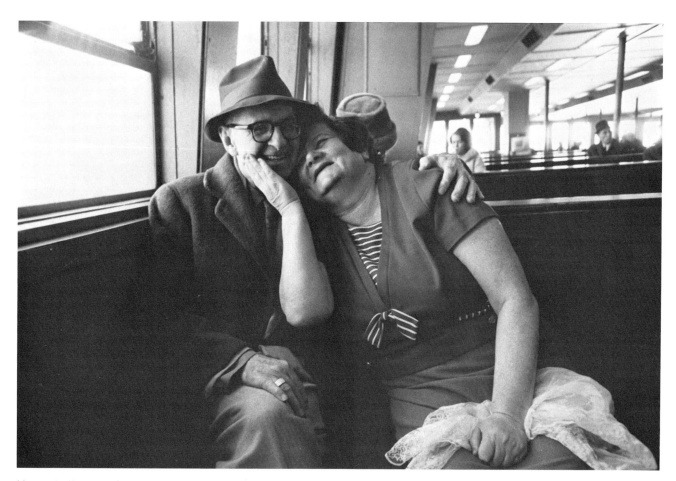

Man and wife on the Staten Island Ferry, New York, 1967, by Mary Ellen Mark. Small, seemingly trivial moments are preserved through photography; when viewed at length, through the eyes of the camera, they take on enhanced significance. Photograph © by Mary Ellen Mark/Archive Photos.

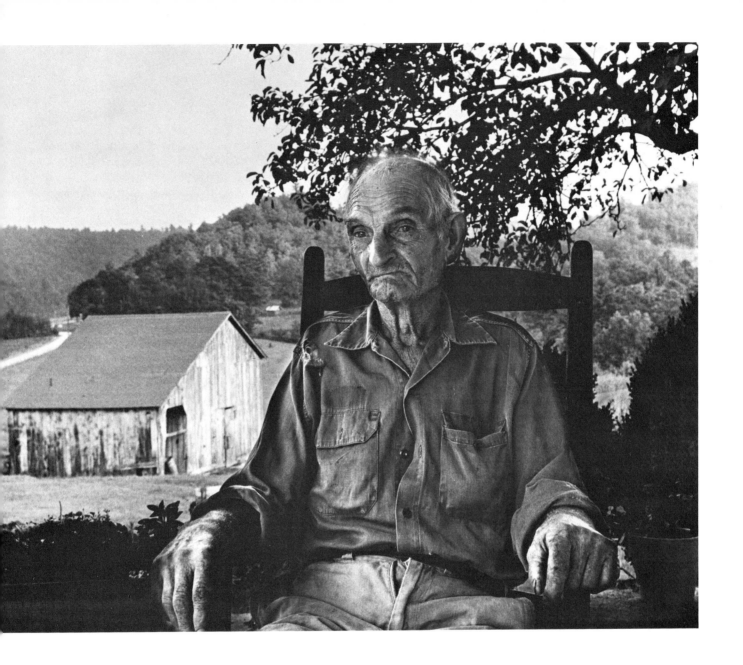

Formal Portraiture

Formal portraiture is photography done in a session at which the subject is present mainly or solely for the purpose of having his or her portrait made. In such portraiture there are levels of sophistication. One of the more common types of sit-down portraiture might best be termed "the flatterer at work." And there is nothing wrong with a little flattery. People generally like it, and almost no one wants to look *worse* than usual. Such portraiture is quite easy to accomplish with standard lighting setups, but these do not necessarily give much information of any significance about the subject.

What might be called "high portraiture" is done with the idea of pictorially exploring the sitter's personal qualities—that is, the revelation of personality is the goal. The photographer must understand the effects of different kinds of lighting and must be able to establish significant personal rapport with a sitter at short notice. You do not have to become instantly chummy or cloyingly close, but you will have to converse enough to form some judgment of the sort of person you are dealing with. If practical, a little advance homework on the sitter's background is useful, for you cannot reveal a personality about which you know nothing. Knowing a person's public personality by research and reputation helps in assessing the photographic possibilities, but it is personal contact that makes the difference.

When attempting to establish rapport—at least the rudiments of a mutual respect and understanding—you might follow my personal guidelines: I have never relied on a line of clever patter. Instead, I often begin by just sitting with the subject in a good light. I state outright that I am going to look closely to form an idea for a good lighting arrangement, one that suits the shape of the head. I succinctly explain what I am doing, so that he or she understands that my scrutiny is for a professional purpose. A conversation nearly always naturally ensues. Since in part I am trying to relax the subject with conversation, and since most sitters are a little nervous to start with and thus tend to welcome a little talk as a way of dissipating tension, our interests converge. The most difficult type of portrait subject is the cold, aloof person who will not converse. Such a person will almost always *look* cold and aloof in the resulting pictures. This may be a true reflection of the basic personality; but it may also be unfair—you may just have failed to establish any rapport, or the person may have had an unsettling experience just before arrival.

Only experience in portraiture will give you a really good idea of the problems of establishing rapport. Good lighting is simple by comparison, for there are only so many basic head shapes. Methods for establishing rapport are highly subjective, and cannot be taught. Each subject will be slightly different, and what works for one may fail notably with another.

How is a personality revealed in a photograph? There are several factors: lighting that models the shape of the head and texture of the skin and clearly delineates characteristic facial expressions and bodily stances; a camera angle that best shows all of these things; and, what is very important, the choice of a moment for exposure when the subject's expression and stance most clearly express his or her basic character as you have perceived it.

Photographic style in portraiture reflects how a particular photographer characteristically presents his or her subjects. Thus, fine photographic portraiture presents a real image of the subject's character and personality, but does so in a style that is clearly assignable. Examples of especially clear-cut style in portraiture include the work of Mathew Brady, Julia Margaret Cameron, and Yousuf Karsh. Brady had a remarkable ability to reveal the strengths and weaknesses of his prominent sitters. His portraits of Henry Clay (see Figure 2-1), Abraham Lincoln, and U.S. Grant are classics. Cameron's affinity for the intellectual giants of England in the late nineteenth century has given us much to admire (see Figure 2-2). Karsh is a contemporary original; his style is so distinctive as to be virtually unmistakable (see Figure 7-11). Though some of his work tends toward the stagy, the best of it is simply the best that has been done. His people live and breathe, and you can almost see into their minds.

Lighting for Portraits

Portrait lighting offers some seeming paradoxes. The effects of apparently simple existing light can be extremely difficult to print, whereas lighting setups that seem complex are often easy to work out and result in easily printed negatives of excellent quality. The essence of good portrait lighting is control. Since light travels in

straight lines, it is quite easy to tell how it will fall, even before you set up anything. Just close one eye, and look at your subject. Everything that you see would be lit by a lamp placed where your eye is located; everything else would be in shadow. If you move around a little, you can easily determine an exact position for the placement of the main light, which will establish the basic shaping of the subject's head.

There are three basic lighting setups well suited to portraiture. One is very simple indeed; the others are more versatile, but without being so complex as to be difficult to handle. By working minor variations of them you can easily get a reputation for considerable expertise. With these arrangements it does not greatly matter what light source is used. Sunlight, diffuse daylight, incandescent lamps, and flash sources will all yield good results. With fast film and a willing subject you could even do them with candles. If using color film, remember the need to balance color temperature. With candlelight you might want to retain the golden glow of the light as part of the pictorial effect.

The simplest of these arrangements can also be the most flattering. The light source is placed directly in front of the subject's head and perhaps 30 degrees above its axis. Or, with existing light, the person is placed so that he or she is in that relative position. The camera can be aligned along the axis of the light source and of the sitter's head, so that it is also directly in front; or it can be placed somewhat to one side (see Figure 14-21). The visual effect will be to cast a small, symmetrical shadow under the nose and some subtle shading under the cheekbones. Because of the symmetrical shape of the nose shadow, some people call this lighting setup "butterfly" lighting. The method tends to make the sitter's nose look smaller and to make many skin blemishes less visible. It is so generally flattering that it has been used many times for publicity pictures of film stars and is sometimes called "Paramount" lighting, after the film studio of that name.

The second lighting arrangement takes only slightly more care to set up, but makes a great variety of visual effects possible—if the lighting used is softly diffused, the effect can be subtle to the point of being romantic; if harshly direct, the skin textures and facial angles can be rendered starkly enough to satisfy the most ruggedly masculine of subjects. (One of my subjects once remarked, "Marvelous! It makes my skin look like the hide of a rhinocerous." He was *pleased*, too.) In this method

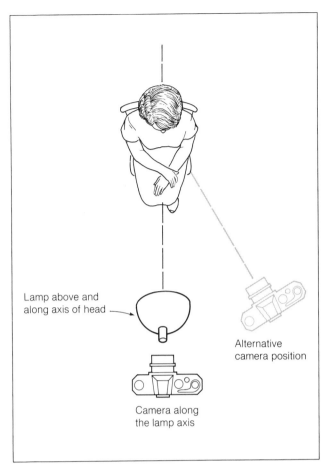

Lamp above and along axis of head

Alternative camera position

Camera along the lamp axis

Figure 14-21 Butterfly, or paramount, portrait lighting.

it is usually best to use more than one light, to make detail visible in all parts of the subject seen by the camera. The main light, the one that is seen as brightest and that models the shape of the head, should be located roughly perpendicular to the axis of the sitter's shoulders. The sitter's head should be turned somewhat to one side. Properly done, this setup fully lights one side of the face, throwing the shadow of the nose on the less well-lit side. Because there will be a triangle of lighted cheekbone between the eye and the middle of the cheek on the shaded side, the setup is sometimes called "triangle" lighting. You can quickly determine the correct place-

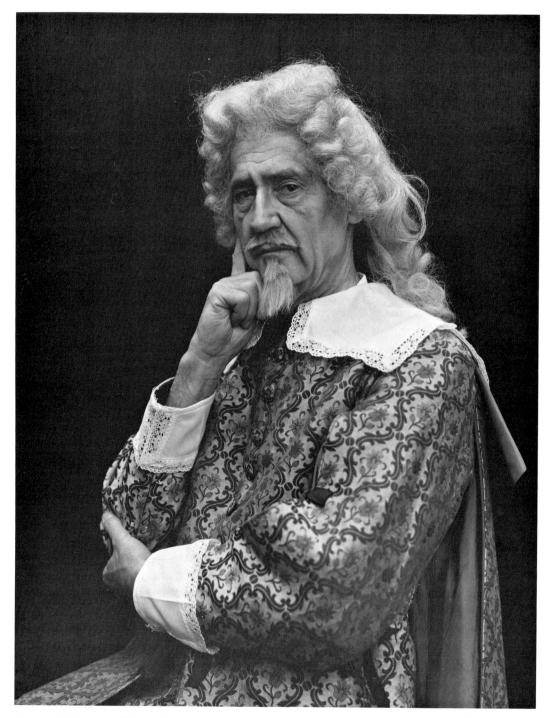

Figure 14-26 *Eakin as William Harvey*, who first explained the human circulatory system; like the pose, the lighting was arranged to generally resemble that of a seventeenth century painting. Basically butterly lighting was used.

15
Camera/Print Alternatives

Usually the photographer's goal is a sharp image that faithfully records reality, but it need not always be so. Whether the photographer's purposes be analytic, interpretive, or expressive, certain deviations from the "normal" image may sometimes be desirable. (For example, we saw in the last chapter that motion in the image can be controlled—either frozen or smeared to some degree.) In this chapter we explore manipulating and altering the image by methods that can be used either on the film in the camera or during printing. The effects can range from the subtle to the vivid, and there will be significant differences between those achieved in the camera and those achieved in printing. Whether you use these techniques to enhance some of your existing images or to experiment from the start with the alternative processes, you will thereby increase your versatility as a photographer.

Soft Focus

Nearly all modern camera lenses are designed to yield very sharp, well-defined images. This is usually a highly desirable characteristic, but for some kinds of photographic ideas you will not necessarily want ultimate detailing. You can introduce a degree of romanticism and even unreality into your pictures by simply reducing this sharpness of rendition. Whereas some interesting effects can be obtained by throwing the image out of focus, here the focus will remain sharp but the image will be given an overall softness.

Old telephones, an example of strong solarization (also known as the Sabatier effect), by Clarence Rainwater. Photo courtesy of the artist.

There are several ways of softening the image structure, usually by interposing some translucent material between the camera lens and the subject, or between the enlarger and the printing paper. As a rule, completely covering the lens results in too much image degradation, so it is usually best to leave a small clear area over the center of the lens, so that a good basic image will be produced. By increasing or decreasing the percentage of rays that pass through the surrounding translucent material, opening or closing the lens aperture allows the overlying softness of the image to be varied. The wider the aperture, the more the light that makes up the whole image will be affected; the smaller the aperture, the less light is affected and the more subtle the effect.

Suitable materials include crumpled cellophane or a piece of discarded sheer nylon stocking. The central opening can be burned in with a cigarette end or cut with scissors. Another alternative is to lightly coat a piece of clear filter glass (or a glass "skylight" filter) with petroleum jelly, leaving clean a small circle at the center. You can buy special lenses or lens attachments that will produce generally similar effects. There are lenses, for example, that have a main central aperture surrounded by concentric rings of smaller aperture (see Figure 15-1); and there is a lens attachment that is basically a slip-on close-up lens with a central area ground flat. Each of these ideas offers a slightly different effect, so you may want to see what you like best.

Placing a translucent material over your lenses gives two different effects depending upon whether you do it while exposing the negative or during enlarging. When it is done in the camera, the image of each point of light is spread into adjacent dark areas. In the resulting print or transparency the overall image is fogged and lightened, giving an airy, summery effect. This method has been much used in pictures of children and young women.

If done in printing, the effect is opposite, by the nature of the negative/positive process. Here the *dark* detail points, which in the negative are tiny transparent specks, will tend to spread into adjacent areas, lowering or darkening the overall image. The result is a sort of gothic-looking, foreboding dark fog.

Both methods have the additional effect of lowering the overall contrast of the projected image, so you may want to print on a high-contrast paper. Sometimes you will find the effect too extreme. At least in printing, where it is more practical, it will help to make part of

the exposure with the diffusing fixture in place over the lens, and the rest with it removed. You can try any ratio of exposure with it on and off: half-and-half, one-third on and two-thirds off, or the like.

Zooming Lenses during Exposure

If you have a zoom lens on your camera you can achieve certain interesting visual effects by changing the focal length during a time exposure. In so doing you produce a concentric size difference in the image. Depending on how it is done, the effect can be seen as a smear rushing toward the middle, or as a series of discrete concentric images.

One good effect can be accomplished by starting with a short focal length (a small image magnification), giving it a calculated correct exposure, then zooming slowly and steadily to a longer focal length for a roughly equal time period. Close the shutter before stopping the zoom movement. This provides a sharp central image, surrounded by a linear-looking radial smearing—one form of the first effect noted in the previous paragraph. (Your main subject must be centrally located or it will disappear into the smearing.) You can also make a series of instantaneous or short time exposures on the same film frame, each at a slightly different focal length setting. This is all just a variation on the theme of multiple exposure, about which there is more to follow.

Somewhat similar effects can be produced in projection printing, if you can mount your zoom lens on your enlarger. Lenses differ; with some, when placed on the enlarger, you cannot maintain a good enough focus while zooming to pull off the first effect above to perfection. Oddly, the controls reverse in the enlarging mode: when the zooming ring is moved the image goes very rapidly in and out of focus, while when the focusing ring is turned the focus changes slowly during a moderate change in image size. You can, then, use the zoom ring to focus, and then—after making an initial small-image exposure—use the focusing ring to produce an outward image expansion. The image will gradually go out of focus as you do so, but this doesn't ruin the effect entirely; it just changes it somewhat.

On the other hand, you can do a sort of concentric multiple-exposure series, using your ordinary enlarging lens. Just raise or lower the enlarger head to change the image size between the separate exposures. For each ex-

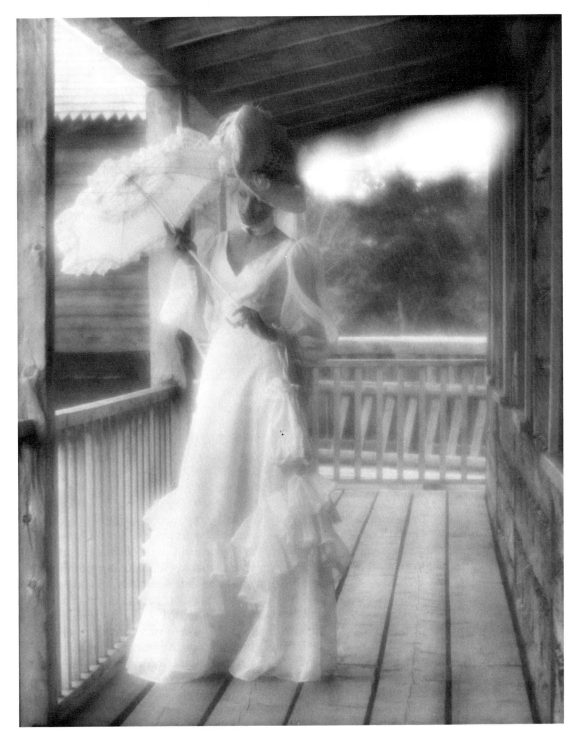

Figure 15-1 *Lauri*, by Gordon R. Henderson, a beautifully romantic soft-focus photograph of a young woman. It was made with a 200 mm Rodenstock Imagon lens, a lens capable of variable soft-focus effects, depending upon the aperture setting. Photo courtesy of Gordon Henderson/ Henderson Photography Limited.

16
Seeing Photographically

Seeing and Perception
Previsualizing the Image
Seeing in Terms of the Medium

Self-portrait in mirror, by Marcia Lamont Goldey, one of a series of self-portraits, photographed at night by available light. The original print was subtly and beautifully toned with selenium toner, but this effect cannot be reproduced in black-and-white. Photo courtesy of the artist.

Good photography is not automatic; it is based on seeing photographically. This requires an understanding of how sight relates to perception, and of how the process of photography affects what you see with your eyes—how and why, that is, the image will resemble or differ from the scene before you. To predict your results—to make a picture that is not just a chance happening—requires that you first "see" the finished image in your mind and adjust your use of the camera to realize your vision in the negative.

Seeing and Perception

Many people use the gift of sight quite mechanically, deriving no more from it than is needed to perform their normal daily activities. It would be too much to say that sight is often used primarily to keep us from falling into holes in our paths—after all, we learn to read; we use sophisticated relationships between the eye and the brain when we walk, run, or drive a car; and we conduct most of the affairs of our lives in close concert with what our eyes are constantly telling us. However, sight can be used for much more than this, with a little thought and perhaps some education.

Visual artists are not alone in developing specialized uses of eyesight and in illuminating visual experience with special education, remarkable feats of mental association, and flights of sheer imagination. Visual artists,

however, must use their traits and training to communicate to others their visual insights in ways that are perceptible to any interested viewer. The visual artist is, then, an interpreter of sorts.

It matters not whether the photographer is thought of as an artisan, as skilled in a craft, or as an artist, presumably gifted with superior powers of observation and interpretation. The aim is to communicate ideas visually, through photographs. To do so effectively, photographers must learn to see as their medium "sees"—as lenses, shutters, and films translate three dimensions, motion, and color into two-dimensional, static images in color or in values of gray. And a point often overlooked by beginning photographers is that black-and-white photography is as profoundly different from color work as an engraving is from a painting—in color photography, the color slide is even a distinctly different medium from the color print.

The first qualification of an artist, then, is the ability to see in terms of the medium, so that the idea being presented is not lost through technical failure. And this brings us to the related but not identical matters, seeing and perception. To look is not the same as to see. Everyone whose eyes are open is looking all the time. Images are being ceaselessly formed by the lenses of our eyes, and are as unceasingly being projected on our retinas. To *see*, however, requires a more complex use of the brain: it is not enough just to direct the head and eyes through the act of looking; it is also necessary to associate ideas about what is seen, and to interpret what each look has seen. We then have *noticed* the image and its various elements and have drawn at least some beginning conclusions about how what we have seen should affect our subsequent actions.

To carry things a step further, we must *perceive*—to, as the dictionary puts it, "become aware of through the senses." What is meant is an *informed* awareness, wherein the brain has been directing the eyes to look for some particular grouping of lines, shapes, colors, etc., or has noticed, through mental associations, such a grouping, even though not specifically directing the eyes to look for it.

Having seen, and having perceived what was seen, the next matter is to *appreciate* the perception. Appreciation can take any of several forms: it may have to do with an understanding of technical difficulty to be met and surmounted; it might be an intellectual appreciation of as-

sociations formed and connections made; or it might be a matter of aesthetics, a perception of opulent beauty or of ascetic spareness. Or it could involve any combination of these, or of still other considerations.

The act of photography uses a combination of human and manmade resources to produce an artifact—a photograph—that directs the attention of another person—the viewer—to a message. The process is steplike, as follows:

The eye sees, in time and in motion, with constant adjustments of depth, focus, and aim; with almost infinite sensitivity to subtleties of color, modeling of forms, and variations in tension, line, texture, and mass.

The mind is stimulated, and then guides the eye in seeing, further analyzes what is seen, and generates ideas about it.

The photographer, using the eye and brain in close conjunction, *sees, selects, and forms with tools* that which is to be communicated.

The photograph exacts of the viewer's eye and mind a perception, through the image, that the photographer intended, by presenting no alternative within its borders.

The result is a shared insight. If a perception is to be appreciated by another person, the photograph must be capable of conveying it. It can be made to do so only if

Figure 16-2 *Woman on Market Street*. The perceived motion of a person within a picture affects how the viewer thinks. Here the woman is moving into the picture area, but is also moving from light into shadow. The one connotation is positive; the other, negative, and the result is visual tension.

Figure 16-3 *Rock Wall No. 2. West Hartford, Connecticut, 1959*, by Paul Caponigro, a master at creating visual art. This photograph is a "pattern" shot, in the sense that there are a number of quite similar forms scattered through the composition; but the variety of those generally similar forms and the beauty of the subtly graded tones prevent visual boredom. Photo courtesy of the artist.

much in the breach as the observance. The pictorial possibilities are so varied and so great in number—being virtually infinite—that hard-and-fast rules can be stultifying to the imagination, and often pointless. Again, they should simply serve as guides, by which some general order is preserved in the mind. However, it is worthwhile to review the major traditional rules, in order to be able to use them when applicable, and to give some consideration to what it is that constitutes a composition. No matter how often or consistently the experienced photographer violates such rules, they are useful to the beginner if only because they require you to think while framing an image. With such guides lodged in the back of your mind, it is easier and quicker to make useful decisions about what you see in the camera viewfinder.

As you look at works in the traditional visual arts—paintings, etchings and the like—you may notice that some pictorial devices that work well in them seem inappropriate in photographs. But more often you will see that certain accepted compositional devices in photography work poorly or not at all in these other media and are seldom used. This is largely because of the unique features of the photographic medium: photographs are instantaneous records, in effect; moreover, photography has an extraordinary relationship to reality, unlike that of any other visual art, inherent in its use of geometrical optics in the projection of images.

One intrinsic feature of photography poorly suited to painting is selective focus. Although it can be simulated to a degree in painting, it is seldom successful there as an artistic device. When portions of the image are placed out of focus in a photograph, there is a considerable change in the internal pictorial relationships, and thus an influence on the overall composition. These effects work well in photography, but in a painting they are so obviously derivative of the camera that they are generally unacceptable.

As another example, the silhouetted foreground frame, so common in photography, cannot be used in painting without producing an oversimplified, unfinished appearance: a foreground frame may be shadowed, but must still possess visual detail. Yet, because we accept the visual contrast inherent in photography, we also accept silhouetted foreground framing.

As you become more familiar with the craft of photography and as you study the work of well-known photographers, other examples of such differences will become apparent. However, many of the pictorial relationships found in painting are regularly applied in constructing photographic images. On the whole, it is useful to have traditional training in the arts before going into photography seriously: there is nothing like drawing an image to make you aware of perspective and pictorial structure; and the understanding of color and color relationships is greatly fostered by learning to mix pigments to match the colors and tones of a scene in light and shade.

Compositional Guides

Pictorial compositions can be framed or constructed in many ways. Over the generations several methods have been successful enough in guiding the work of photographers to be widely accepted. Among these are: the *golden mean*, a system of proportional framing and division of pictorial elements; the rule of *strategic placement* of the picture elements; and the dynamic use of *lines of movement* in a picture.

The Golden Mean

One of the oldest sets of rules in the arts, the golden mean was formulated by the ancient Greeks and is applicable to all of the visual arts, including painting, sculpture, architecture, and photography. It is basically a way of relating the parts of a composition to the whole in a visually pleasing way by means of proportions. The golden mean is based on the assumption that a part is most pleasingly related to the whole in a ⅓ or ⅔ proportion.

In photography, the golden mean is generally applied by dividing the rectangle of the picture area into a grid of thirds, both horizontally and vertically, to place an important picture element at one of the line intersections or along any of the lines. You do not actually draw lines on the picture, of course, but instead imagine their presence while looking through the viewfinder. (Of course, you *could* apply such lines to the ground glass viewing screen of a view camera as some photographers have done. Many photographers consider this technique satisfying, however.)

As the ancient Greeks formulated the rule, and especially as they applied it to sculpture and architecture, the

Figure 17-6 *Rotting apples.* Fruit, leaves, and straw, just as they were found under the apple tree. Although the major picture elements are symmetrically arranged, their placement generally follows the dictates of the golden mean. Additionally, there is enough variety of form and tone to add to the pictorial interest. Photo by A. Blaker.

divisions were not exact thirds. In photography, however, the division into thirds is a good rule of thumb and is also quite easy to visualize. And since picture elements of importance are rarely discrete points or lines, but instead are masses or tonal areas occupying substantial amounts of space, exactness of the proportions is rarely a practical concern. Say, for example, that part of a building occupies one side of the picture area and a person the other. If the edge of the building falls along a line one-third of the way across the picture and the

person is one-third in from the other side with the head about a third down from the top, the golden mean is fulfilled.

Not every picture can be composed in this manner, of course, but if you keep these proportions and the method of their use floating in the back of your mind, you may be able to use them profitably with at least some of your work. The proportions of the golden mean have been applied to all sorts of subject matter and photographic approaches with pleasing effect and with no sense of

Figure 17-14 *Boxer* (Floyd Patterson), by Gordon Clark, an excellent impromptu portrait from ring-side. All lines and masses focus the viewer's eye on Patterson's battered face. Photo courtesy of Gordon Clark.

describes how to establish a viewpoint, choose a lens, and make use of view camera movements to improve the image. It is fully illustrated with his usual fine photographs.

More discursive and less practical, but interesting and quite provocative, is Kay Tucker's succinct 1972 paperback, *The Educated Innocent Eye: Some Criteria for the Criticism of Photography*. Of special note are a series of paragraph-length quotations by well-known photographers and writers such as Minor White, Paul Strand, Helmut Gernsheim, and Jerry Uelsmann, offering some of their ideas relating to photography. This little booklet is a "think piece" rather than a practical guide for action, but is well worth a look.

An excellent work combining the psychological and the theoretical with a full helping of very clear practical examples is Herbert Zettl's *Sight•Sound•Motion: Applied Media Aesthetics* (1973). Although intended for students of the television arts, three-quarters of its content is directly applicable to present-day still photography. The headings tend to use psychological and technical jargon, but the text is easy to read, well illustrated with both drawings and photographs, and readily applicable to your own concerns.

Analyzing Composition

The only possible general conclusion concerning composition is that circumstances alter cases. Rules should act not as restrictions but as guides that will assist you more often than not. If there are good enough reasons to break them, you should do so without qualms. No rule should be followed without question. You should be looking for reasons to make exceptions even while applying rules.

There are three useful ways of testing the validity of any composition. They are all based on the assumption that a picture that *looks* right usually *is* right, regardless of how far it may seem to depart from conventional standards.

For the first method, cut out two L-shaped pieces of gray or white cardboard (if gray on one side and white on the other, their edges can be seen clearly against any sort of picture). Face them in opposite directions, overlaid to make a frame of adjustable proportions, on top of a full-negative print. Move it around so that it frames varying parts of the image, and vary its proportions as you go. If you can make a stronger composition by cropping the image, then reprint doing so.

There is nothing sacred about the proportions of standard film dimensions. You can crop a side or bottom or top any time that a given image is thereby improved. There is also nothing immutable about how you composed while looking through the viewfinder. You may well find it better to print and display only a portion of the image on any given negative.

The second method of analysis is better suited to guiding your future work than to saving what you have already done. If you make a picture that just does not "look right," hold a thumb over the various major or minor picture elements one at a time. If the picture looks better without that element, it should not have been included. But if the picture looks weaker by its absence, that element can be considered necessary. If such deletion does not strengthen the picture, perhaps you had no potentially successful composition to start with. Although this is a post-mortem device (to see why the picture died), it may help to prevent a similar catastrophe in the future.

Finally, it is beneficial to allow time to affect your judgment. Reserve some wall space for hanging your best efforts for long-term examination. See how well you can live with an image. Should you become tired of it before long, try to analyze why. Is the picture dull? Do subtle flaws become obtrusive with time? Does the image have a posterlike "grab-the-eye" quality without sufficient complexity to engage the mind more than temporarily?

There is nothing like time to give you the answer to these questions, and others that will come to you. Sometimes, in fact, pictures that you had first thought to be rather slight develop staying power to a remarkable degree. (These are the really subtle ones.) Let time pass while you keep on looking and thinking.

The best fashion photographs usually do more than record the appearance of a garment. They create a mood or suggest an environment to engage the viewer's imagination. In this image, with its spare background, the photographer, Ted Betz, accomplished his goal by the lighting and by capturing the model's fleeting, evocative gesture. Photo © 1979 by Ted Betz.

18
Careers in Photography

Photographic training and experience offer unlimited opportunities for employment as a photographer or in endeavors related to photography. Among the professional fields are advertising and fashion, and scientific photography. Other specialized fields include travel, nature, industrial, medical, studio, editorial, and architectural photography.

Moreover, not everyone in the world of professional photography makes a living from behind a viewfinder. Among the several careers related to photography, some are independent business enterprises and others are salaried positions in business, private institutions, or government. For example, owners and operators of photography galleries and writers for photography magazines may or may not also pursue serious photography on their own. This is equally true of those who earn their living repairing cameras. Additionally, hundreds of good photographers teach at universities and schools throughout the country.

While thousands of jobs exist, the competition is keen. More is required for success than enthusiasm and talent. And most professionals remember a time when doors were shut in their faces. As Arthur Leipzig, a photography professor at C. W. Post College in New York, has said, "It's a tough business to break into. There are those who don't like to gamble on an unknown who is just getting started." Nevertheless, Leipzig is optimistic. According to him, "Persistence, confidence, and a good portfolio of one's work should eventually lead to assignments or a job." He and other established photographers recommend that newcomers train as apprentices or assistants to a

professional in the field or specialty of greatest interest to them. The pay may be low, but it is a practical way of learning a particular craft and, of course, the business.

Several professionals also suggest getting at least some formal instruction to learn the basics of camerawork, and virtually all of them say it is crucial to get to know as many professional photographers as possible. Professionals will also tell you that it is not enough to simply make good pictures—you have to sell them and yourself as well. Moreover, with all the glamour and thrills of the work come long days, late-night schedules, deadline pressures, and personal sacrifices. Most photographers have the difficult task of satisfying assignments, meeting schedules, and getting along with their employers or clients without compromising themselves.

All of the above is not to imply that professional photographers would choose a different career if they had it to do over again. Most of them cannot think of anything they would rather be doing to make a living. Somehow they have managed to retain both love and creative vigor for the pursuit of their private visions as well.

Photojournalism

Staff Positions

Virtually every newspaper and magazine across the country has photographers on staff. There are a wide variety of general and specialized publications ranging from local weeklies in the suburbs to great national newspapers and magazines. Photojournalists cover a wide range of activities—from sports events like championship tennis, to violent political cataclysms like the Vietnam war or the continuing unrest in the Middle East, Central America, and Africa, to such mundane events as organizational gatherings or the local beauty pageant. Salaries for those on staff at a publication range from a relative pittance to a solid living wage, with the best in the business doing substantially better. It is important to remember that most photojournalists getting started will receive the less exciting assignments, and that almost all of them will be required to work some odd hours and overtime.

Even the most modest of such jobs, however, provides an invaluable stepping-stone to better opportunities. And any connection at all with the recognized print media

offers opportunities to approach people and events not accessible to others.

Freelancing

Freelancing is another journalistic possibility. Unlike photographers on staff at a single publication, freelancers must constantly seek markets to sell their work. In fact, most freelancers getting started spend as much time finding clients and assignments as they do actually taking pictures. While staffers are usually provided with darkroom facilities and all photographic equipment, freelancers are required to find and pay for their own. There is no job security, and there are no fringe benefits.

Why, then, would anyone choose freelancing over a staff position? Most photographers getting started simply have no choice. It is difficult to get a staff position unless you have had work published, and the only way to accomplish that is to freelance. Still, many freelancers who become successful never look for full-time staff jobs because they enjoy their flexible schedules and the satisfaction of being their own boss. It is not uncommon, either, for longtime staffers to return to freelancing later in life.

General Freelancing

Specialization for freelancers is usually rewarded. Arthur Fellig (Weegee), working in the 1930s and '40s, specialized in spot news (crimes, accidents, fires, etc.) and in feature photographs that often contrasted rich and poor, high and low society, and the like. Further, he specialized in working by flash in the lively evening and night-time hours. There is still a large market for such work. Although most of it is paid for at low rates, if you do enough of it and develop a name in the business, an adequate living is certainly possible.

There are specialties—even subspecialties—in a variety of fields. For instance, sports, itself a specialty, can be further subdivided into categories (e.g., contact sports, team sports, individual competition) or even into single sports (e.g., gymnastics, motor racing, hockey) depending upon the interests, knowledge, and mobility of the individual freelancer. Sometimes it is even possible to specialize by location, by making an exclusive agree-

Figure 18-1 *Hindenburg Disaster,* by Sam Shere. Most reporters and photographers who were sent to cover the landing of the Hindenburg expected a routine news story. Some, bored with the waiting that becomes an expected part of covering a news event, left early and missed the story. One even reported erroneously that the landing had been uneventful. Sam Shere had the discipline to wait the story out and the professionalism to act quickly when the story presented itself. United Press International Photo.

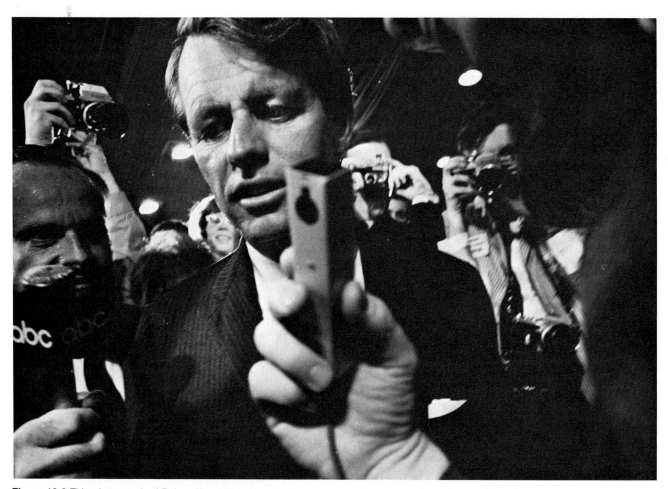

Figure 18-2 This photograph of Robert Kennedy, taken after he lost the Oregon Presidential Primary in 1968, captures the fatigue, the disappointment, and the almost constant attention that are part of any politician's life. Photo courtesy of Gordon Clark.

Figure 18-3 Sports photographers have to know enough about the sport they are photographing to understand the significance of what is happening. In baseball, not only the runner but the ball is important. Here Gordon Clark has caught the action at the critical moment when the second baseman boggles the ball and the runner comes in safe. Photo courtesy of Gordon Clark.

Figure 18-4 *Stock pond on the slope of Mt. Diablo.* A low-level aerial photograph made with a 105 mm lens. Aerial photography is a natural specialty for those who like flying. Photo by A. Blaker.

Figure 18-10 *Anencephalic female, full term,* by Gabriel A. Palkuti. Medical photographers are frequently called upon to record subjects that might seem disconcerting or even gruesome to a layperson, but are both important and urgently needed. Here Gabriel Palkuti has made an excellent record of a difficult medical subject. Photo courtesy of the artist.

Teaching

Teaching photography is yet another career option, one that offers reasonable financial security, direct involvement with photography and photographers, and an opportunity to have some influence on the coming generation of young photographers. Yet it does not require you either to run a business or to be employed doing someone else's photography.

Naturally, the competition for teaching positions in high schools, colleges, universities, and art schools is strong and getting stronger all the time. In addition, there is an ever-increasing pressure on prospective teachers to obtain a Bachelor of Fine Arts, Master of Fine Arts, or higher degree directly in photography.

In my opinion, a prospective photography teacher would be well advised not only to follow a prescribed degree program in a reputable institution but also to obtain as much practical experience in as many fields of photography as possible—and to continue to do so after becoming a teacher. Part-time jobs and varied freelance activity within the general photography world can be quite enlightening to an academically trained young teacher, for two reasons: it broadens the teacher's personal perspective and it helps the teacher to understand the motives and needs of students who may not fully share or want to restrict themselves to the teacher's possibly limited views. (It is no particular service to students to turn them into virtual carbon copies of oneself, whether intentionally or inadvertently.)

Teaching need not be a full-time occupation. In fact, it may be more stimulating for both teacher and student if it is not. Many working photographers, in both the aesthetic and practical fields, engage in regular or occasional part-time teaching. In part-time teaching, both parties benefit. There is nothing like teaching to clarify your own ideas on a subject; and there is nothing like practical working experience to broaden your knowledge, to the students' ultimate advantage. It resembles the relationship between teaching and research in university organization—teaching sharpens insights, while research provides genuinely new material to teach.

Remaining an Amateur

Some people feel ambivalent about the whole idea of professional photography as a career—and, for them,

rightly so. It is not for everyone. If you have doubts, stop and think for a little while. A dedicated amateur may find that the daily exercise of professional craft in pursuit of nonpersonal objectives jades the sensibilities. An art photographer is almost by definition an amateur (which term, after all, comes from the French for "lover"). Few persons can make a living out of photography done purely for personal artistic motives, yet you may find professional work, with its constant pressures and demands, to be excessively draining of creative energies. Your creativity may all go into solving purely technical problems, or into fulfilling someone else's artistic needs. Most professional photography involves the production of pictures for other people's purposes—not your own.

Anyone with serious doubts of this nature should stay away from professional, commercial, and technical photography as a way of earning a living. Instead, earn your living in another way that appeals to you, or that is available, and save your love of photography and your pictorial creativity for your personal work.

Sources of Information

If you have already decided to pursue a career in photography, there are a number of organizations to turn to for help in determining what you are best suited for and how to go about entering the profession. Among these, other than the previously listed BPA, are:

Advertising Photographers of America
5 East 19th Street
New York, NY 10003

American Society of Magazine Photographers (ASMP)
205 Lexington Avenue
New York, NY 10016

National Free Lance Photographers Association
60 East State Street
Doylestown, PA 18901

National Press Photographers Association
P.O. Box 1146
Durham, NC 27702

Professional Photographers of America
1090 Executive Way
Des Plaines, IL 60018

Professional Women Photographers
c/o Photographics Unlimited
43 West 22nd Street
New York, NY 10010

There are a surprisingly large number of magazines in the field of photography, some published by organizations such as the ASMP, the BPA, and the PPA, others by commercial publishers, and yet others by business firms such as Calumet and Eastman Kodak Company. Many of these are listed in the Bibliography.

For educational information—locations of schools teaching photography, programs offered, etc.—probably the best source is *A Survey—College Instruction in Photography—Motion Picture/Graphic Arts/Still Photography* (Kodak publication T-17). This source is frequently updated.

Remember, whatever your interest, the opportunity is there, the variety is there, the excitement of working in a growing field is there, and last but certainly not least the challenge is there.

Gernsheim, Helmut, and Alison Gernsheim, *Creative Photography: 1826 to the Present* (Detroit, Mich.: Wayne State University Press, 1963). An exhibition catalog.

Pollack, Peter, *The Picture History of Photography* (New York: Harry N. Abrams, Inc., 1970). Revised edition.

Braive, Michael F., *The Photograph: A Social History* (New York: McGraw-Hill Book Company, 1966).

Gernsheim, Helmut, and Alison Gernsheim, *The Recording Eye: A Hundred Years of Great Events as Seen by the Camera, 1839–1939* (New York: G. P. Putnam's Sons, 1960).

Taft, Robert, *Photography and the American Scene* (New York: Dover Publications, 1968). A social history, 1839–1889.

Newhall, Beaumont, *The Daguerreotype in America* (New York: Dover Publications, 1976). 3rd edition.

Dennis, Landt, and Lisl Dennis, *Collecting Photographs: A Guide to the New Art Boom* (New York: E. P. Dutton, 1977).

Sipley, Louis Walton, *Collector's Guide to American Photography* (Philadelphia: American Museum of Photography, 1957).

Eaton, George T., *Preservation, Deterioration, Restoration of Photographic Images* (Chicago: The University of Chicago Press: 1970). Excerpted from *The Library Quarterly*, Vol. 40, No. 1, January 1970.

East Street Gallery, *Preservation of Contemporary Photographic Materials* (Grinnell, Iowa: East Street Gallery, 1976).

Keefe, Laurence E., Jr., and Dennis Inch, *The Life of a Photograph* (Stoneham, Mass.: Focal Press, 1984).

Horan, James D., *Mathew Brady: Historian with a Camera* (New York: Bonanza Books, 1955).

Gardner, Alexander, *Gardner's Photographic Sketchbook of the Civil War* (New York: Dover Publications, 1959). A facsimile edition of the 1866 original.

Gernsheim, Helmut, *Julia Margaret Cameron: Her Life and Photographic Work* (Millerton, N.Y.: Aperture, 1975).

Gernsheim, Helmut, *Lewis Carroll, Photographer* (London: Max Parrish and Co., 1949).

Karsh, Yousuf, *Portraits of Greatness* (London and New York: Thomas Nelson and Sons, 1960).

Marie Cosindas: Color Photos (Boston: New York Graphic Society, 1978). A monograph on the renowned practitioner of Polaroid color photography, with an essay by Tom Wolfe.

Goodrich, L. Carrington, and Nigel Cameron, *The Face of China: As Seen by Photographers and Travelers, 1860–1912* (Millerton, N.Y.: Aperture, 1978).

Worswick, Clark, and Ainslie Embree, *The Last Empire: Photography in British India, 1855–1911* (Millerton, N.Y.: Aperture, 1976).

Hannavy, John, *Roger Fenton of Crimble Hall* (Boston: David R. Godine, 1976).

Naef, Weston, and James N. Wood, with an essay by T. T. Heyman, *Era of Exploration: The Rise of Landscape Photography in the American West, 1860–1885* (New York: Albright-Knox Art Gallery/Metropolitan Museum of Art, 1975).

Fowler, Don D., editor, *Photographed All the Best Scenery* (Salt Lake City: University of Utah Press, 1972). Jack Hiller's diary of the Powell Expeditions, 1871–1875.

Horan, James D., *Timothy O'Sullivan: America's Forgotten Photographer* (Garden City, N.Y.: Doubleday, 1966).

Newhall, Beaumont, and Nancy Newhall, *T. H. O'Sullivan: Photographer* (Rochester, N.Y.: George Eastman House/Amon Carter Museum of Western Art, 1966).

Jackson, William Henry, *Time Exposure* (New York: G. P. Putnam's Sons, 1940). Jackson's autobiography, written in old age.

Newhall, Beaumont, and Diana E. Edkins, *William H. Jackson* (Dobbs Ferry, N.Y.: Morgan and Morgan/Amon Carter Museum, 1974).

Newhall, Nancy, *P. H. Emerson* (New York: Aperture, 1975).

Doty, Robert, *Photography as a Fine Art* (Rochester, N.Y.: The George Eastman House, 1960). An account of "Photosecession."

Craven, George M., *The Group f/64 Controversy* (San Francisco: San Francisco Museum of Art, undated). A short pamphlet.

Bullock, Barbara, *Wynn Bullock* (Berkeley, Calif.: Scrimshaw Press, 1971).

Paul Caponigro (Millerton, N.Y.: Aperture, 1967).

Hiley, Michael, *Frank Sutcliffe: Photographer of Whitby* (Boston: David R. Godine, 1974).

Tilden, Freeman, *Following the Frontier with F. Jay Haynes: Pioneer Photographer of the Old West* (New York: Alfred A. Knopf, 1964).

Graybil, Florence Curtis, and Victor Boesen, *Edward Sheriff Curtis* (New York: Crowell, 1976).

Mahood, Ruth I., *Photographer of the Southwest: Adam Clark Vroman, 1856–1916* (Los Angeles: The Ward Ritchie Press, 1961).

Daniel, Pete, and Raymond Smock, *A Talent for Detail: The Photographs of Miss Frances Benjamin Johnston, 1889–1910* (New York: Harmony Books, 1974).

Riis, Jacob A., *How The Other Half Lives* (New York: Dover Publications, 1971). A reprint of the 1901 edition.

Cordasco, Francesco, editor, *Jacob Riis Revisited* (Garden City, N.Y.: Doubleday Anchor, 1968).

Lewis W. Hine (New York: Viking Press, 1974).

Trachtenberg, Arthur, editor, *A Vision of Paris* (New York: The Macmillan Company, 1963). Photographs by Eugène Atget, text by Marcel Proust.

Abbott, Berenice, *The World of Atget* (New York: Horizon Press, 1964).

Lartigue, Jacques-Henri, *Boyhood Photographs of J.-H. Lartigue: The Family Album of a Gilded Age* (Lausanne, Switzerland: Ami Guichard, 1966).

Szarkowski, John, *The Photographs of Jacques—Henri Lartigue* (New York: The Museum of Modern Art, 1963).

Sander, August, *Deutshenspiegel* (Gütersloh, Germany; Sigbert Mohn Verlag, 1962).

———, *Men without Masks: Faces of Germany 1910–1938* (Boston: New York Graphic Society, 1973).

August Sander (Millerton, N.Y.: Aperture, 1978).

Cartier-Bresson, Henri, *The Decisive Moment* (New York: Simon and Schuster, 1952).

Henri Cartier-Bresson (Millerton, N.Y.: Aperture, 1976).

Maddox, Jerald C. (introduction by), *Walker Evans: Photographs for the Farm Security Administration, 1935–1938* (New York: Da Capo, 1974).

Kirstein, Lincoln (essay by), *Walker Evans: American Photographs* (New York: East River Press, 1976). A reprint of the 1938 edition.

Meltzer, Milton, *Dorothea Lange: A Photographer's Life* (New York: Farrar, Straus and Giroux, 1978).

Dorothea Lange (New York: The Museum of Modern Art, 1966).

Newhall, Beaumont, *Dorothea Lange Looks at the American Country Woman* (Fort Worth, Tex.: The Amon Carter Museum, 1967).

W. Eugene Smith: His Photographs and Notes (Millerton, N.Y.: Aperture, 1969).

Smith, W. Eugene, and Aileen M. Smith, *Minimata* (New York: Holt, Rinehart and Winston, 1975).

Lyon, Danny, *The Bikeriders* (New York: The Macmillan Company, 1968).

Davidson, Bruce, *East 100th Street* (Cambridge, Mass.: Harvard University Press, 1970).

Owens, Bill, *Suburbia* (Bill Owens, P.O. Box 588, Livermore, Calif.: 94550, 1973).

Salomon, Erich, *Portrait of an Age* (New York: The Macmillan Company, 1967).

Arthur Fellig (Weegee), *Weegee by Weegee: An Autobiography* (New York: Da Capo, 1975). A reprint of the 1961 edition.

Stettner, Louis (edited and biographical introduction by), *Weegee* (New York: Alfred A. Knopf, 1977).

Callahan, Sean, editor, *Photographs of Margaret Bourke-White* (Boston: New York Graphic Society, 1972).

Steichen, Edward, *A Life in Photography* (Garden City, N.Y.: Doubleday/The Museum of Modern Art, 1963).

Capa, Robert, *Images of War* (New York: Paragraphic Books, 1965).

Duncan, David Douglas, *This is War!* (New York: Bantam Books, 1967).

———, *I Protest!* (New York: The New American Library/Signet, 1968).

Corn, Wanda M., *The Color of Mood: American Tonalism, 1880–1910* (San Francisco: M. H. DeYoung Memorial Museum/California Palace of the Legion of Honor, 1972).

Norman, Dorothy, *Alfred Stieglitz* (New York: Duell, Sloan and Pearce, 1960).

Bry, Doris, *Alfred Stieglitz: Photographer* (Boston: Museum of Fine Arts, 1965).

Margolis, Marianne Fulton, *Alfred Stieglitz: Camera Work, A Pictorial Guide* (New York: Dover Publications, 1978).

Ray, Man, *Self Portait* (Boston: Little, Brown, 1963).

Weston, Edward, *My Camera on Point Lobos* (New York: Da Capo, 1968).

Maddow, Ben, *Edward Weston* (Boston: New York Graphic Society, 1978).

Newhall, Nancy, editor, *Edward Weston: The Flame of Recognition* (Millerton, N.Y.: Aperture, 1975).

Newhall, Nancy, *The Eloquent Light* (San Francisco: Sierra Club, 1963). A biography of Ansel Adams.

White, Minor, *Mirrors, Messages, Manifestations* (Millerton, N.Y.: Aperture, 1969).

Hall, James Baker (biographical essay by), *Minor White: Rites & Passages* (Millerton, N.Y.: Aperture, 1978).

Robert Frank (Millerton, N.Y.: Aperture, 1976).

Diane Arbus (Millerton, N.Y.: Aperture, 1972).

Chapter 3

Auer, Michel, *The Illustrated History of the Camera* (Boston: New York Graphic Society, 1975).

Thomas, D. B., *Cameras: Photographs and Accessories* (London: Her Majestie's Stationery Office, 1966).

Cartier-Bresson, Henri, *Photographs* (New York: Grossman, 1963).

Scharf, Aaron, *Bill Brandt: Photographs* (New York: The Museum of Modern Art, 1969).

Chapter 4

Cox, Arthur, *Photographic Optics* (New York: Hastings House, 1975). 15th edition.

Neblette, C. B., *Photographic Lenses* (Dobbs Ferry, N.Y.: Morgan and Morgan, 1974).

Brown, Sam, *Popular Optics* (Barrington, N.J.: Edmund Scientific Company, 1974). A book of particular interest to the do-it-yourself gadgeteer, but useful to anyone interested in practical photographic optics.

Blaker, Alfred A., *Applied Depth of Field* (Stoneham, Mass.: Focal Press, 1985).

Dater, Judy, and Jack Welpott, *Women and Other Visions* (Dobbs Ferry, N.Y.: Morgan and Morgan, 1975).

Chapter 5

Gibson, Ralph, *The Somnambulist* (Los Angeles: Lustrum Press, 1970).

Sturge, John, editor, *Neblette's Handbook of Photography and Reprography: Materials, Processes and Systematics* (New York: Van Nostrand and Reinhold Company, 1977).

Blaker, Alfred A., "The Craft of Chromogenics," *Darkroom Photography*, October 1986, pp. 38-41.

Blaker, Alfred A., "The Case for RC," *Darkroom Photography* September 1986, pp. 22-27, 45-46.

Chapter 6

Szarkowski, John (introduction by), *The Portfolios of Ansel Adams* (Boston: New York Graphic Society, 1977).

Larmore, Lewis, *Introduction to Photographic Principles* (New York: Dover Publications, 1965).

Berg, W. F., *Exposure* (New York: Hastings House, 1971).

Dunn, J. F., and G. L. Wakefield, *Exposure Manual* (Dobbs Ferry, N.Y.: Morgan and Morgan, 1974).

Todd, Hollis N., and Richard Zakia, *Photographic Sensitometry* (Dobbs Ferry, N.Y.: Morgan and Morgan, 1969).

Sanders, Norman, *Photographic Tone Control* (Dobbs Ferry, N.Y.: Morgan and Morgan, 1977).

Zakia, Richard D., and Hollis N. Todd, *101 Experiments in Photography* (Hastings-On-Hudson, N.Y.: Morgan and Morgan, 1969). This little paperback is a surprisingly broad self-teaching device.

Pittaro, Ernest M., editor, *Photo-Lab Index* (Dobbs Ferry, N.Y.: Morgan and Morgan, 1977). This looseleaf encyclopedia is the standard compendium of manufacturers' technical information on darkroom products and processes. There are periodic supplements.

Adams, Ansel, *The Negative* (Boston: New York Graphic Society/Little, Brown, 1981).

Adams, Ansel, *The Print* (Boston: New York Graphic Society/Little, Brown, 1983).

White, Minor, with Richard Zakia and Peter Lorenz, *The New Zone System Manual* (Dobbs Ferry, N.Y.: Morgan and Morgan, 1976).

Gassan, Arnold, *Handbook for Contemporary Photography* (Athens, Ohio: Handbook Publishing, 1970).

Dowdell, John J., III, and Richard D. Zakia, *Zone Systemizer for Creative Photographic Control* (Dobbs Ferry, N.Y.: Morgan and Morgan, 1973).

Picker, Fred, *The Zone VI Workshop* (White Plains, N.Y.: The Zone VI Studios, Inc., 1972).

Adams, Ansel, and Robert Baker, *Polaroid Land Photography* (Boston: New York Graphic Society, 1978).

Chapter 7

Adams, Ansel, *Natural Light Photography* (Boston: New York Graphic Society, 1965).

———, *Artificial Light Photography* (Boston: New York Graphic Society, 1966).

Bomback, Edward S., *Manual of Photographic Lighting* (New York: Hastings House, 1971).

Feininger, Andreas, *Light and Lighting in Photography* (Englewood Cliffs, N.J.: Prentice-Hall, 1976).

Edgerton, Harold E., *Electronic Flash, Strobe* (New York: McGraw-Hill Book Company, 1970). The inventor of electronic flash recapitulates his life's work in a fine technical compendium.

Jacobs, Lou, *Electronic Flash* (Garden City, N.Y.: Amphoto, 1971).

Eastman Kodak Company, *Exposure with Portable Flash Units, AC-37* (Rochester, N.Y.: Eastman Kodak Company, 1978).

General Electric Company, *Photolamp & Lighting Data, P1-63P* (Cleveland, Ohio: General Electric Company, 1971).

Drafahl, Jack and Sue, "Through-The-Lens Flash," *Petersen's PhotoGraphic*, April 1986, pp. 58-61.

Chapter 8

Stroebel, Leslie, *Photographic Filters* (Dobbs Ferry, N.Y.: Morgan and Morgan, 1974).

Rothchild, Norman, and Cora Kennedy, *Filter Guide: For Color and Black-and-White* (Garden City, N.Y.: Amphoto, 1971).

Clauss, Hans, and Heinz Meusel, *Filter Practice* (London and New York: Focal Press, 1964).

Guide to Hoya Filters: How to Use Filters for the Best Results (Tokyo: Hoya Corporation, 1976). A good brief general guide to the use of filters.

Eastman Kodak Company, *Kodak Filters for Scientific and Technical Uses, B-3* (Rochester, N.Y.: Eastman Kodak Company, 1978). An excellent guide, providing all essential information on the theory of color filtering.

Millard, Howard, with Andrew Davidhazy and Henry Horenstein, "What's The One Filter You Can't Do Without? The Polarizer," *Modern Photography*, July, 1985, pp. 43-58.

Chapter 9

Reynolds, Clyde, *The Focalguide to Cameras* (New York: Hastings House, 1977). A general guide to the use of all varieties of cameras.

Adams, Ansel, *Camera and Lens* (Boston: New York Graphic Society, 1970).

Stroebel, Leslie, *View Camera Technique* (Stoneham, Mass.: Focal Press, 1986). 5th edition.

Shaman, Harvey, *The View Camera: Operations and Techniques* (Garden City, N.Y.: Amphoto, 1977).

Chapter 10

Jacobsen, C. I., and L. A. Mannheim, *Developing: The Technique of the Negative* (New York: Hastings House, 1972). 18th edition.

Eastman Kodak Company, *Processing Chemicals and Formulas, J-1* (Rochester, N.Y.: Eastman Kodak Company, 1977). A guide to film processing.

Eaton, George T., *Photographic Chemistry* (Dobbs Ferry, N.Y.: Morgan and Morgan, 1986, 4th ed.).

Wall, E. J., and Franklin Jordan (revised by John Carroll), *Photographic Facts and Formulas* (Garden City, N.Y.: Amphoto, 1975). An updated version of a classic work.

Stensvold, Mike, *Increasing Film Speed: How to Get the Most from Your Film, Black-and-White and Color* (Los Angeles: Petersen Publishing Company, 1978).

Chapter 11

Hattersley, Ralph, *Beginner's Guide to Darkroom Techniques* (Garden City, N.Y.: Doubleday, 1976).

The Morgan and Morgan Darkroom Book (Dobbs Ferry, N.Y.: Morgan and Morgan, 1977). A compendium by a number of expert professionals.

Lewis, Eleanor, editor, *Darkroom* (New York: Lustrum Press, 1977). Descriptions by 13 prominent American photographers of their darkroom techniques.

Kelly, Jain, editor, *Darkroom 2* (New York: Lustrum Press, 1978). Ten more prominent photographers describe their darkroom methods.

Lootens, J. G. (revised by L. H. Bogen), *Lootens on Photographic Enlarging and Print Quality* (Garden City, N.Y.: Amphoto, 1975). 8th edition.

Adams, Ansel, *The Print* (Boston: New York Graphic Society, 1968).

Picker, Fred, *Zone VI Workshop: The Fine Print in Black and White Photography* (Garden City, N.Y.: Amphoto, 1975).

Blaker, Alfred A., "Brickwork," *Darkroom Photography*, December 1987. Correction of image perspective in enlarging.

Henry, Dr. Richard, *Controls in Black-and-White Photography, 2nd edition* (Stoneham, Mass: Focal Press, 1987).

Eastman Kodak Company, *The ABC's of Toning, G-23* (Rochester, N.Y.: Eastman Kodak Company, 1977).

Haffer, Virna, *Making Photograms: The Creative Process of Painting with Light* (New York: Hastings House, 1969).

Bruandet, Pierre, *Photograms* (New York: Watson-Guptill, 1974).

Duffy, Pamela, editor, *Storing, Handling, and Preserving Photographs: A Guide* (Stoneham, Mass: Focal Press, 1983).

West, Kitty, *Guide to Retouching Negatives and Prints* (Garden City, N.Y.: Amphoto, 1972).

Croy, O. R., *Retouching* (New York: Hastings House, 1964).

Chapter 12

Post, George, "Darkroom Color Printing Handbook," *Darkroom Photography*, September-December, 1984.

Chapter 13

Gibson, H. Lou, *Closeup Photography and Photomacrography, N-12* (Rochester, N.Y.: Eastman Kodak Company, 1977).

Blaker, Alfred A., *Field Photography: Beginning and Advanced Techniques* (San Francisco: W. H. Freeman and Company, 1976). A compendium of photographic techniques relating to outdoor photography, with special emphasis on close-up and photomacrographic methods.

————, *Handbook for Scientific Photography* (San Francisco: W. H. Freeman and Company, 1977). A laboratory-oriented handbook for those with scientific interests.

Dalton, Stephen, *Borne on the Wind: The Extraordinary World of Insects in Flight* (New York: Readers' Digest Press/Dutton, 1975). Masterful photography of flying insects, caught in mid-air.

General Electric Company, *Photographic Lamp & Equipment Guide, P4-61P* (Cleveland, Ohio: General Electric Company, undated but current).

Chapter 14

Chernoff, George, and Hershel B. Sarbin, *Photography and the Law* (Garden City, N.Y.: Amphoto, 1977). Revised edition.

Cavallo, Robert M., and Stuart Kahan, *Photography: What's the Law?* (New York: Crown Publishers, 1976).

Davies, Thomas L., *Shoots: A Guide to Your Family's Photographic Heritage* (Danbury, N.H.: Addison House, 1977). How to collect, copy, restore, and preserve family photographs.

Szasz, Susanne, *Child Photography Simplified* (Englewood Cliffs, N.J.: Prentice-Hall, 1976).

Mitchell, Margaretta, *After Ninety: Imogen Cunningham, Photographs* (Seattle: University of Washington Press, 1976).

Brassai (The Museum of Modern Art, New York, 1968). A monograph on the French photographer, including his documentation of seamy 1930s Paris nightlife and some fascinating graffiti.

Owens, Bill, *Our Kind of People* (New York: Simon and Schuster/Bill Owens, P.O. Box 588, Livermore, Calif. 94550, 1975). A chronicler of modern suburbia photographs the meetings and ceremonies of voluntary organizations.

———, *Working: I Do It For The Money* (New York: Simon and Schuster/Bill Owens, P.O. Box 588, Livermore, Calif. 94550, 1977). Photographs of people at work, with their descriptions of how they feel about their work.

Turner, Richard, *Focus on Sports: Photographing Action* (Garden City, N.Y.: Amphoto, 1975).

Reich, Hanns, *Sports* (New York: Hill and Wang, 1974). Photographic impressions.

Chittenden, Gordon, *How to Photograph Auto Racing* (Los Angeles: Vivitar Corporation, 1970). A small but useful pamphlet.

Sheedy, Jack, and George Long, *How to Photograph Sports* (Santa Monica, Calif.: Vivitar Corporation/Ponder & Best, 1972). A companion piece to the foregoing.

Owens, Bill, *Documentary Photography* (Bill Owens, P.O. Box 588, Livermore, Calif. 94550, 1978). How to do Owens-style documentary photography.

Gatewood, Charles, *People in Focus* (Garden City, N.Y.: Amphoto, 1978). Photography on the streets.

———, "The Art of Successful Candid Photography," *Petersen's PhotoGraphic*, December 1978, pp. 48-52.

Duncan, David Douglas, *Self-Portrait: U.S.A.* (New York: Harry N. Abrams, 1969). A neglected masterpiece of political photography, illustrating the Republican and Democratic conventions of 1968.

Rothstein, Arthur, *Photojournalism* (Garden City, N.Y.: Amphoto, 1974).

Eastman Kodak Company, *Professional Portrait Techniques, 0-4* (Rochester, N.Y.: Eastman Kodak Company, 1973). A description of formal portraiture techniques.

———, *Picturing People, E-99* (Rochester, N.Y.: Eastman Kodak Company, 1976). How to make natural "environmental" pictures of people.

Manning, Jack, *The Fine 35 mm Portrait* (Garden City, N.Y.: Amphoto, 1978).

Karsh, Yousuf, *Karsh Portfolio* (Camden, N.J., and London: University of Toronto Press/Thomas Nelson and Sons, 1967).

Chapter 15

Bunnell, Peter, *Jerry N. Uelsmann: Silver Meditations* (Dobbs Ferry, N.Y.: Morgan and Morgan, 1975). Images displaying masterful multiple-printing technique.

Rainwater, Clarence, and Sandy Walker, *Solarization* (Garden City, N.Y.: Amphoto, 1974).

Jolly, William L., "B&W Sabatier Print Solarization," *Darkroom Photography*, May/June, 1987, pp. 30-35, 67-68.

Wade, Kent, *Alternative Photographic Processes* (Dobbs Ferry, N.Y.: Morgan and Morgan, 1977). Photographic printing on ceramics, metals, fibers, glass, wood, linoleum, and plastics.

Stevens, Gloria, *The Metaphorical Eye: Special Effects in Photography* (Garden City, N.Y.: Amphoto, 1976).

Karsten, Kenneth, *Abstract Photography Techniques* (New York: Hastings House, 1970).

Tait, Jack, *Beyond Photography* (New York: Hastings House, 1977). Manipulative processes.

Chapter 16

Arnheim, Rudolf, *Art and Visual Perception* (Berkeley: University of California Press, 1954).

Evans, Ralph M. *Eye, Film, and Camera in Color Photography* (New York: John Wiley and Sons, 1959).

Halsman, Julius, "Tips for Gross Specimen Photography," *Visual/Sonic Medicine*, Vol. 3, No. 1 (February/March 1968), pp. 26-34. Although meant specifically for medical photographers, this succinct treatment of color perception is also of value to the general photographer.

Zakia, Richard, *Perception and Photography* (Englewood Cliffs, N.J.: Prentice-Hall, 1974).

Feininger, Andreas, *Photographic Seeing* (Englewood Cliffs, N.J.: Prentice-Hall, 1973).

Tucker, Kay, *The Educated Innocent Eye* (Berkeley, Calif.: The Image Circle, 1973). Criteria for criticism of photography.

Ward, John L., *The Criticism of Photography as Art* (Gainesville: University of Florida Press, 1970). Concentrates on the work of Jerry Uelsmann.

Bayer, Jonathan, *Reading Photographs: Understanding the Aesthetics of Photography* (New York: Pantheon Books, 1977).

Sontag, Susan, *On Photography* (New York: Farrar, Straus and Giroux, 1978). This book upsets virtually all photographers, but thoughtful people will find much to consider in it.

Chapter 17

Szarkowski, John, editor, *Callahan* (Millerton, N.Y.: Aperture, 1976). A large monograph on the photographer Harry Callahan, with an introduction by Szarkowski.

Zakia, Richard D., and Hollis N. Todd, *Color Primer I & II* (Dobbs Ferry, N.Y.: Morgan and Morgan, 1974).

Clulow, F. W., *Color, Its Principles and Their Applications* (Dobbs Ferry, N.Y.: Morgan and Morgan, 1974).

Robinson, Henry Peach, *Pictorial Effect in Photography: Being Hints on Composition and Chiaroscuro for Photographers* (Pawlet, Vt.: Helios, 1971). A facsimile edition of the 1869 original.

Cott, Hugh B., *Zoological Photography in Practice* (London: Fountain Press, 1956).

Jonas, Paul, *Guide to Photographic Composition* (New York: Universal Photo Books, 1961).

Zettl, Herbert, *Sight·Sound·Motion: Applied Media Aesthetics* (Belmont, Calif.: Wadsworth Publishing Company, 1973).

Feininger, Andreas, *Principles of Comparison in Photography* (Garden City, N.Y.: Amphoto, 1973).

Litzel, Otto, *Litzel on Photographic Composition* (Garden City, N.Y.: Amphoto, 1974).

Mante, Harald, *Photo Design: Picture Composition for Black-and-White Photography* (N.Y.: Van Nostrand Reinhold, 1977).

Bothwell, Dorr, and Marlys Frey, *Notan: The Dark-Light Principle of Design* (New York: Van Nostrand Reinhold, 1968).

Chapter 18

Perry, Robin, *Photography for the Professional* (Waterford, Conn.: Livingston Press, 1976).

Milton, John, *The Writer-Photographer* (Philadelphia: Chilton Book Company, 1972).

Edom, Clifton C., *Photojournalism* (Dubuque, Iowa: William Brown, 1976).

McDarrah, Fred. W., editor, *Photography Market Place* (Ann Arbor, Mich.: R. R. Bowker, 1977).

Buziak, Ed, *The Focalguide to Selling Photographs* (New York: Hastings House, 1978).

Eidenier, Connie Wright, ed., *1988 Photographer's Market* (Cincinnati, Ohio: Writer's Digest Books, 1987). Appears annually.

Ahlers, Arvel, *Where and How to Sell Your Photographs* (Garden City, N.Y.: Amphoto, 1977). 8th edition.

Shulman, Julius, *The Photography of Architecture and Design* (New York: Watson-Guptill, 1977).

Angel, Heather, *Nature Photography: Its Art and Techniques* (New York: Hastings House, 1974).

Blaker, Alfred A., *Field Photography: Beginning and Advanced Techniques* (San Francisco: W. H. Freeman and Company, 1976).

Farber, Robert, *Professional Fashion Photography* (Garden City, N.Y.: Amphoto, 1978).

St. Joseph, J. K. S., editor, *The Uses of Air Photography* (New York: The John Day Company, 1966).

Schwartz, Ted, *How to Start a Professional Photography Business* (Chicago: Contemporary Books, undated but recent).

Guterman, Sy, *Business Management for the Professional Photographer* (New York: American Photographic Book Publishing Co., 1981).

Delly, John Gustav, editor, *Biomedical Photography: A Kodak Seminar in Print* (Rochester, N.Y.: Eastman Kodak Company, 1976).

Bracegirdle, Brian, *Photography as Illustration: The Use of the Camera for Books and Reports* (New York: A. S. Barnes and Company, 1970). Primarily a book on scientific photography.

Engel, Charles E., editor, *Photography for the Scientist* (London and New York: Academic Press, 1968). A compendium of writings by 18 British, German, and American scientific photographers.

Blaker, Alfred A., *Handbook for Scientific Photography* (San Francisco: W. H. Freeman and Company, 1977).

Moser, Lida, *Grants in Photography: How to Get Them* (Garden City, N.Y.: Amphoto, 1978).

Owens, Bill, *Documentary Photography* (Bill Owens, P.O. Box 588, Livermore, Ca. 94550, 1978). Contains valuable information, based on personal experience, on getting grants.

———, *A Survey—College Instruction in Photography—Motion Picture/Graphic Arts/Still Photography, T-17* (Rochester, N.Y.: Eastman Kodak Company, 1983).

Gilbert, George, *The Complete Photography Careers Handbook* (New York: E.P. Dutton, 1983).